GAUGUIN

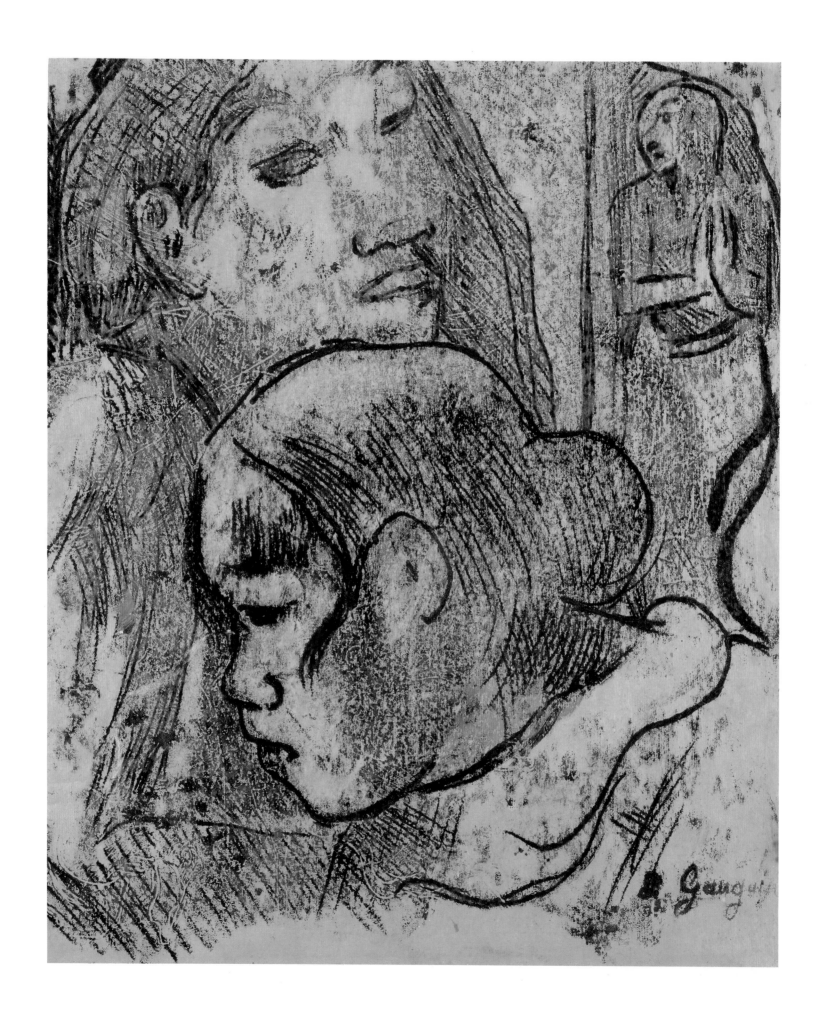

GAUGUIN

Peggy Vance

LONGMEADOW
P R E S S

For my mother, Claire Nielson

The author would like to acknowledge her debt to the scholarship
of the exhibition catalogue *The Art of Paul Gauguin* published by
the National Gallery of Art, Washington DC and the Art Institute
of Chicago and to express her thanks to Sarah Sears
at Studio Editions.

First published in Great Britain in 1991 by Studio Editions Ltd
This revised edition published 1992 by
Studio Editions Ltd
Princess House, 50 Eastcastle Street
London W1N 7AP, England

Reprinted 1993

Published by Longmeadow Press,
201 High Ridge Road, Stamford, CT 06904.

ISBN: 0-681-45330-3

Printed in Hong Kong

First Longmeadow Press Edition 1993

0 9 8 7 6 5 4 3 2 1

INTRODUCTION

Eugène Henri Paul Gauguin was born in Paris on 7 June 1848, first son of Pierre Guillaume Clovis Gauguin, a republican newspaper editor, and Aline Marie Chazal. The artist rarely spoke or wrote about his father's family, and little is known of them but that they hailed from Orléans. Of his maternal ancestry, however, he was particularly proud, as it offered him the opportunity either to assert that he was of aristocratic birth, or when it suited him, to cast himself in the role of Peruvian savage. In fact he could barely claim to be an eighth Peruvian as his great-grandfather, Don Mariano Tristan y Moscolo (whose brother indeed became the viceroy of Peru), was essentially of Spanish stock. The connection was, however, strengthened in the artist's mind by the romantic figure of his grandmother, Moscolo's illegitimate daughter, the writer Flora Tristan, well known in the 1830s and '40s for her crusading socialist views. The stories of his grandmother's colourful life in Paris and Peru were so numerous and contradictory, however, that in writing of her towards the end of his own life, Gauguin declared that he could not distinguish the fact from the fiction, and described her both as 'a blue-stocking Socialist Anarchist' and 'a very pretty and noble lady'. Despite this confusion, the example of her bravery and pioneering ideas undoubtedly offered encouragement to the unorthodoxy of his own existence, reason enough for him to claim that she had genius.

Clovis Gauguin met Flora's daughter when he was already a political reporter, but when she was still at boarding school. They married, but without the prospect of settling down into a quiet domestic life in Paris. Following the suppression of the 1848 revolt against the July Monarchy of Louis-Philippe, Clovis's republican sympathies placed him in increasing danger. With a view to preserving his family and finding a voice elsewhere, he planned their departure for Lima, where he firmly intended to start his own newspaper. In August 1849 the one-year-old Paul Gauguin and his two-year-old sister Marie sailed with their parents to Peru.

But Clovis Gauguin was already suffering from an advanced stage of heart disease, a condition which deteriorated, making him increasingly ill on the journey. According to his son, their 'dreadful captain' mismanaged the affair and Clovis subsequently died of a ruptured aneurism in the lifeboat taking him ashore to the Gulf of Port-Famine in Lima. The family had some small assets, but Aline was nevertheless now left with the daunting task of bringing up the two young children alone.

After the horrors of the journey the diminished family could not have been received more cordially by their great-uncle Don Pio de Tristan Moscolo. Gauguin later related how:

The old uncle Don Pio fell head over heels in love with his niece, so pretty and bearing such a strong resemblance to his beloved brother, Don Mariano. Don Pio remarried at the age of 80, having several children by this new marriage . . . This made for a large family and my mother, in the midst of it, was a truly spoilt child.

Gauguin's lifelong quest for the exotic and the primitive may in part be attributable to a desire to regain the happiness experienced growing up in the beauty, heat and excitement of Peru. He adored his mother, lived wealthily, spoke Spanish, was mischievous and healthy; but it was an idyll that was to be rudely interrupted by a letter from Paris. Gauguin's paternal grandfather had died and it was therefore necessary that Aline should return with the children to settle the estate. Accordingly, early 1855 saw their arrival in Orléans, and a decline in their fortunes. The inheritance was small and Aline, who had once chided her son for engaging in 'trade' – when he bartered a rubber ball for some marbles – was now in the unhappy position of having to find work.

The boy Gauguin was soon sent as a boarder to the Junior Seminary of the Saint-Mesmin Chapel at Orléans. A child of ready intelligence but little stomach for study, he fared relatively well, passing into secondary school at eleven; there he received a solid classical education and, as he chose to remember, made 'very rapid progress'. His ambitions, however, were neither academic nor clerical, his first instinct – no doubt cultivated by the excitements of his childhood – being to become a sailor. At the age of fourteen he therefore joined his mother in Paris, where she had for the previous year been earning their living as a seamstress. He enrolled at the Loriol Institute, and began to prepare for the entrance exam of the Naval Academy.

It is probable that by this stage Gauguin had received some kind of tuition in drawing and the history of art. If this is the case, however, he cannot have considered these lessons particularly formative for they are nowhere referred to in his later writings. In a rare anecdote relating to 'art' during this early period, he recalled being discovered as he crafted unusual, highly decorative objects:

I was carving with a knife and sculpting dagger handles without the dagger; a lot of dreams incomprehensible to grown-ups. A little old lady, a friend of ours, exclaimed with admiration: 'One day he will be a great sculptor.' Unfortunately, that woman was no prophet.

This rather laboured recollection (the false modesty of the last sentence begs forgiveness for its self-consciousness) suggests that Gauguin could not without effort recall any early sign that he would later become a great painter. At the age of sixteen his sights were firmly set on a life at sea, and a career as an artist was as yet far over the horizon. His mother, too, was keen that he should attend the Naval Academy so when, ultimately, it became apparent that he was not up to the exam, it seemed natural for him to settle on the next best option, in order still to have the opportunity of going to sea. Accordingly he enlisted in the merchant marine and promptly found himself bound for Rio de Janeiro on the three-masted ship *Luzitano*.

Prior to her son's arrival in Paris, Aline Gauguin had revived a long-standing connection with the businessman and art collector Gustave Arosa and his family and, in 1865, she officially named him as the legal guardian of her children. Given the precariousness of her financial situation this cannot but be seen as a shrewd move, however it is likely also to have been motivated by worries for Paul's future in particular. The extent to which he was causing her concern is nowhere made more clear than in the severe request of her will that he 'get on with his career, since he has made himself so disliked by all my friends that he will one day find himself alone.' Luckily Arosa took his obligations seriously and spent time with the boy, discussing questions both of finance and art. Arosa's collection, although not particularly avant-garde, was varied and of extremely high quality, and Gauguin was therefore in the privileged position of having direct access to canvases by Delacroix, Corot, Daumier and Courbet.

Gauguin's first and second voyages aboard the *Luzitano* each lasted for nearly four months, taking him

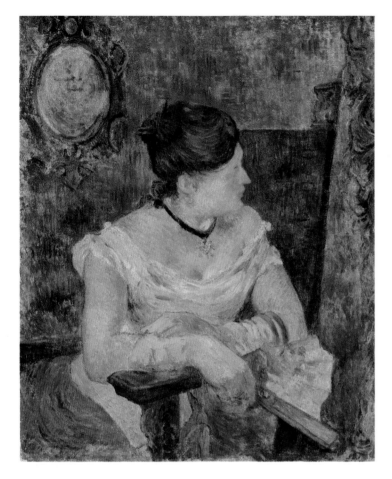

Madame Mette Gauguin in Evening Dress, 1884.
Oil on canvas, 65 × 54 cm
National Gallery, Oslo

twice to Rio and giving him time enough to prove himself an excellent seaman. At the end of October 1866 he was duly promoted to the rank of second lieutenant and began a long voyage on the *Chili*, which was to last over a year and show him countries all over the world, including Panama and Oceania. News of his mother's death in July 1867 finally arrived during a stopover in India, but it was five months before his ship was to dock in France, and over a year before he was legally entitled to inherit a portion of his mother's money and her collection of drawings and paintings.

Aged nearly twenty and with few family ties, Gauguin officially committed himself to the sea, enlisting in the military as a sailor of the third class based at Le Havre. On his new ship, the *Jérôme-Napoléon*, he sailed to the eastern Mediterranean and London and then, as a second-class sailor, further afield to the Arctic Circle. He was off the coast of Norway when news broke that France had declared war on the Prussians and the *Jérome-Napoléon* was therefore ordered immediately to return to Calais for use in operations. Engaged in active service from July until the fall of the Empire in September 1870, Gauguin was finally released from the military on six months renewable leave in the spring of 1871, having been at sea almost continuously for over five years.

His mother's house in Saint-Cloud having been destroyed by the Prussians, Gauguin, at the age of twenty-four, was now without either home or occupation, so duly found lodgings in Paris for himself and his sister, becoming officially registered as unemployed. Luckily Gustave Arosa, out of respect to the memory of Aline, did not abandon his responsibilities now that his ward was an adult, and promptly secured him a job with Paul Bertin, a brokerage firm in the rue Laffitte. This employment was to mark the beginning of nearly a decade in which Gauguin moved from strength to strength in the business world, to become a rich and respected broker and family man.

In the autumn of 1872 he made the acquaintance of Mette Gad, a well-to-do young Danish woman who was holidaying in Paris with a friend. His circumstances now being favourable, indeed requiring that he should take a wife, the young Paul Gauguin lost no time in wooing and proposing to her. After an engagement of ten months they were married in the presence of Arosa and Bertin and moved immediately into their marital home in the Place St Georges. Within a fortnight Gauguin's wife, then only twenty-three, was pregnant with the first of their five children, Émile.

At the time of their marriage Paul was already filled with a zeal for art that had led him, during the

summer, to try his hand at *plein air* (open-air) painting. Strangely, however, Mette was kept entirely in the dark about the passion that was increasingly to dictate the path of their life. She later recalled:

No one gave Paul the idea to paint. He painted because he could not do otherwise, and when we were married I had no idea that he was inclined to the arts. As soon as we were married, he began painting every Sunday – sometimes going to the Colarossi studio – but without thinking of a teacher . . .

From 1873 onwards Gauguin began to produce oils in what may broadly be described as an Impressionist manner, and although it is true that he never received a formal schooling in art, these early works show a profound debt both to the style and subject matter of Camille Pissarro, the friend and mentor with whom he first began to paint (page 45). It is hardly surprising that the two men got on well; Pissarro was a man of enormous energy and enterprise, never afraid to be experimental in his work and generous in communicating his ideas. Like Gauguin he had seen more of the world at a young age than was usual, and was assertive and opinionated, with a volatile temperament but a great zest for living. Although Gauguin was eighteen years his junior, untrained and with the status only of a 'Sunday painter', it is likely that Pissarro enjoyed the rawness of his ideas and found his company stimulating. Conversely it is probable that Pissarro's courageous example was an important factor in Gauguin's later decision to paint full-time, regardless of the risks involved.

Gauguin's Impressionist 'upbringing' was consolidated by his attendance at their first group exhibition in 1874, where Pissarro's paintings could be seen alongside those of Boudin, Cézanne, Degas, Guillaumin, Monet, Morisot, Sisley and other important modern artists working outside the jurisdiction of the Salon. Unable yet to join their ranks but earning enough to buy their work, Gauguin at this time began what was to become a formidable collection of Im-

pressionist canvases, making him one of the most important champions of the new style and bringing him into frequent contact with the artists. Were he not today remembered for his own work, he would nevertheless still be known as a major collector. Primarily his patronage was of those landscape artists who, to date, had been the least successful in commercial terms: Guillaumin, Cézanne and Pissarro. But this bias was less the result of charity than of self-interest, since it was to these artists that he owed a particular debt in the development of his own style.

Spurred on by the excellent works that now surrounded him and by his increasing knowledge of the history of French painting, Gauguin made enormous strides, struggling to master the inadequacies of his figure drawing and his understanding of perspective, yet not wishing to participate in any institutionalized training. Ironically his technical progress was such that in 1876 one of his landscapes was accepted for exhibition at the annual Salon.

Simultaneously the artist was beginning to explore the possibilities of other media and, in 1877, was eagerly learning about modelling and carving techniques from his new landlord, the sculptor Bouillot. Before long he was producing sensitive and accomplished portraits in marble, amongst which was a small bust of his son Émile, chosen as a late entry to the fourth Impressionist exhibition of 1879; his first work to be shown with the group.

By this time Gauguin had left the employment of Bertin, had worked for a short while for the banker André Bourdon, and was now in a high position on the stock exchange. In addition to his daytime obligations he was increasingly active in buying and helping to sell Impressionist canvases, continued to paint and sculpt, and was awaiting the birth of his third child. Despite these heavy demands, he immediately took up the invitation to participate in the fifth group exhibition in 1880 and duly submitted eight recent works, delighted by the prospect of being hung alongside

Guillaumin and Pissarro. But the juxtaposition of his landscape canvases with those of his mentor did not show him to advantage in the eyes of the critics, and his submissions were almost unanimously dismissed as being weakly imitative of Pissarro's style and subject matter.

Increasingly prominent as an organizer within the group, Gauguin was determined that at the next show his work should both gain the acceptance of his fellow artists (some of whom had queried his inclusion) and win some critical recognition. To this end he put together for the sixth exhibition in 1881 a far more varied and accomplished selection of eight paintings and two sculptures, including a figure study and still-lives in addition to landscape subjects. The exhibition went up, but this time his work seemed to have been overlooked by the critics, either for praise or censure; it was two years before Gauguin discovered (on the publication of *L'Art Moderne*) that one canvas in particular, a nude study (page 47), had been admired by the Realist novelist and critic Joris-Karl Huysmans. Despite his protestation that Huysmans was only interested in the literary aspect of the work,

Garden in the rue Carcel, *1881.*
Oil on canvas, 87 × 114 cm
Ny Carlsberg Glyptotek, Copenhagen

this recognition greatly boosted Gauguin's self-esteem and undoubtedly encouraged him during the turbulent period that lay immediately ahead.

By 1882 Gauguin had for two years been living with his ever-growing family in a comfortable and commodious house in the rue Carcel (page 49). This was located conveniently close to a small pottery factory where, under the supervision of its director Chaplet, he made rapid progress in the medium of ceramics. His painting, if not widely acclaimed, was nevertheless now generally accepted by his fellow artists, and he was both helping to organize and preparing his submission to the seventh group exhibition in March. His own art collection too had grown substantially to include paintings by Manet, Renoir, Monet, Jongkind and Daumier. His financial career was also going well. To many he must have seemed to have achieved the perfect balance between the worldly and the spiritual; but Gauguin was not content with what he increasingly considered to be a compromised existence, and he began to look for a way of spending more time as an artist than as a businessman.

The end of Gauguin's financial career came about more quickly than even he could have engineered, with the crash of the Union General bank and the subsequent collapse of stockmarket trading. Financially his personal loss was great, but it gave him the opportunity to 'take the bull by the horns' and consider his first employment to be as an artist. Yet an obvious problem now presented itself — how to support his wife and four young children in anything approaching the comfort they expected. His initial notion was to develop his talents as an art dealer, but Mette's fifth pregnancy and increasing costs in Paris — 'a desert for a poor man' — soon made it clear that this could not be relied upon to bring in sufficient cash.

Following the example of Pissarro, who had also stayed there for financial reasons, the family moved in January 1884 to a small flat in Rouen, Gauguin's only immediate prospect being the possible sale of some

paintings left with the dealer Durand-Ruel in Paris, and the somewhat naive hope that the wealthy Rouennais would take to his work. But before even six months were up Mette could stand no more and, despairing of the 'lunatic' impracticality of her husband, she left with two of the children for a two-month visit to Copenhagen.

Ironically, but perhaps not surprisingly, Gauguin had produced very little since giving up his job, and was making hardly any money from sales. Those canvases that he did complete display a more forceful use of colour and confident description of form than his earlier exercises in Impressionism, but the fact that they were increasingly difficult to categorize also militated against their finding buyers. Faced with impending destitution, he was once again in the position of having to find a job that would finance both his family and his ambitions as an artist. In October 1884 he finally managed to secure the post of Danish representative for the canvas and tarpaulin manufacturer A. Dillies and Co., which allowed him immediately to send his entire family to Copenhagen, and then to join them in a home of their own. But still they could in no sense be described as rich, and Mette was obliged to supplement their income by giving French lessons. Gauguin continued to paint when he could afford the materials and to draw, exhibiting with the Society of Friends of Art in Copenhagen, where his work caused shock-waves. His marriage was still fraught with difficulty, however; indeed the couple separated in June 1885.

By now almost completely broke, Gauguin returned to Paris with his second son Clovis and moved in temporarily with the artist Émile Schuffenecker, with whom he had formerly worked at Bertin's (page 77). Like Gauguin, and possibly following his lead, Schuffenecker had also given up banking to devote himself to art, taking the somewhat more practical route of becoming a teacher of the subject. Though little respecting his painting, Gauguin had much need of his unstinting kindness during the ensuing fraught years,

Poplars, *1883.*
Oil on canvas, 73 × 54 cm
Ny Carlsberg Glyptotek, Copenhagen

but inevitably took every opportunity to abuse it.

Effectively a single man again and without regular daytime employment, Gauguin was, though poor, for the first time free to dedicate himself to his art. Sad at parting from his wife, but feeling liberated from the stuffy, bourgeois environment of Copenhagen – 'misery in a foreign town' – he took the opportunity to visit Dieppe and London, doing some business on behalf of the Spanish republicans, but spending most of his time studying, drawing, and trying to see beyond his Impressionist upbringing. As his son Pola Gauguin later put it:

We have no reason to regret [his parting from Mette], for left to his own devices Gauguin was able to devote himself entirely to his art in a spirit of complete physical and moral freedom.

Writing to Schuffenecker towards the end of his period in Copenhagen, Gauguin had begun to explain his rapidly developing ideas about the way in which form could, by a direct connection, communicate feeling, asserting:

All our five senses reach the brain directly imprinted with an infinity of things that no education can destroy. I conclude from this that there are lines that are noble, deceptive, etc . . . a straight line gives infinity, a curve limits creation without consideration for numerical fatality. Colours are even more explanatory, though less multiple than lines, because of their power over the eye. There are noble tones, others which are common, quiet, comforting harmonies, and others which excite you with their boldness.

This notion of lines and colours being expressive in their own right indicates how far Gauguin had now diverged in his thinking from what may broadly be described as an Impressionist philosophy. Increasingly his aim was not to be 'merely an eye' (as Monet had once been described), capturing fugitive effects of light, but to paint an emotive response to his subject matter. He was now drawn even more closely to the example of Cézanne, whom he described as being 'fond of the mystery and the heavy tranquility of a man lying down to dream', and of Raphael, in whose painting he perceived intuitive 'harmonies of line'. Accordingly, in *Notes synthétiques*, written in 1885, he made an extended plea for the recognition of a canvas as an expressive unity, rather than as a tool for the tame representation of nature. But Gauguin was not alone in these anti-academic sentiments; Paris was coming alive with Symbolist ideas, avant-garde artists in all media beginning to look beyond the rationalism of such as Zola to explore subjective worlds of fantasy and exaggeration.

In stark contrast to the wealth of Gauguin's ideas was the physical poverty of his living conditions. Clovis had smallpox and, the small amounts of money made on sales of his paintings being insufficient to pay for treatment, Gauguin was obliged to take whatever work he could find, which initially meant bill-posting in train stations for 3.50 fr. a day. Although not unprepared for this degradation – in 1885 he had anticipated 'life as a vagabond, a *labourer*' – he resented the effect that it had upon his ability to work. In the *Cahier pour Aline* he was later to recall:

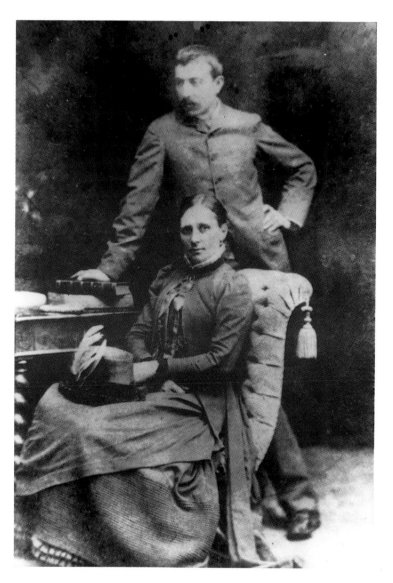

Photograph of Paul and Mette Gauguin
in Copenhagen, *c.1874.*
Musée Gauguin, Papeari, Tahiti

I have known the depths of want: to be hungry and all that this means. It is nothing or almost nothing: one gets used to it and, with the exercise of will, one ends by making sport of it. But what is terrible is the bar to work, to the development of intellectual faculties. It is true, on the other hand, that suffering sharpens genius, but you must not have too much of that suffering, else it kills you.

It is a measure of Gauguin's sheer determination not to be 'killed' by his penury that he submitted nineteen paintings and a wood relief to the eighth Impressionist exhibition in 1886. Although less revolutionary in appearance than his contemporary writings might suggest, these works were distinguished by a rich but sombre palette, a firmer use of outline and more varied brushwork, showing vigorous effort, but tending nevertheless to lack an overall coherence of conception. Once again the critical response was muted, Gauguin's contributions being seen, even by the 'Symbolist' Félix Fénéon, as a throwback to Impressionism in the mode of Guillaumin, Monet or Sisley. Attention was focused rather on the Neo-Impressionist style being developed by Seurat, a pseudo-scientific manner of painting, using small dashes of pure colour across the entire canvas, the so-called *pointilliste* technique with which Gauguin was wholly ill at ease. Disdaining the 'little dots' rapidly creeping into the work of Pissarro and Schuffenecker, and finding himself, once again, overwhelmed by his expenses, Gauguin determined to leave Paris for the summer.

Looking back on developments of the late 1880s, the artist Maurice Denis (one of Gauguin's most significant followers) described what he considered to be the direct connection between this initial dissent from Neo-Impressionist ideas and the later development of a new and revolutionary aesthetic:

This period of confusion and renaissance was brilliantly resolved in van Gogh and Gauguin. Alongside Seurat's scientific Impressionism, they represented barbarism, revolution and turmoil – and in the end wisdom. At first their efforts escaped all classifications, and there was little to distinguish their theories from old-style Impressionism. Art for them, as for their predecessors, was the rendering of a sensation, the exaltation of the individual sensibility. They began by exaggerating all the excessive, disorganized elements belonging to Impressionism, and it was only gradually that they became aware of their innovatory role, and realized that their synthetism or symbolism was the precise antithesis of Impressionism.

Having borrowed money from a relative, Eugène Mirtil, Gauguin departed for what was to be the first of many stays in Brittany, lodging, from July 1886, in the Gloanec inn at Pont-Aven. Aside from considerations of economy, there were other strong reasons for choosing this area; it was far from being an artistic backwater, since a substantial number of Parisian artists and students retreated to the town in the summer; the Breton people with their particular customs and costumes provided a fascinating subject matter; the landscape was stark and evocative, and for Gauguin it offered the hope of long uninterrupted periods of work. It is probable that, during his three months in the region, he explored the surrounding countryside quite extensively, also visiting Le Pouldu, where he was later to paint with Meyer de Haan.

The vast majority of this time was spent sketching, developing a repertoire of images that would form the basis for his oil and ceramic work during the ensuing winter months. At a distance from Paris, he was able to explore far more freely the expressive effects of exaggerated form, rich colour and stylized line, and this period of intensive study may be looked on as, in a sense, a 'rite of passage' between a reliance on Impressionist schemata and the development of his own stylistic vocabulary. This is not to say that he repudiated their precedent – indeed it is clear that he was looking ever more closely at Degas's figure studies – but that he was to become increasingly able to take liberties with these sources, combining their influence with that of popular illustration, Japanese prints and even Pre-Columbian art.

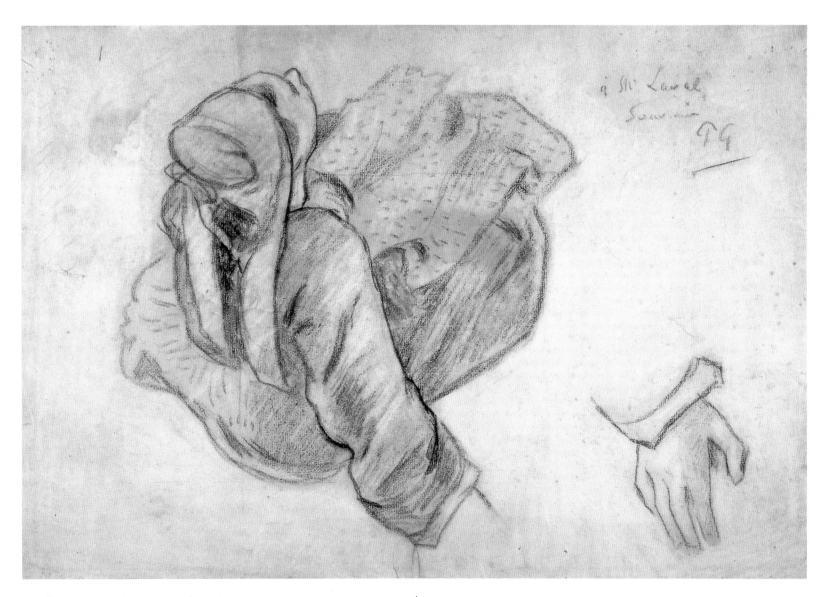

Seated Breton Woman, c.1888.
Charcoal and pastel on ivory laid paper, 33 × 45 cm
The Art Institute of Chicago
Gift of Mr and Mrs Carter H Harrison

Back in Paris, having refused to exhibit at the Independents' exhibition two months earlier, Gauguin definitively severed all remaining links with the Neo-Impressionists by refusing to shake hands with Signac and Pissarro at the popular artists' drinking place, the Café de la Nouvelle-Athènes. Having thus ostracized himself from an important circle of artists, he devoted the majority of his time to the design of innovative (and in some cases bizarre) ceramics for Chaplet, the discipline of incising decoration into clay serving further to simplify and strengthen his use of line in other media. Gauguin has often been said to be essentially a decorator, and certainly his early experimentation in applied art anticipated a life-long pleasure in pattern-making that was to reach its apogee in his Tahitian work.

In November 1886 Gauguin met Vincent van Gogh, whose younger brother Theo, a dealer with the Goupil Gallery (later Boussod, Valadon and Co.), had occasionally acted as an agent on Gauguin's behalf. Although no record remains of the particulars of their encounter, it would seem that each was intrigued by the personality and work of the other, both having an innate sympathy for the pupils of the Cormon studio, who included Henri de Toulouse-Lautrec and Louis Anquetin. At this point, however, furtherance of their

friendship was delayed by Gauguin's decision to leave for the West Indies with the artist Charles Laval (page 51).

In keeping with early escapist impulses (recalling childhood he wrote 'I have always had a whimsical tendency to run away'), and perhaps out of a desire to recapture his sense of freedom as a sailor, the artist embarked upon the first of his quests for the exotic. He hoped to 'live like a savage' on the Pacific island, Taboga, but eventually landed, penniless, in Colon, Panama. In fury he wrote to Mette:

Our trip was as stupidly undertaken as possible, and we are mired now, as they say, 'in the soup'. To hell with these people who misdirect travellers! We stopped over in Guadaloupe and Martinique – beautiful countries where there is work for an artist, where life is cheap and easy, and where people are friendly. We should have gone there; the trip would have cost half as much, and we would have saved time. Unfortunately we have come to Panama. My stupid brother-in-law has a store here that doesn't seem to prosper at all; he couldn't even spare 100 sous to greet us; it was totally rotten. In anger I stole a 35 franc shirt from him which I'm sure will be barterable for 15 francs.

Laval was in a position to make some money painting portraits, but Gauguin, who was unwilling and unable to work in what he described as the *'very bad style'* required, had to labour for over twelve hours a day on the cutting of the Panama Canal. His being laid off after only fifteen days, however, prompted the two artists to leave immediately for what Gauguin was sure would be the 'good life' of Martinique.

In July 1887 they arrived in the port of Saint-Pierre and Gauguin's spirits were instantly lifted by the scene there. As usual, he sent a bulletin to Mette:

For the time being both of us are living in a negroes' cabin, a paradise near the isthmus. Below us, the sea bordered by coconut trees, overhead every sort of fruit tree, and 25

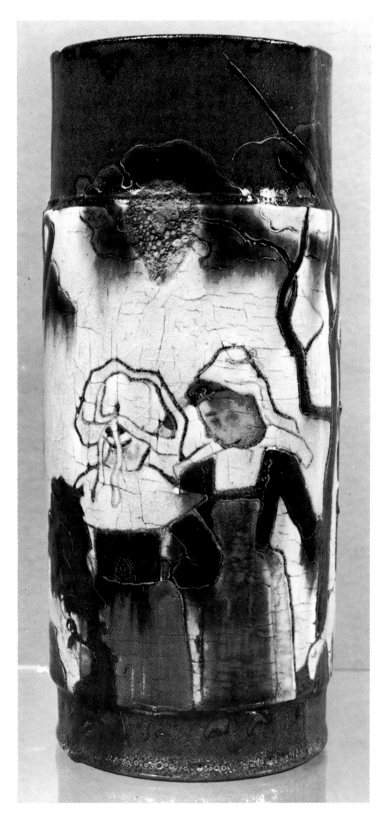

Vase with Breton Girls, executed by Chaplet and decorated by Gauguin, 1886–7.
Glazed stoneware, height 29.5 cm
Musées Royaux d'Art et d'Histoire, Brussels

minutes from town. Negro men and women walk past all day long, singing Creole songs and chattering; not that it's monotonous, on the contrary it's quite varied. I can't describe to you my enthusiasm for life in the French colonies, but I'm sure you'd feel the same.

The two artists started work promptly, Gauguin embarking upon large, idealized landscape canvases that became the hallmark of this journey to the Caribbean (page 55). Delighted by their vibrancy and his renewed artistic vigour, he confidently informed his old friend Schuffenecker, 'I am bringing back a dozen canvases [in reality about ten], including four

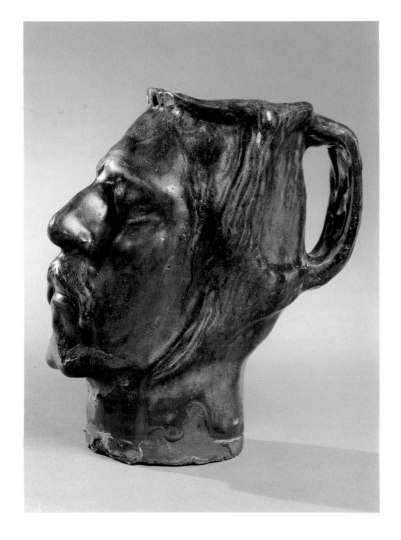

Self-Portrait Jug, *1887.*
Glazed stoneware, height 19.5 cm
Museum of Decorative Art, Copenhagen

with figures that are far better than those of my Pont-Aven period' (page 57). Physically, however, he was in an appalling state. He was suffering from malaria and dysentery contracted in Panama, and the combined effects of these illnesses forced him to return to Paris in October 1887.

Haggard, weak and desperately poor, Gauguin arrived, strongly convinced that the journey had been 'a decisive experience' and firmly determined that he should one day paint in the freedom (both financial and artistic) of a primitive society. Being unable to afford lodgings, he had no qualms about relying once again on the hospitality of the Schuffenecker family, with whom he now stayed for a period of two months. Happily his optimism about the Martinique canvases proved to be relatively well founded, since several, including *Mango Pickers, Martinique* (page 57), were much admired by Vincent and bought by Theo van Gogh following their exhibition at Boussod, Valadon and Co. Like Schuffenecker he now found work teaching art, giving classes at the open studio of Mr Rawlins, a London businessman, but this was to be a short-lived arrangement; in the early months of 1888 he made the decision to return to Pont-Aven.

Once again he booked into the Gloanec inn, determined to consolidate his previous visit to the area by steeping himself in his surroundings and letting what he hoped would be the primitive, Celtic environment dictate the nature of his work. Despite continuing illness he was in ebullient spirits, writing:

I love Brittany. When my clogs resound on the granite earth, I hear the dull, matt, powerful tone that I'm after in my painting . . .

Increasingly he became fascinated by the folkloric romance of the area and, in the sparsely populated winter months, began to focus his attention on the depiction of ritual and superstitition, endowing his often traditionally clothed figures with an other-worldly, enigmatic presence (pages 53 and 59).

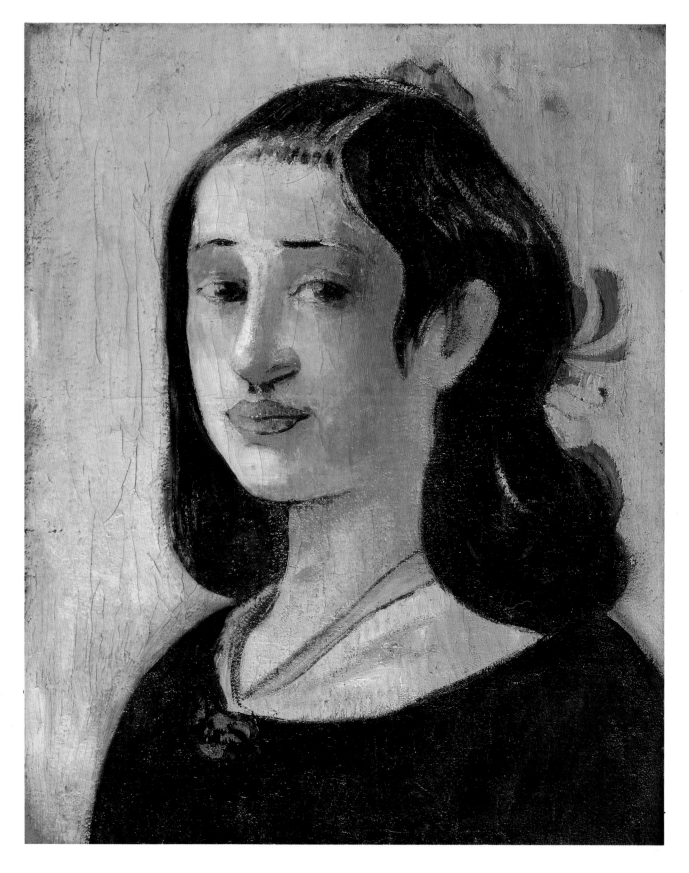

The Artist's Mother, *1889.*
Oil on canvas, 41 × 33 cm
Staatsgalerie, Stuttgart

Although obviously influenced by Degas in his figure drawing and clearly still in debt to Impressionist handling, the Breton works of the first half of 1888 display an extraordinary combination of treatments, broken brushstrokes being used in conjunction with firm continuous outline and strong areas of textured, but essentially homogeneous colour. Similarly, his palette during this period was enormously varied, saturated primaries glowing against mixed, rich and earthy hues.

In early August Gauguin was joined (at the suggestion of Vincent van Gogh) by Émile Bernard, who had just spent three months studying in Saint-Briac. The latter recalled:

I approached Gauguin, who this time greeted me cordially. He came back to my house to see what I had brought back from Saint-Briac and looked at it carefully. In it he found much character, and appreciated the rich colouring and simple execution. He then took me to his studio in Mme Gloannec's [sic] attic. His style had become more and more marked; the division of tones, to which he still adhered, destroyed the colours, creating a somewhat sickly atmosphere overall. I said this to him politely, trying only to compliment his talent.

Both artists were intrigued to compare notes, and subsequently worked together extremely closely, communicating when apart by means of lengthy, involved letters. However, as is suggested by the tone of Bernard's recollection, they were later to become intensely distrustful of each other, the breach in their friendship resulting directly from Gauguin's claim to be author of the Synthetist style.

While Gauguin had been looking at the line drawings of illustrators such as Kate Greenaway and Randolph Caldecott, and had been producing strongly linear and decorative ceramic work, Bernard had been studying stained glass and the popular woodblock *Images d'Épinal*. It seems that each had begun to search concurrently for a less naturalistic, graphic

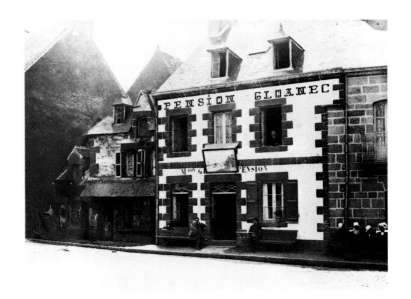

*Photograph of the Pension Gloanec
in Pont-Aven, Brittany.*

style which would allow them to extend their subject matter into the realm of the spiritual and surreal and which would accord with Jean Moréas's stated Symbolist credo of 'cloth[ing] an idea in visible form'. In August 1888 Gauguin advised Schuffenecker:

Don't copy too much from nature. Art is an abstraction; derive it from nature by dreaming in front of her, and think more of the creation than of the actual result. The only way to reach God is to do what he does: create.

Although Bernard addressed Gauguin as '*le maître*', it is clear from work the younger artist was producing contemporaneously that he had in fact advanced further along the path of simplification, reducing background areas to an overall flat tone, perspective to a relative distance in size, and figures to broadly outlined forms. Descriptive detail and narrative content were minimized, so that the overall effect was of bold shapes patterning the canvas area. In association with the artist Louis Anquetin, Bernard had for over a year been developing a decorative, linear approach to the depiction of everyday scenes and objects, using cursive black lines, a style which came to be known as '*Cloisonnisme*' for its resemblance to *cloisonné*

enamels. The step into Synthetism, which involved still greater deformation of form to represent a symbolic subject matter, seems therefore to have been a more natural progression for Bernard than Gauguin, the latter still to an extent working in the shadow of Impressionism. Bernard remembered the circumstances that led to their later disagreement:

I painted, with sketches, the Bretons in black sitting in a meadow of yellow-green. Gauguin was very impressed with the work which broadly demonstrated what I had said to him about his own colours, and which arose only out of my own studies of colouration. 'The more one divides the tone,' I said to him, 'the more it loses its intensity and becomes grey or murky.' He wanted to see for himself, so borrowed some of the colours that I had used, like Prussian blue, banished from the Impressionist palette, and which he did not have. And so he painted Vision after the Sermon, *for which he earned the title 'the creator of Symbolism'. In this work he did not merely put into effect the colour theory that I had told him about, but the exact style of my* Breton Women in a Meadow, *using an intentionally red background instead of my yellow-green. In the foreground he put the same large figures in their monumental women's headdresses. He was so happy with the painting that he continued in this vein thereafter and definitively abandoned the Divisionism he had adopted from Pissarro.*

A comparison of Bernard's *Women . . .* with Gauguin's *Vision . . .* (page 61) reveals a similarity in their use of strong, flat areas of colour and what Maurice Denis was to call their 'caricatural simplification of form', suggesting that Gauguin indeed borrowed quite brazenly from the younger artist. At the time Bernard did not balk at being imitated, and even helped to carry the painting to the church at Nizon. It was only later, when the work was hailed as the template for pictorial Symbolism, that he was to become embittered, protesting, 'It was always I who showed the most daring and the most innovation.'

In October 1888 Bernard introduced Gauguin to

Les Bretonnes dans la prairie
(Breton Women in a Meadow), *1888.*
Painting by Emile Bernard
Oil on canvas, 74 × 92 cm
Private Collection

another young artist, Paul Sérusier, a contemporary of Pierre Bonnard, Maurice Denis and Edouard Vuillard at the Académie Julien. Their encounter was to enhance still further the image of Gauguin as the master of the new style, since his teachings were relayed back to Sérusier's peers in the succinct form of a small painting of devastating importance: *The Talisman.*

The story of the creation of this work is now legendary. The two artists were working together, Sérusier on a landscape, about which Gauguin proffered the following advice:

How do you see those trees? They are yellow? Well, paint them yellow. The shadow bluish? Make it pure ultramarine . . . Red leaves? Use vermilion.

The resulting image, executed on the lid of a cigar box, used broad blocks of colour to near-abstract

effect, creating a rich surface pattern in which the viewer might, but need not read the representation of a landscape. This equivocation between pattern-making and picture-making devastated those of the Julien circle who saw it in Paris, and the work became quite literally the talisman of the Nabis, the avant-garde group that they formed in 1892.

For some time Vincent van Gogh had harboured the notion that he and the other 'new' painters – Gauguin, Laval and Bernard – should work together as a brotherhood, and to this end had suggested that the Pont-Aven artists should paint each other's portraits. The scheme was not a complete success because of tensions of which van Gogh cannot have been fully aware (pages 63 and 65), but it nevertheless sowed in van Gogh's mind the idea that he should form a 'school' of painters in the south. Accordingly, having settled in Arles and consulted with Theo, he wrote to Gauguin with a proposal:

The truth is that my brother cannot send money to you in Brittany, and at the same time to me in Provence. Would you be willing to share it with me here? If we join forces, there may be enough for both of us; in fact I am sure there would be. Having attacked the South, I see no reason to give it up.

Gauguin took a long time to leave Pont-Aven, even after Theo van Gogh had made the conditional offer to buy a painting a month should he agree to the plan. Finally, in September 1888, he wrote to explain that this delay was due rather to financial problems than to any disinclination on his part, and that he too was keen to paint in the south, even entertaining the idea that they should be joined by Bernard and Laval ('put up in a small furnished bedroom nearby'). For another month, however, he would be obliged to stay in Pont-Aven in order to settle his debts.

Finally, on 21 October, Gauguin left for Arles and two days later became one part of the most notorious partnerships in the history of art. He assured Schuf-

fenecker that Theo's offer to support him in the south was based on shrewd business principles, protesting, 'as much as [Theo] van Gogh loves me, he would not undertake to feed me in the Midi for the sheer pleasure of it.' What he did not choose to recognize was that he might be expected to keep an eye on the younger artist, whose eccentricities were becoming pronounced, exacerbated by his having spent eight months virtually alone.

The 'yellow house' of which Vincent had spoken so proudly was in a state of complete disarray; 'everywhere and in every respect' Gauguin found chaos. Before long their mutual finances were to take on the same complexion, the situation becoming so grave as to require an instant remedy. Rather than sacrifice their visits to the brothel, the artists chose to give up eating in their local restaurant, resolving to cook instead. Almost inevitably this proved disastrous; over a decade later Gauguin could still recall the day when his companion determined to cook: 'Vincent wanted to make a soup, but I don't know how he mixed it – no doubt like the colours in his paintings – in any event, we couldn't eat it.'

Once again Gauguin equated his seniority with superiority, and assumed the role of artistic mentor, critic and instructor to van Gogh. Perceiving a preference for complementary colours in his friend's work, he urged Vincent to break with this essentially Neo-Impressionist approach in order to achieve bolder, more telling colour combinations. With typical immodesty he recalled:

With all these yellows on violets, all this use of complementary colours – disorganized work on his part – he accomplished only subdued, incomplete and monotonous harmonies; the sound of the bugle was missing from them. I undertook the task of enlightening him, which was easy for me, for I found a rich and fertile soil.

This viewpoint must have been particularly difficult for van Gogh to stomach as he had gone to inordinate

trouble to prepare a series of canvases for his friend's bedroom. It must also have been hard, after months of unhindered artistic experimentation (in which he had made phenomenal progress), to find himself placed very firmly in the role of pupil.

Recognizing Gauguin as the more forceful and capable personality, van Gogh allowed himself to be patronized, but not overwhelmed as an artist. A comparison of the canvases they painted before the same subjects suggests that there was, in fact, a mutual and balanced interaction between the two men (pages 67 and 69). This is not to say that the artists were likely to agree about what to paint or how to paint it; as Gauguin had sought the primitive in Brittany, so van Gogh hoped to discover his 'Japan' in Arles – an artistic 'homeland' where his work could be the direct result of his communion with town and landscape. Gauguin, on the other hand, maintained a 'Synthetist' approach, concentrating on figures imbued with a mystical dimension, and firmly recommended that van Gogh should do the same (page 73).

Together they visited the Bruyas Collection at the Fabre Museum in Montpellier where their discussions only served to point up their basic difference in taste: Gauguin had little regard for Daumier, Daubigny, Ziem and Théodore Rousseau, all of whom van Gogh revered, whilst van Gogh disliked Gauguin's favourite artists – Ingres, Raphael and Degas. Rapidly it became apparent that their school of two would not provide the ideal working environment of which van Gogh had dreamed, and Gauguin, who had already considered returning to Martinique, began to make plans to leave.

This news, combined with anxieties about his brother's forthcoming marriage, was more than van Gogh could cope with, and Gauguin watched with alarm as his companion's actions became even more strange and erratic: 'Between two people, him and me, one all volcano and the other boiling too, but inwardly, there was a struggle of some sort brewing.'

Finally, on 23 December, van Gogh's increasingly violent behaviour culminated in his cutting off his own ear and making a present of it to a prostitute. Assured that van Gogh was still alive, but without waiting for him to regain consciousness, Gauguin left the yellow house, made an urgent request that Theo should come to tend his brother, and departed from Arles promptly on 26 December.

Back in Paris, he again headed for the sanctuary of Schuffenecker's home and updated himself on what had been happening in his absence. It is probable that he now took the opportunity of spending time with Degas, who among the older generation of artists had proved himself Gauguin's most firm supporter. Primarily it was a period of study and a consolidation of what he had learned in Arles, resulting in only one major oil painting, *The Schuffenecker Family* (page 77), but it was also the point at which Gauguin made an important venture into print production.

Prior to the 1880s fine artists tended to employ professional engravers to translate their work on to paper for sale as prints. This practice was slowly to die out, however, as printmaking was gradually accepted as a legitimate medium for the fine artist at first hand. Never slow to experiment with new techniques, especially when he thought they might be lucrative, Gauguin had initially entertained the idea of publishing an illustrated periodical in Arles. Ultimately this came to nothing, but the artist still harboured a desire to try his hand at lithography, and at the first opportunity he began to produce 'zincographs' with Bernard, so-called because of their use of zinc (rather than stone) plates. Although in themselves these attracted little attention from buyers or critics, and therefore made the artist hardly any money, they provided a vital stepping stone to the photomechanical reproduction of drawings in the catalogue of the exhibition held later in the year at the Café des Arts.

After a short spell in Pont-Aven, Gauguin was back in Paris to organize this exhibition, which he was well

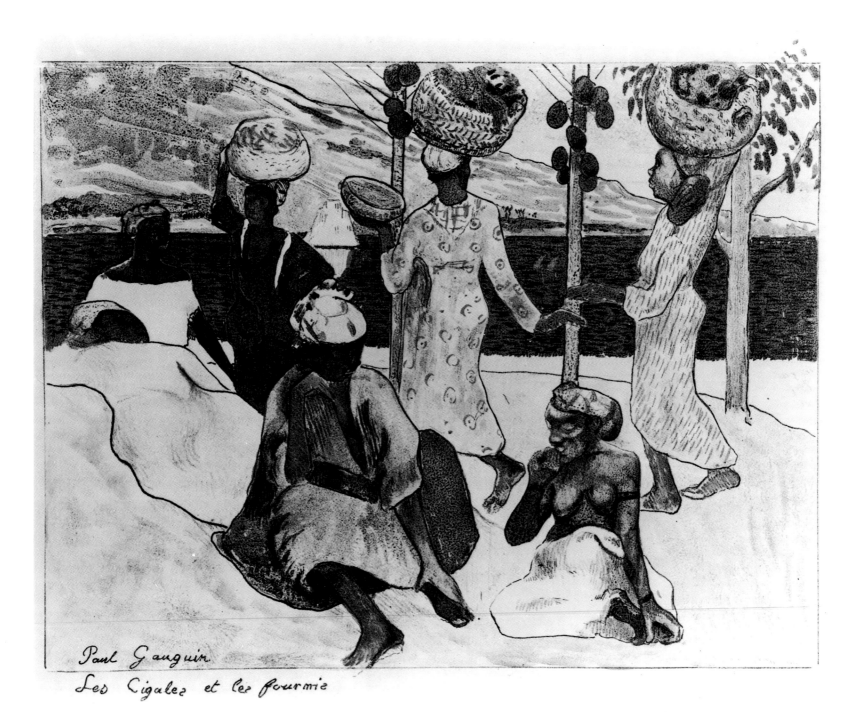

The Locusts and the Ants, *1889.*
Zincograph, 22.2 × 29 cm
State Museum of Art, Copenhagen

aware could provide a major showcase for the 'Groupe Impressionniste et Synthétiste' (as Gauguin, Bernard, Schuffenecker, Laval, Anquetin and others chose to call themselves). The Café, which belonged to a M. Volpini, was situated in the grounds of the *Exposition Universelle*, which in 1889 promised to be particularly lavish in celebration of the centenary of the French Revolution. Gauguin and Schuffenecker were delighted to have secured exhibition space within the domain of officially recognized artists, and despite Theo van Gogh's violent disapproval of the scheme, gathered a provocative selection of works from nine independent artists.

On the whole the critical response was not favourable, Gauguin being particularly angered by the suggestion that he had imitated the style of Anquetin. Among his fellow artists, however, he was the undisputed leader of the exhibition, and despite the poor level of sales and lukewarm reception, the show undoubtedly served as a useful platform from which to re-introduce himself to the Parisian scene. The small hand-printed catalogue was also important in extending awareness of the new Synthetist style to younger artists and students in Paris, to many of whom Gauguin's name now became known for the first time.

A further result of the exhibition was the reproduction of a number of the works in the new Symbolist journal *Le Moderniste illustré*; and Gauguin and Bernard were invited to review the fair for its readership. In Albert Aurier, the young poet and editor of the journal, they now found a firm friend and sympathizer.

Although the main halls of the *Exposition* appalled Gauguin for their narrow-minded approach to art and design, he was nevertheless hugely attracted to the sideshows and exhibitions in the *Palais des Colonies*, in which could be seen a fascinating range of artefacts accompanied by native representatives of countries including Martinique and Tahiti. When in Martinique, he had written at length to Mette about the possibility of one day settling in this colony, had entertained the same idea when in Arles, and now seemed more likely than ever to want to realize his dream of living in the Tropics.

Soon after the opening of the exhibition, which was to run for four months, Gauguin once again escaped from the pressures of Paris to Brittany, but was disappointed to find himself surrounded by people in Pont-Aven. In search of peace he moved on to Le Pouldu, where he worked for a month with Sérusier and the Dutchman Meyer de Haan (page 93). For the remainder of 1888 he was to travel frequently between Marie Henry's inn at Le Pouldu and the Pension Gloanec at Pont-Aven, his movements dictated by the subjects he wished to paint and his changing need for company or isolation.

The following year was particularly healthy and prolific for Gauguin, for he had both time and energy to devote himself to working in a very wide range of media, putting into practice his firm belief that an artist should adopt different methods for working in different materials:

Plaster, marble, bronze and fired clay ought not to be modelled in the same fashion, considering that each material has a different character of hardness, and of appearance.

In Paris he had produced a large number of extraordinary ceramics, including the *Self-Portrait Jug* (see page 15), distinguished by its expressionist use of red glaze, appearing like broad streaks of blood on the face and hair. In Brittany he drew extensively, painted watercolours, worked with pastel, carved wood, and painted on silk in addition to producing ceramics and a substantial number of major paintings. Although his 'Brittany period' is best known for the latter, canvases such as *La Belle Angèle*, *Portrait of Madame Satre* (page 83) and *The Yellow Christ* (page 85) evolved in conjunction with decorative and sculptural work of

The Green Christ, Breton Calvary, *1889.*
Oil on canvas, 92 × 73 cm
Musées Royaux des Beaux-Arts de Belgique, Brussels

which the artist was equally proud. On completion of *Soyez amoureuses . . . (Be in Love . . .)* (page 89), his most complex woodcarving to date, he sent it to Theo van Gogh for sale with a price tag of over double what he expected for paintings he was producing at this time.

The esoteric discussions of de Haan and Sérusier may well have been instrumental in widening Gauguin's symbolic vocabulary in the latter half of the year. Whilst rejecting too literal or literary a symbolic content, the artist began to draw heavily on Christian iconography for its textures of meaning. But paintings such as *The Yellow Christ* (page 85) and *The Green Christ* are not in themselves 'Christian' for they were not painted with the aim of promoting Christianity. They are rather Gauguin's visual analogues for the piety of the Breton people in response to such images.

Hearing of the astonished response to these canvases in Paris, Gauguin decided against sending Theo *Christ in the Garden of Olives* (page 87), undoubtedly his most provocative 'religious' work to date. In casting himself as Christ in the garden, Gauguin was extending his self-identification as outcast to a blasphemous extreme, proving that he had few qualms about manipulating Christian imagery to his own expressive ends. Repeatedly during this period in Brittany he made his own isolation the subject of his work, either in a secular or a religious context. In November he and de Haan undertook to decorate the dining-room of Marie Henry's inn in Le Pouldu, Gauguin incorporating in the scheme an excellent example of this tendency: *Self-portrait with Halo* – a caricature in the guise of a fallen angel.

The sense of being persecuted, which was to become overwhelming towards the end of the year, was brought about as much by personal as artistic circumstances. For over six months he had been out of contact with his family, and he now wrote to his wife reproachfully:

What is it you want of me? Above all, what have you ever wanted of me? Whether in the Indies or elsewhere, I am, it appears, to be a beast of burden for a wife and children whom I cannot see. In return for my homeless existence I am to be loved if I love, I am to be written to if I write.

Circumstances were now such that he again began to consider leaving France, strongly urging Meyer de Haan to escape with him to the Tropics where, he insisted, the light would be more beautiful, the colours more vibrant and the people more attractive. With some urgency, Gauguin now began making enquiries about the possibility of securing a post in the protectorate of Tonkin.

Money sent from Schuffenecker enabled him to return to Paris and, after his longest stay in Brittany, he once again made full use of his friend's comfortable home, taking on teaching work in order to make money. By May his heart was set upon founding a 'studio in the Tropics' (this time in Madagascar) with Meyer de Haan and Bernard, but these plans foundered when a potential sale to the inventor Dr Charlopin was lost.

By now desperate to get away, and leading a restless existence between Brittany and Paris, Gauguin's productivity in 1890 declined sharply. When he did find the time and inclination to paint in oils, the work produced was far more varied in quality than that of the previous year; the spectrum of subject matter ranged from landscape scenes without obvious symbolic content to a portrait of his long-dead mother. Two quite different canvases, however, distinguish themselves as the masterpieces of the year; the first, a homage to Cézanne's style and subject matter, *Portrait of a Woman with Still-Life by Cézanne* (page 97), and the second a haunting image of his Parisian mistress Juliette Huet, painted in response to the style of Puvis de Chavannes (page 99). It would seem that Gauguin, perhaps in anticipation of his departure from France, was taking stock of the formative influences upon him, both as a man and as an artist.

Having finally tried Schuffenecker's patience to the limit, he had little choice but to find lodgings of his own in Paris, and in November 1890 moved into a furnished hotel, making arrangements to work from Monfried's studio. In the evenings he would invariably venture out to eat and drink, frequently joining the gatherings of Symbolist writers at the Café Voltaire. Although at first the group of poets found his trenchant manner disconcerting, they were soon impressed by the force and intensity of his opinions. The poet Charles Morice vividly recalled the first time that he saw the artist:

Above all, his head took on a real beauty in its gravity when it became illuminated and, in the heat of argument,

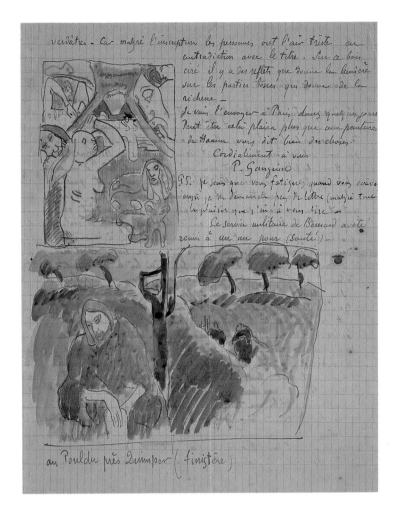

Letter to Vincent van Gogh, showing sketches of Soyez amoureuses . . . *and* Christ in the Garden of Olives, *November 1889.*
Vincent van Gogh Foundation
Vincent van Gogh Museum, Amsterdam

intensely blue rays flashed suddenly from his eyes. When I perceived Gauguin for the first time on that evening, he was experiencing one of these moments. Although there were other strangers in the group which centred around him, I saw only him and, approaching, I remained standing for a long time close to the table where a dozen or so poets were listening to him . . . In a deep and slightly hoarse voice he said: 'Primitive art comes from the spirit and uses nature. So-called refined art proceeds from sensuality and serves nature. Nature is the servant of the former and the mistress of the latter. But the servant cannot forget her origin and degrades the artist by allow-

ing him to adore her. This is how we have fallen into the abominable error of naturalism which began with the Romans and the Greeks of Pericles. Since then the more or less great artists have been only those who in one way or another reacted against this error.'

Another important figure in the group, Jean Moréas, remarked upon 'the way in which the poets always showed a spontaneous and profound deference to Gauguin', accounting for this fact by the observation that the artist's work seemed also to be motivated by 'poetic thinking'.

Soon Gauguin was in his element, stimulated artistically and stretched intellectually by the company of some of the most gifted men in the Parisian avant-garde. By the beginning of 1891 he had met Verlaine and Mallarmé, was a frequent visitor to the studio shared by Bonnard, Denis and Vuillard, and was firm in the defence of the Symbolist painters, Odilon Redon, Puvis de Chavannes and Gustave Moreau. It seemed for the first time as though his work had found its context within a wider movement, in which he seemed likely to become a principal figure, as a painter, sculptor and theorist.

Yet even before returning to Paris, Gauguin had proclaimed his firm resolution to escape to the Tropics, writing to Redon in September 1890:

I am set in my decision, but since I have been in Brittany I have modified it. Madagascar is still too near to the civilized world; I am going to Tahiti and I hope to finish my life there. I believe that my art, which you love, is only a seed and I hope that down there I can cultivate it for myself to a primitive and savage state.

He was still in Paris in early 1891, but with an ever more urgent desire to get his plan under way. Realizing that a substantial sum – in the region of 10,000 fr. – would be necessary for the trip, he organized a fund-raising sale of his work from Martinique, Brittany and Arles, and suggested to Morice that this should be heralded by 'a resounding article in a major newspaper, an article which could then be used as the preface to the catalogue'.

Immediately the loyal Morice went to see Mallarmé, who, though knowing Gauguin only a little, was keen to help with the plan. To this end he contacted Octave Mirbeau, the novelist, critic and amateur painter, with the result that Mirbeau subsequently published in *L'Écho de Paris* a critical appraisal that was to mark a turning point in the appreciation of Gauguin's work in French artistic circles.

Word of Theo van Gogh's death was received by the artist with some irritation, as he felt that Theo's influence could have been useful in the preparations for the impending 'retrospective', to be held at the Hôtel Drouot. He had probably hoped that Theo would be helpful in organizing and supplementing any funds raised, and was piqued that this arduous job would now be his own responsibility. Nevertheless, he tirelessly 'canvassed' his supporters and admirers, ensuring that he was present at every significant social event; attending a Symbolist banquet in honour of Moréas, as well as many dinners and meetings.

Mirbeau's article, published on 16 February 1891, a week prior to the sale and indeed as the introduction to the sale catalogue, was in the main an extended biographical account of the artist's life, but included a now much-quoted passage in which Mirbeau attempted to describe the nature of the work itself:

[It] is strangely cerebral, passionate, still uneven but poignant and superb in that very inequality. The work is sad because to understand it, to feel the impact of it, one must have known sadness and the irony of sadness, which is the threshold of mystery. Sometimes the work raises itself to the height of a mystic act of faith; sometimes it seems to be scared and grimacing in the shadows of doubt. And always emanating from it is the bitter and pungent smell of the poisons of the flesh. In his work there is an

unsettling and savoury mixture of barbaric splendour, Catholic liturgy, Hindu meditation, Gothic imagery, and obscure and subtle symbolism. With stark realism and desperate flights of poetry Gauguin creates an art that is absolutely personal and wholly new; an anguished art of the painter and the poet, of the apostle and the devil.

This commentary, together with a second article by Mirbeau (appearing in *Le Figaro* two days later) and another by Roger-Marx, had the desired effect, whipping up interest both in the artist's paintings and ceramics; the sale, which included such masterpieces as *Vision after the Sermon . . .* (page 61), *The Yellow Christ* (page 85), *Christ in the Garden of Olives* (page 87) and *Soyez amoureuses . . .* (page 89), duly grossed a total of 9,635 fr., with only one painting unsold. Its importance, however, cannot be measured purely in financial terms; subsequently it was announced that a presentation would be held at the Théâtre d'art to benefit the poet Verlaine and 'the admirable Symbolist painter, Paul Gauguin'; another major article, this

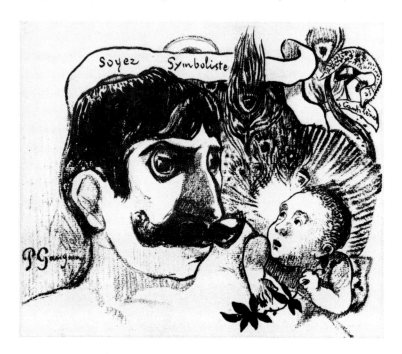

Soyez symboliste (Be a Symbolist.
Caricature of Jean Moreas), *1891.*
Pen and ink, 35 × 42 cm
Private Collection

time by G. Albert Aurier, was published in the *Mercure de France*; a large farewell banquet was planned in honour of Gauguin's departure, and the artist was now confident enough of his status to request a government grant from the Minister of Public Education and Fine Arts.

Having achieved so many of his immediate aims, the artist now felt that he could afford to visit his family in Denmark, and arrived in Copenhagen on 7 March 1891. Although he still believed that they had a future together, it was in fact the last time that he was to see his wife and children.

Barely a fortnight later he was back in Paris for the banquet at the Café Voltaire. This was to prove a spectacular occasion, attended by at least forty guests and presided over by Mallarmé himself. Still basking in the glory of this event, the artist's contentment was to be promoted still further by the news that the Minister had granted immediate funding to his mission to 'study and ultimately paint the customs and landscapes of [Tahiti]'.

Some were of the opinion that Gauguin had procrastinated too long in his departure, but now the farewells had been taken, the funds raised and the artist recommended to the Under-Secretary of State for the Colonies, nothing remained to justify further delay. On 1 April 1891 the artist duly set sail from Marseilles aboard the *Océanien*; ironically, he had chosen to ostracize himself just when his work had begun to receive a measure of recognition in Paris.

During the journey Gauguin seems not to have painted at all, but rather chose to spend his time eating, drinking, and idly despising his fellow passengers. The route took him through Suez, the Seychelles, and to Australia before finally he reached Tahiti, sixty-four days after his departure from France.

Armed with a little money and a letter of recommendation from the French authorities, he dis-

embarked in Papeete, hoping finally to prove to all those who had doubted it the firmness of his resolution to become, if not the first nineteenth-century European artist to paint in Tahiti, at least the first to want to learn from its primitivism and to assimilate its culture, his desire being to 'soak [himself] once again in Nature's purity, see nothing but savages, and live their lives'.

His first reaction, however, was an overwhelming sense of disappointment as he discovered the prejudices of the affluent in Papeete to be little different from those of the Parisian bourgeoisie. As he was later to recall in *Noa Noa*:

Life at Papeete soon became a burden.

It was Europe – the Europe I thought I had shaken off – and that under the aggravating circumstances of colonial snobbism, and the imitation, grotesque even to the point of caricature, of our customs, fashions, vices and absurdities of civilization.

Was I to have made this far journey, only to find the very thing which I had fled?

This disappointment must have been exacerbated by the fact that, by leaving when he did, he had missed a number of important events in Paris, including the opening of the Salon of the Société Nationale des Beaux-Arts and a benefit matinée held at the Vaudeville Theatre on his behalf. Having made the journey, however, he had little choice but to cope with its consequences and, with the aid of a Lieutenant Jénot, soon found a room in the town. After his idleness at sea he was keen to start work immediately, writing to Mette of his desire for some 'well-paid [portrait] commissions'. Within a month just such a commission was offered to him (*Portrait of Suzanne Bambridge*), but the canvas was not liked, its reception threatening any hopes of his being able to make money in this way in the future.

More in keeping with his original reasons for wanting to work in Tahiti, Gauguin made sketches of the

Photograph of Paul Gauguin and his children, Emile and Aline, taken in Copenhagen, c.1874. Musée Gauguin, Papeari, Tahiti

scenes at the funeral of King Pomare, and in so doing began to acclimatize himself to the forms and features of the native people, noting with wonder the natural elegance of the widowed Queen Marau: 'With the beautiful instinct of her race, she distributed grace everywhere about her, and made everything she touched a work of art.' For their part, however, the Tahitians found Gauguin an extraordinary figure, his long hair leading them to nickname him *taata-vahine* ('man-woman'). Duly having had his hair cut and wearing a conventional colonial suit, he made one last attempt to mingle at the officer's club, but was soon confirmed in his belief that he neither liked nor had anything in common with the 'military circle' who met there.

Quickly, I made up my mind. I would leave Papeete and withdraw from this European centre.

I felt that in living intimately with the natives in the wilds I would by patience gradually gain confidence in the Maoris and come to know them.

In August 1891 Gauguin made his first major excursion from Papeete, staying with the drawing instruc-

tor Gaston Pai at Paea, some thirteen miles away. Here he attempted to learn Tahitian, but with such little success that he soon returned to the town. His failure to produce any significant work using Tahitian subject matter was by now causing him some anxiety, and as soon as the opportunity arose he once again ventured out of the city in search of somewhere that could become his home. Even before settling upon Tahiti as a destination he had envisaged the ideal dwelling, describing it to Bernard as early as June 1890:

With the money I'll have I can buy a native house like those you saw at the World's Fair. Made of wood and dirt, with a thatched roof, near the city, but off in the countryside, that costs almost nothing . . .

Accompanied by an Anglo-Tahitian woman called Titi, he now set out in search of just such a dwelling,

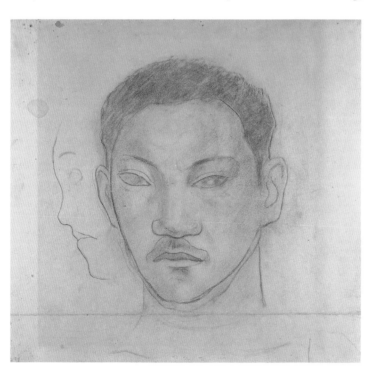

Head of a Tahitian Man, *c.1891–3.*
Graphite, black and red chalk
on paper, 35 × 37 cm
The Art Institute of Chicago
Gift of Mrs Emily Crane Chadbourne

heading towards the district of Mataiea in a carriage lent to him for the purpose. Almost immediately Gauguin found a suitable hut for rent, and although somewhat further from the city than he had originally planned, it had the advantage of having the sea on one side and an enormous mountain on the other. It was obvious to him that Titi was keen to be his *vahine* ('woman'), but although attracted, he was reluctant to limit his options too soon:

Titi had a terrible reputation in Papeete for having successively brought a number of lovers to their graves. But it was not this which made me put her aside. It was her half-white blood. In spite of traces of profoundly native and truly Maori characteristics, the many contacts had caused her to lose many of her distinctive racial 'differences'. I felt that she could not teach me any of the things I wished to know, that she had nothing to give of that special happiness which I sought.

I told myself that in this country I would find that which I was seeking; it would only be necessary to choose.

Finding this policy of 'positive discrimination' more difficult to put into practice than he had anticipated, and becoming more than a little lonely in the countryside, Gauguin soon sent for Titi who joined him promptly. The sexual and practical aspects of his life now taken care of, he was at long last able to turn his attention to his work. He began to paint and draw avidly, and by the end of the year, a month after purporting to Monfried that he had yet to produce a major work, he had in fact painted at least twenty scenes of life in Tahiti, accumulating at the same time a large number of 'documents' (drawings) from which he hoped that oil works might later be developed.

The scope and assurance of these early Tahitian paintings is quite staggering. Although he spoke of difficulties in getting used to his new environment and applying himself, it would seem that he hardly put down the brush. Despite the inconvenience of Titi's sudden departure he was able to produce some of his most important compositions – *Vahine no te tiare*

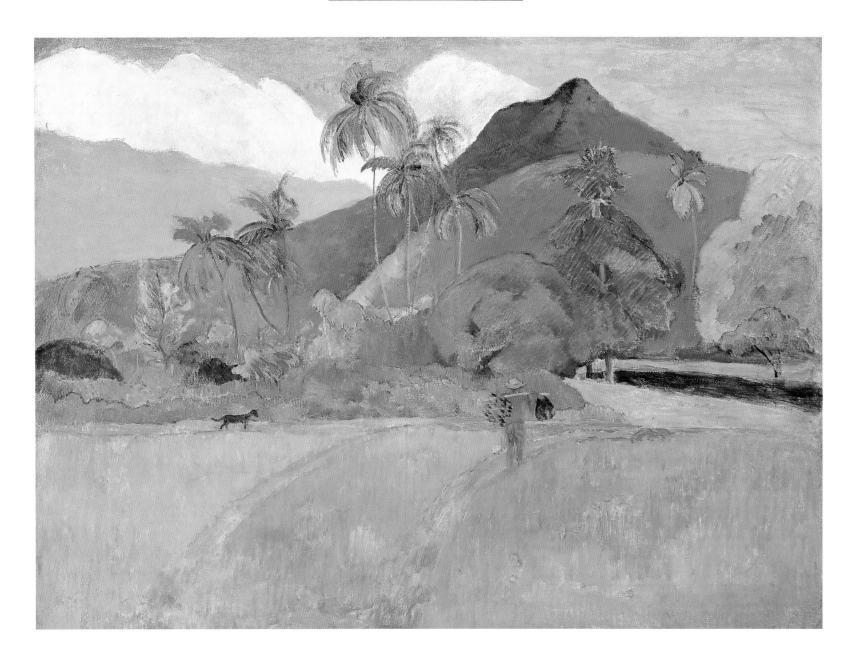

(Woman with a Flower) (page 101), *The Meal* (page 103), *Two Women on a Beach* (page 105) and *Man with an Axe* (page 109) – all involving native figures as their primary subject matter.

Painting the people of Tahiti was for Gauguin a non-verbal way of getting to know them; a tangible exploration of their customs, beliefs and superstitions, and a statement of empathy with their way of life. Only a few weeks after his arrival in Papeete he had written to Mette, expressing the hope that like them he too could become spiritually attuned to this new environment:

Tahitian Landscape, *c.1892.*
Oil on canvas, 68 × 92 cm
The Minneapolis Institute of Arts

―――――――――――――

I understand why these people can remain hours and days sitting immobile and gazing sadly at the sky. I apprehend all the things that are going to invade my being and feel most amazingly at peace at the moment.

As much in need of a model as a mistress – for he was encountering unforeseen difficulty in getting the native women to pose (page 101) – Gauguin set out on a

journey to Faone on the east coast of the island, where he met the family of thirteen-year-old Teha'amana (whom he called Tehura). There was only one condition attached to the offer that she should become his *vahine*; that they should live together for a trial period of eight days. This having passed without incident, he took the girl as his bride, with the full consent of both her natural and adoptive parents, and brought her to live (bigamously) with him in Mataiea (pages 105, 119 and 121):

Then a life filled to the full with happiness began. Happiness and work rose up together with the sun, radiant like it. Tehura's face flooded the interior of our hut and the landscape around it with joy and light. She no longer

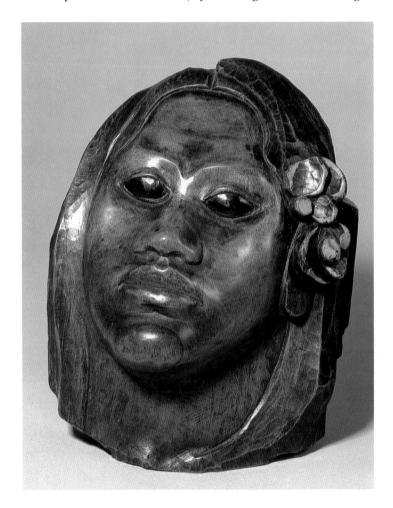

Mask of Tehura, *c.1892.*
Pua wood, height 25 cm
Musée d'Orsay, Paris

studied me and I no longer studied her. She no longer concealed her love from me, and I no longer spoke to her of my love. We lived, both of us, in perfect simplicity.

But a familiar problem was soon to disturb this peace, as Gauguin yet again found himself indigent. Eagerly he awaited each monthly mail-boat in the hope of cheques or letters, but received few. Bitterly he reproached his wife, Charles Morice, dealers and friends for what he considered to be their blatant neglect of him, complaining, 'I cannot practise as I feel it ought to be done, and as I could do if relieved of the poverty which ties my hands.'

Gauguin hoped that the materials he had brought with him from Paris would be sufficient to allow him to paint for a good few months; a huge assortment of different coloured oils, a large quantity of thick hemp canvas in addition to the standard variety, casein, glue and Spanish white used for sizing. It was not long, however, before he was forced to use alternative substances for the latter process, employing for some of his largest and most ambitious works, a paste of ripe or rotten breadfruit.

Poverty now also began to take its toll upon his health and he started the first of many interrupted courses of medical treatment. Admitted haemorrhaging to the hospital in Papeete, it was only a matter of days before he discharged himself, fearful of the expense. His ex-mistress in Paris, Juliette Huet, had by now given birth to a sickly baby girl, and the news that she was urgently in need of money only served to highlight his inability to provide either for himself or for others. As had so often been the case in France, he now had to consider taking on full-time employment. He put in an application for a civil service post in the Marquesas Islands but this was refused so that he was, in the spring of 1892, to write to Sérusier informing him of his urgent need to return to France.

Throughout these trials, however, he continued to work prolifically, producing masterpieces of stunning

variety and invention. Having brought with him from Paris a mass of visual material ('a whole little world of friends . . . in the form of photographs and drawings'), he reworked themes, poses and forms from a diverse range of sources – from classical sculpture to Japanese prints – to create exciting and bizarre fusions of imagery, united by a vibrant Tahitian context (pages 107, 109 and 111).

This is in no sense to suggest that Gauguin was suffering from a paucity of ideas; in fact the scope of his subject matter was significantly increased by his growing knowledge of Polynesian superstitions and customs, as related by his young wife (pages 119, 121 and 123). His own reading, particularly of Jacques Moerenhout's *Voyages aux Îles du Grand Océan* (1837), promoted his fantastic notions of Tahitian religious history (page 121), and the absence of indigenous sculpture gave the artist a free rein to invent his own idols; grotesque divinities carved and/or painted in an intentionally savage manner.

In terms of colour, this 'brutalizing' tendency manifested itself in a riot of hot, saturated hues, confidently applied in broad brushstrokes. The symbolic shorthand of Brittany now developed into a near-abstract use of flat or patterned areas, strongly graphic and emotive in their impact. In *Vahine no te tiare* (page 101), the first painting to be sent back to Paris, an 'arbitrary' scheme of red, yellow and blue creates a firm structure for the composition, the red and yellow serving no representational purpose whatsoever. Similarly in *Two Women on a Beach* (page 105) flat horizontal bands create a wholly ambiguous background that the viewer may or may not choose to interpret as representing the sea.

Gauguin was certainly taking risks with the limits of naturalism, but also had to bear in mind the need for his work to appeal to potential purchasers. His preference for painting young native women was undoubtedly influenced by a belief that they would please a male audience, and he was therefore particularly keen to discover what had been the reaction to his *Vahine no te tiare (Woman with a flower)* in Paris.

By April 1892 he had completed at least thirty canvases, their subjects ranging from pure landscape scenes, through portrait and figure studies to mystical and overtly symbolic compositions, such as the quasi-Christian *Ia orana Maria* (page 107). Confident that he had met the artistic challenges posed by his new environment, he wrote to Mette, 'I am in the midst of work . . . now that I have got to know the soil and its smell', and felt sure that he could return safely to France without being accused of having wasted his time abroad:

My actions, my paintings, etc. are criticized and repudiated every time, but in the end I am acknowledged to be right. I am always starting all over again. I believe I am doing my duty, and strong in this, I accept no advice and take no blame.

Urgently he appealed to Governor Lacascade for funds, and to the Director of Fine Art in Paris for permission to repatriate. By October he had entirely run out of canvas and was forced instead to carve wooden statuettes. His situation had become desperate when at last word arrived from France that his request had been granted, allowing him, should he wish, to leave in January 1893.

Encouraged by this news he sent a consignment of paintings to Europe for the forthcoming Free Exhibition of Modern Art in Copenhagen, where they were to be hung exclusively with those of Vincent van Gogh. The selection of seven canvases was very carefully made, balanced between easily accessible ('*doux*') and relatively obscure ('*raide*') subjects, in order, as far as possible, to please a range of tastes. But however much he doctored the selection, Gauguin must have relished the fact that the exotic subject matter and perplexing Tahitian titles (upon which he insisted), would cause something of a stir in conservative Denmark.

January arrived, but the much hoped for funding for the passage to France was refused by Governor Lacascade, so that the artist was obliged to remain in Tahiti, and to apply yet again for repatriation. Little is known of the fate of the young Teha'amana; when eventually Gauguin managed to leave the islands, she must already have been a mother for the previous August Gauguin had written to Monfried:

Soon I shall be a father again in Oceania. Good heavens! I can't help sowing my seed everywhere. It is true that there is no inconvenience here, where children are well received and claimed in advance by all relatives. Everybody wants to be a foster father or foster mother. For you know that in Tahiti the best present one can give is a child. Thus I don't have to worry about this one.

Though apparently sanguine about abandoning his young 'wife', the thought of returning provoked mixed feelings in the artist. He had left Paris at a high point in his career, and now felt anxious about re-entering a scene with which he had been out of touch. Gloomily, he realized that for financial reasons he might anyway be forced to give up painting, a reasonable prediction in view of the fact that he was to arrive in Orléans with exactly 4 fr. in his pocket. In *Noa Noa* he adopted a dramatic, declamatory tone to describe his feelings on his eventual departure:

Farewell, hospitable land, land of delights, home of liberty and beauty!

I am leaving, older by two years, but twenty years younger; more barbarian *than when I arrived, and yet much* wiser.

Yes, indeed, the savages have taught many things to the man of an old civilization; these ignorant men have taught him much of the art of living and happiness.

Above all, they have taught me to know myself better; they have told me the deepest truth.

But just when he had every reason to fear destitution, good fortune arrived in the form of an inheritance of half of his uncle's estate. Whether Gauguin would in fact have given up painting had this windfall not occurred, it is difficult to tell, but it is certain that the sudden prospect of affluence filled the artist with renewed energy and optimism. Mette having refused to meet him on arrival, he now once again entreated her to visit him in Paris.

Meanwhile he set about persuading the dealer Paul Durand-Ruel to hold a one-man show, and busied himself gathering, retouching, and framing between forty and fifty paintings; at the same time trying to ensure that enough remained in the public eye. Feeling that the reaction to the Copenhagen exhibition had been tepid, he was determined that his Tahitian work should not go unnoticed in Paris. He paid for the invitations, posters and catalogues of the forthcoming exhibition himself and, in his fervour for publicity, offered (unsuccessfully) to donate *Ia Orana Maria* (page 107) to the Musée du Luxembourg.

It was a time of excitement, but also of anxiety for the artist, who had to try to re-establish himself in a much-altered artistic circle. The arrangement of the Copenhagen exhibition and the recent publication of Vincent van Gogh's letters made him uneasy, anxious about being implicated in his friend's last days; Bernard could no longer be counted upon as an ally; and the paranoia that other artists had begun to make a living out of what were originally his ideas still lingered. But in other ways the auspices looked good; an article by G. Albert Aurier that had appeared during Gauguin's absence had hailed him as the leader of visual Symbolism; Paris was thirsting to see his new, erotic subject matter; and his young 'disciples', Sérusier and the 'Nabis', were still loyal.

Mette, however, remained firm in her refusal to join her husband, requesting rather that he make the journey to Copenhagen. But now it was Gauguin's turn to refuse, on the basis that he needed all his time and energy to promote his work. Gauguin had reason to claim that time was short; in a matter of two months he had to make ready over forty paintings

from Tahiti, three from Brittany, a number of wood sculptures and a ceramic. The effect must have been quite fabulous, and although it did not result in significant sales, the show did attract a large, if uncomprehending audience. Charles Morice, who had contributed a preface to the catalogue, observed the artist at its opening:

In the vast gallery where the walls were aflame with his visions in painting, he watched the people and he listened. Soon he had no doubt: nobody understood. It was the definitive separation between him and Paris; all his grand schemes were ruined, and perhaps the most cruel wound of all for this overly proud man, he had to allow that he had devised his plans poorly.

Critical opinion was rather more mixed, and as well as the predictable ridicule ('exaggerated landscapes dotted with gingerbread men'), there were a number of adventurous articles, attempting to describe the artist's new vision. Gauguin was delighted to be 'treated rationally, and with words of praise' by the press, but most gratifying of all was the approval of Edgar Degas who purchased two canvases.

On the strength of the inheritance he was to receive, Gauguin was now able to rent two large rooms on the top floor of 6 rue Vercingétorix (page 125), which he immediately painted chrome yellow and decorated with the canvases unsold at the exhibition. He inscribed *ici faruru* ('here there is love') in the windows, and opened his doors to a stream of friends and artists, including Vollard, Mucha, Monfried, Leclerq, Morice and Maillol. At regular Thursday-evening parties he and his guests would discuss art, drink, tell stories and play music, tended by his new thirteen-year-old mistress.

The dealer Ambroise Vollard is credited with having introduced Gauguin to this young girl, known as Annah the Javanese, but who was in fact half-Indian and half-Malay. Before long she had moved into the artist's studio, filling the position of *vahine* made

vacant by the departure of Teha'amana, serving as lover, model and housekeeper. Together they must have looked an extraordinary couple, the tiny Annah brightly dressed beside the artist in his new finery. Robert Rey described:

A costume which combined magnificence with singularity: a long frock coat of light blue cloth, fitting close at the waist, with mother-of-pearl buttons; a waistcoat – blue also – buttoning down the side, and with a collar embroidered in yellow and green silk. A pair of yellowish trousers, a grey felt hat adorned with a broad bright blue ribbon, white gloves, a walking stick carved by himself and at the top of which was set a pearl.

Confident and in a convivial frame of mind, Gauguin made the journey to Brussels to attend the opening of the exhibition of *La Libre Esthétique*, which included five of his Tahitian canvases. But rather than use this opportunity to travel on to Denmark, he returned quickly to Paris, sending 1,500 fr. on to his wife.

Once again his output of oils dropped in favour of other media, as he began in earnest to reproduce his most important drawings in a set of innovative woodcuts, carved and printed in his own bedroom. These were intended to illustrate the autobiographical journal *Noa Noa*, and were deliberately rough-hewn and textural in appearance; in style more akin to his sculpture than to his painting.

Noa Noa was born out of various writings that the artist had accumulated in Tahiti, but related most directly to one long notebook, *Ancien culte mahorie*, which contained fanciful accounts of Tahitian mythology. Gauguin had already drafted his ideas for the longer manuscript when he arrived in France, but hoping to have the work published, he enlisted the help of Charles Morice to serve as his co-writer. Later he explained:

I had the idea, speaking of uncivilized peoples, to contrast their character with our own, and found it rather original

Folio 57 from the Louvre manuscript of Noa Noa,
with woodcut of Hina and Tefatou from Te atua,
*watercolour sketch and a photograph of
an unidentified Tahitian girl.
Cabinet des Dessins, Musée du Louvre, Paris*

*to write (simply myself) like a savage, side by side with the
very civilized style of Morice.*

The effect of this joint effort was to make the journal
more literary in tone. The manuscript was not pub-
lished until 1897, but it served to introduce the artist
to a new medium and to consolidate his visual and
emotional experience of the South Seas.

Tiring of Paris, he now decided to return to Le Pouldu
and Pont-Aven, possibly in the hope that he would
once again be inspired to paint in the region. But any
plans he might have harboured were to be rudely
interrupted by a disastrous event. On 25 May Gau-
guin visited the port of Concarneau near Pont-Aven
with Annah and some painter friends. Some sailors
threw stones at Annah, accusing her of being a witch;
a brawl ensued and Gauguin emerged battered and
with a broken leg. For two months he was unable to
walk, morphine and alcohol providing the only
escape from excruciating pain. Unable to work on any
scale, he temporarily abandoned oil painting in
favour of watercolour and woodcut prints. No longer
prepared to live with the crippled, dissolute and irri-
table artist, Annah returned to Paris, where she
ransacked his studio home, stripping it of everything
valuable bar Gauguin's own work.

Alone and ill, Gauguin remained in Pont-Aven, but
made a special effort to attend the trial of his
assailants twenty-five miles away at Quimper. Their
paltry fine of 600 fr. filled him with rage and the
whole episode helped to confirm him in the view that
he would do best to return to the South Seas:

*All these misfortunes and the difficulty of earning a regular
income despite my reputation, and with my taste for
exoticism, have made me reach an irreversible decision: in
December I shall go back to Paris, where I shall work
tirelessly to sell everything I own, either as a whole or
piecemeal. Once I have money I shall again leave for
Polynesia . . . Nothing will stop me from leaving, and this
time it will be for good. What a senseless existence this
European life is.*

True to his word, Gauguin set about organizing an
exhibition to be held on 2 December in his own Paris
studio, and within a week had announced his decision
to leave. The *Journal des Artistes* commented drily:
'Paul Gauguin had to choose between the savages
here or the ones over there; without a moment's
hesitation, he will leave for Tahiti.'

A main feature of the exhibition were the watercolour
monotypes produced during Gauguin's convalesc-

ence; they were now hailed by Julian Leclerq in the *Mercure de France* as being of revolutionary importance. In itself the method of monotype was not new, but the patina of the paint surface it created was particularly effective for the strange Tahitian subjects that Gauguin continued to depict. These prints were mounted on mottled blue paper and were shown informally to the visitors, who were assaulted on all sides by a multitude of other objects and images. In his article Leclerq gave a clear impression of the unorthodox nature of the event:

It was an excellent idea to show these watercolours and engravings in his own space, right in the midst of the canvases seen last year at Durand-Ruel's which, here, take on a particular quality of silence – their true character – and near as well to the ceramics and sculptures, in which his attention to shapes is so well manifested. Between the paintings on the yellow walls of the radiant studio, where colour loses nothing of its quality, there are Japanese prints and photographs of old works (Cranach, Holbein, Botticelli) and modern ones (Puvis de Chavannes, Manet, Degas) whose company, so dangerous for the others, proves that the master of the house is from the great family, the beautiful family of the strong; of those whose presence inspires him; there are also sketches by Odilon Redon, paintings by Cézanne and Van Gogh. Gauguin is only happy in this world, because it is his.

Although he had created this magical artist's den, Gauguin still did not produce any major oil paintings, turning his attention rather to the production of ceramic sculpture, and once again choosing to work in the studio of the great ceramist Ernest Chaplet. The stoneware pieces that he now produced no longer bore a debt to Caldecott and Greenaway, for they were based rather upon the strange and brutal forms of his own Tahitian pantheon. The most astonishing of these works was a large, strangely distorted, female figure with animals at her feet. The large mask-like face and stylized breasts, contrasted with wiry and twisted limbs, result in a sinister totemic form aptly named *Oviri* ('Savage') (see page 42). Gauguin was

hugely pleased with it, but probably little surprised when it was initially rejected by the official Salon of the Société Nationale des Beaux-Arts. In an attempt to explain his aim in producing ceramics he later wrote to *Le Soir*:

I saw the possibility of giving a new impetus to ceramic art by creating innovative hand-made forms . . . To replace the wheel with intelligent hands that could invest a vase with the life of a figure, whilst remaining true to the character of the material . . . this was my aim.

He now directed all his efforts towards preparations for his impending departure for Tahiti and in February 1885, as before, held a fund-raising sale at the Hôtel Drouot. This time, however, not only was the turn-out poor but hardly any works sold, partly a response to the unrealistically high reserves placed upon them. Degas remained loyal, but his purchase of two paintings and six drawings was not enough to make the event pay; Gauguin was obliged to buy back a number of paintings under a variety of names, and after expenses was left with little over 450 fr.

Still not totally recovered from the injuries sustained at Concarneau, Gauguin now confided in Monfried that he had caught what he delicately described as 'an unfortunate disease'. A popular misconception is that he contracted syphilis from the native women of the South Seas; in fact, it is more likely that it was he who gave it to his teenage lovers in Tahiti. Ill and discouraged by his stay in France, he made haste to leave, without having established any satisfactory source of funding. Taking leave of Morice, his new ally August Strindberg and other friends, he sailed from Marseilles on 3 July 1895, never to return.

Travelling via Auckland, he took the opportunity to visit the newly opened wing of the Ethnological Museum, studying its rich collection of Maori art and architecture, the latter often highly sculptural in its carved decoration. His love of the primitive had by now become a well-developed aesthetic creed, so that

when he arrived in Papeete, he was horrified by how the place had been debased by Western influences and commerce. It occurred to him instantly that he might be better off living in the Marquesas Islands, but for the time being he lodged in Papeete, satisfying his desire to escape the city by making sailing trips to neighbouring islands.

By November he had decided against moving far and began, at significant expense, to renovate and build on to a grand hut that would serve as a studio and home. Located three miles outside Papeete at Punaauia, it was a convenient compromise between isolation and integration allowing the artist, whose leg was still paining him, to remain within reach of letters, money and newspapers sent from Paris.

The construction was expensive, but Gauguin continued profligately to spend what remained of his resources, perhaps in an attempt to alleviate the depression and illness that now plagued him. In the hope of a little happiness he summoned Teha'amana, who had by then married a fellow Tahitian. She came to Gauguin but, terrified by the sight of his eczema, she hastily returned to her husband. The artist now found himself alone, poor, and still disinclined to undertake any major work in oils.

Although 1896 began auspiciously with the arrival of Pahura, a new fourteen-year-old *vahine*, Gauguin was soon taking significant amounts of morphine and began to consider suicide as the only escape from what he saw to be a pattern of poverty and pain. But one large oil completed in the spring did help to restore, albeit temporarily, his self-confidence, and in a long, illustrated letter to Monfried he proudly described the work he entitled *Te arii vahine (The Noble Woman)*:

I have just finished a canvas of 1.30 by 1 metre that I believe to be far better than anything I've done before: a naked queen reclining on a green rug, a female servant gathering fruit, two old men near the big tree, discussing

the tree of science; a shore in the background . . . I don't think I have ever done anything in such deep, sonorous colours . . .

By painting a monumental reclining nude Gauguin was addressing himself to a perennial subject of western art, examples of which could be found in the *oeuvres* of old and modern masters (including Cranach the Elder, Giorgione, Manet and Puvis de Chavannes). Called by Leclerq 'The Black Olympia', the figure does most closely relate to that of Manet's great painting – which Gauguin had copied when in France. This 'quotation' was undoubtedly deliberate, partly used as a means of illustrating Gauguin's belief in the moral superiority of the primitive:

In order to achieve something new, you have to go back to the sources, to man's childhood. My Eve is almost animal. That is why, for all her nakedness, she is chaste. But all the Venuses in the Salon are indecent and disgracefully lewd.

The argument that primitivism sanctioned what in Western terms would be tasteless or obscene, is one that Gauguin had used before to justify the poses of the less idealized nudes of his first Tahitian period. But in *Te arii vahine* he wished more profoundly to challenge conventional aesthetic archetypes, by representing a native woman as a composite Venus–Eve figure.

The summer of 1896 saw the first of numerous spells in hospital, which were now to punctuate the rest of Gauguin's life, interrupting a period in which both artistically and sexually he was surprisingly fertile. Financially, however, he was in a more calamitous state than ever, but preferred to default on payments rather than accept any money which he considered to be given to him out of charity.

In response to Pahura becoming pregnant, Gauguin painted another reclining figure in *Te tamari no atua (The Child of God)*, this time employing Christian iconography to suggest mother and baby as Virgin

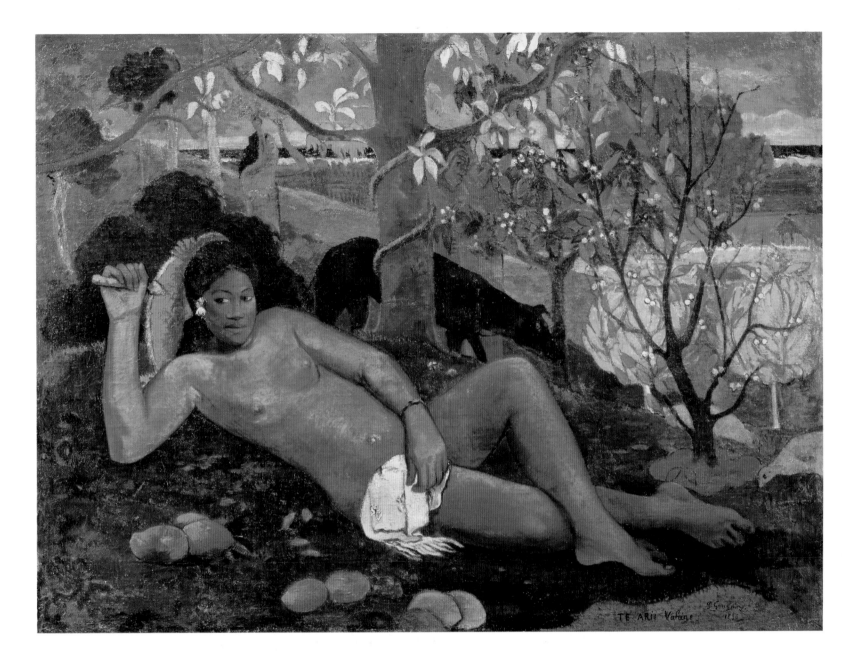

and Child. This iconic painting was completed before
the birth, but with horrible irony their baby daughter
died when she was only two weeks old.

Te arii vahine (The Noble Woman), *1896.*
Oil on canvas, 97 × 128 cm
Hermitage Museum, Leningrad

and Child. This iconic painting was completed before
the birth, but with horrible irony their baby daughter
died when she was only two weeks old.

A further bereavement was to devastate the artist; in
April 1897 he heard that his daughter Aline had died
three months earlier. Overflowing with grief, he
wrote to Monfried:

*Your letter arrives at the same time as a very brief and very
terrible letter from my wife. She tells me bluntly of the
death of my daughter, who was taken after a few days by a
pernicious pneumonia. This news didn't touch me at all,*
*long-schooled as I am in suffering: then each day, as
reflections come, the wound opens deeper and deeper and
at this moment I am completely despondent. I surely have
some enemy up there who does not give me a moment's
rest.*

His peace was further disturbed when the death of his
landlord necessitated his moving from his carefully

prepared hut. Borrowing over 1,000 fr. he bought a little land in Panaauia where a studio was built, adjacent to a wooden house which he embellished with highly decorative carved panels. But while he was working on his new home, illness gripped him again, this time more savagely than before; he suffered a series of heart attacks and his skin became so cankered that he was generally mistaken for a leper. In a state of profound dejection he wrote a letter to his wife, so reproachful that all communication between them now came to an end.

In Paris, however, his prospects were looking up slightly, with the sale at Vollard's of a number of the Tahitian works and the publication of *Noa Noa* in *La Revue Blanche* – altogether a more radical and interesting paper than the *Mercure de France* had become. The long-awaited copy of the first instalment reached him two months after its publication, but very disappointingly no money arrived with it. The artist had survived on nothing, but having less than nothing – owing 1,800 fr. without hope of repayment – threw him into a state of acute despair: the threatened crisis could be averted no longer, and Gauguin dragged himself up to the mountains and attempted suicide with arsenic. Luckily this caused him to vomit, so voiding him of the worst of the poison and saving his life. Defeated even in his attempt to die, he returned to town the next morning, weak and even more ill than before.

Whether or not Gauguin had completed the enormous canvas, *Where Do We Come From? What Are We? Where Are We Going?* (page 129), by the time of his suicide attempt is a matter of some debate. It would seem that in subsequent writings he distorted the order of events to make the work appear as a last will and testament, finished, but with the paint still wet when he took himself off to die. The painting is a panorama of the ages of man from birth to death, a composite reiteration of many of the forms and themes developed throughout his Tahitian work, and as such is a deliberate swansong.

A slight reprieve in Gauguin's illness allowed him to seek paid work and he duly applied for the post of Secretary Treasurer of the Caisse Agricole in Papeete. Humiliatingly he failed to get the job, which forced him to accept far more humble employment as a draughtsman in the Department of Public Works. Having to put on Western clothes and turn up at regular hours must have been hard for the artist, accustomed as he was by then to wearing only a native *pareu* and spending the days as he wished. Certainly the disruption of moving nearer to Papeete affected his will to work, and it would seem that for at least five months he painted nothing. Pahura, who had been Gauguin's *vahine* for over two and a half years, was now able to stand no more; the artist was over fifty – tired, ill, depressed, bad tempered and unsightly – while she was only sixteen, pregnant again, and probably now also infected with his 'unfortunate disease'. Like Annah the Javanese, she helped herself to the artist's belongings, causing Gauguin (unsuccessfully) to press charges against her.

The exhibition at the Galerie Vollard of *Where Do We Come From? . . .* and eight other paintings raised 1,000 fr. which enabled Gauguin to leave his job and move back to Panaauia; but he returned to find the studio in a deplorable state. Complaining to Monfried, he wrote:

Rats have destroyed the roofing and as a result the rain has damaged many things. A whole series of drawings, very useful records, destroyed by cockroaches, a large unfinished canvas also destroyed by those dirty insects . . . But it was important not to lose everything, to repair the disasters, restore the roofing and somewhat replenish my wardrobe and linen. I had nothing left.

From his first setting foot upon the islands, Gauguin had been critical of the way in which colonial rule was administered, and had become increasingly prone to air his strong opinions on the affairs of the government. This led him quite logically to contribute short essays and political articles to *Les Guêpes* ('The

Wasps'), a satirical journal based in Papeete. But only two months after the appearance of his first piece, he established his own broadsheet, *Le Sourire* ('The Smile'), for which he alone was writer, editor, printer, illustrator and distributor. Although journalism might seem an extraordinary digression at this late stage in his career, Gauguin had in fact grown up in a highly politicized environment, had always amused himself by drawing vicious, though humorous caricatures, and more recently he had become fascinated by various printing techniques. The sharp and acerbic character of his writing appears at odds with the profound serenity of some of his greatest oil paintings of this period (page 135), but it is not in any sense out of keeping with the exasperation so consistently expressed in his letters.

Much of the writing can only be described as hysterical, the artist lashing out at a wide variety of people; not just the colonial government, but also the legal profession, Protestant missionaries and immigrant Chinese. His opinions of the latter are particularly unpalatable, but serve as a reminder that his love of the exotic was not inconsistent with racial prejudice. He wrote in *Les Gûepes*:

Along with the Chinese who are invading our beautiful colony, something else is naturally occurring; I mean this new half-Chinese, half-Tahitian gentleman. Half! I do not believe it, because the Chinese leave their indelible mark physically as well as morally. The child is given French citizenship at birth, and later becomes a voter like ourselves. This yellow stain soiling our national flag brings a flush of shame to my face.

Drunk on polemics, the artist reached ever more lofty and ludicrous conclusions, not unified by a single philosophy, but rather reached in response to specific events. His zeal for journalism was now further indulged by his being made editor of *Les Guêpes*, a post that introduced a measure of social and financial stability to his life. But this activity distracted Gauguin from painting, and despite fresh supplies of

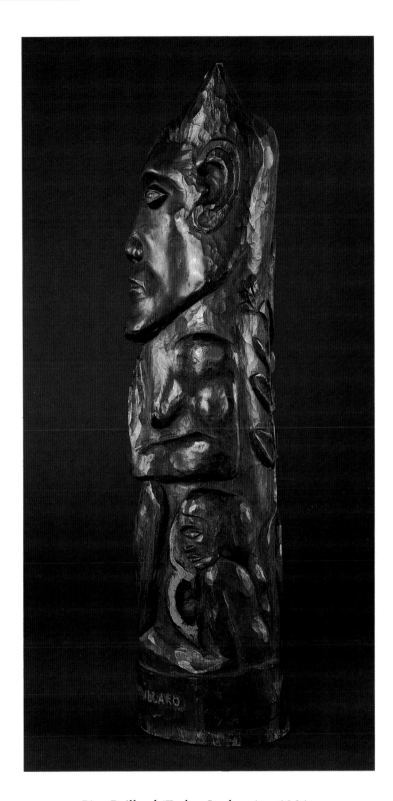

Père Paillard (Father Lechery), c.1901.
Wood, height 67.9 cm
National Gallery of Art, Washington DC

materials from France, pitifully little new work was produced between 1900 and 1901.

Numerous anxieties continued to prey heavily upon the artist's mind, but one in particular – that his sculptures might be dispersed in Paris – made him issue an 'edict' to Monfried and Vollard immediately to stop all sales and recall as many works as possible. The request that *Oviri* should be used as decoration for his tomb suggests that this sudden possessiveness was in some way connected with the realization that he had not long to live.

At last Gauguin had established what seemed to be a satisfactory contract with Vollard, according to which he received a monthly salary of 300 fr. in return for no less than twenty finished paintings per year. This gave him the opportunity to start painting once again on a full-time basis and to go in search of the last of his utopian dreams:

I think that in the Marquesas, in view of the facilities for procuring models (which becomes more and more difficult in Tahiti) and with open landscapes – in short with wholly new and more primitive elements – I shall accomplish great things. Here [in Tahiti] my imagination is beginning to cool, and besides, the public has got too used to Tahiti. People are so stupid that when we show them pictures containing new and terrible images, Tahiti will become comprehensible and charming. My paintings from Brittany will seem like rose-water after those of Tahiti; Tahiti will seem like cologne after the Marquesas Islands.

Accordingly he departed for the Marquesas archipelago on 10 September 1901, determined to refresh his powers of invention and hopefully to regain his health. Buying two plots of land in the centre of the village of Atuona on the island of Hivaoa, he began to construct an unusual building, which he called his 'House of Pleasure'. This was of two storeys, entered by the first floor, and quite sophisticated in containing a number of rooms, including a relatively large studio. Gauguin was delighted with the result, but

was very much in need of a *vahine* to manage this new home. Within two weeks he had arranged with a Marquesan chief that his daughter should be removed from school, and therefore fourteen-year-old Vaeoho Marie Rose soon joined him.

There is not so notable a stylistic difference between the Tahitian and Marquesan work as the artist's rose-water/cologne analogy might suggest, but his output of high-quality canvases did increase significantly once he was settled in the new house. In the early years of 1902 he was particularly prolific, and was able to promise spring shipments of twelve and twenty paintings to Monfried and Vollard respectively. But as was so frequently the case when things seemed to be going well, Gauguin manufactured a disturbance that immediately rebounded on his own happiness and well-being.

His caprice now was to withhold his taxes, and he advised all the natives he knew to do the same, thus profoundly angering the colonial authorities. Pregnant, his *vahine* had left him, and importunately he pressed the parents of other native girls not to send them to school. The head of the Catholic mission, Bishop Martin, who prevented this scheme from going ahead, was now viciously taunted by the artist who staged a satirical tableau (about Martin's supposed sexual licence) outside the 'House of Pleasure' and began to write counter-propaganda against the Catholic school.

Having thus stirred up trouble, Gauguin soon became dejected and apathetic, wondering whether it would be better for him to leave the South Seas altogether and move to Spain. In an increasingly pessimistic mood he lashed out again, this time in response to the petty officialdom of the governor, stretching nearly to breaking point his already strained relationship with the authorities of the island.

Effectively a cripple, it now required a superhuman effort for Gauguin to work at all, let alone complete a

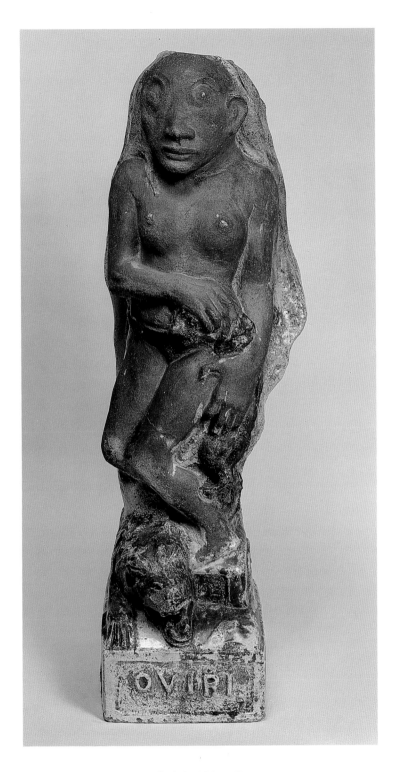

Oviri, 1894–5.
Stoneware, glazed in parts and painted,
height 74 cm
Musée d'Orsay, Paris

painting. A neighbour on the island observed and described his increasing decrepitude in the last years:

All the time I knew M. Paul Gauguin he was ill and almost impotent. Rarely leaving his house, he produced a painful effect upon one when . . . one met him in the Atuona vale, dragging himself along with difficulty, his legs bandaged, and wearing, besides, only the very primitive Maori costume: a coloured skirt around the waist and the torso covered with a Tahitian chemisette; almost always barefoot, and on his head a flat schoolboy's cap of green cloth with a silver ball on one side.

As far as possible he contented himself by constantly writing down his thoughts and recollections (in the journal known as *Avant et après*), but this was not enough to keep the artist out of trouble and by February 1903 he had re-entered the political fray by attempting to defend twenty-nine natives accused of drunkenness. His appearance in court dressed only in a filthy *pareu* did not aid his advocacy, and he was summarily dismissed on the first day of the trial.

This time he had pushed his luck too far, and the authorities rapidly rose to the bait, charging him with libel against the governor and allowing him only three days to ready his defence. Inevitably he lost the case, was duly fined and sentenced to imprisonment. Too weak to do anything but write a vitriolic letter to the chief of police Gauguin rapidly sickened, and on 8 May died of a heart attack.

As he had requested, *Oviri* was sent to stand sentry over his grave, a small and unostentatious plot in the Catholic cemetery above Atuona. The contents of his house were soon auctioned in Papeete and an announcement of his death was made in France by Monfried. A neighbour reported overhearing the natives lament:

Gauguin is dead! We are doomed!

1848 ❧ 1903

P Gauguin

THE PLATES

Gauguin had only been painting for about four years when he executed this canvas in a quasi-Impressionist style. Through Pissarro he had recently been introduced to Monet, Degas and Renoir who had staged the first Impressionist exhibition a year earlier. In choosing a modern, everyday scene, he conformed to the tenets of the Impressionists who were opposed to the formal and historicist content of established Salon works. The bold linearity and the emphasis on tone as opposed to broken, pure colour, however, suggest that Gauguin was not dogmatic in his modernism, nor afraid to interpret the ideas of better known avant-garde painters. The influence of Pissarro is evident particularly in the handling of the trees, but the brushwork is generally less fractured than in the older artist's canvases of the same date. It is not, perhaps, surprising that the jury of the Salon accepted a landscape painting by Gauguin in 1876, but refused the work of Manet and Cézanne.

The artist's later writings suggest that he subsequently considered his 'Impressionist' oils prior to 1886 to be of little interest, although he produced over a hundred canvases during this period, some of which were exhibited in the annual Impressionist exhibitions.

The Seine at Pont d'Iéna

Painted 1875

65 × 92cm

Musée d'Orsay, Paris

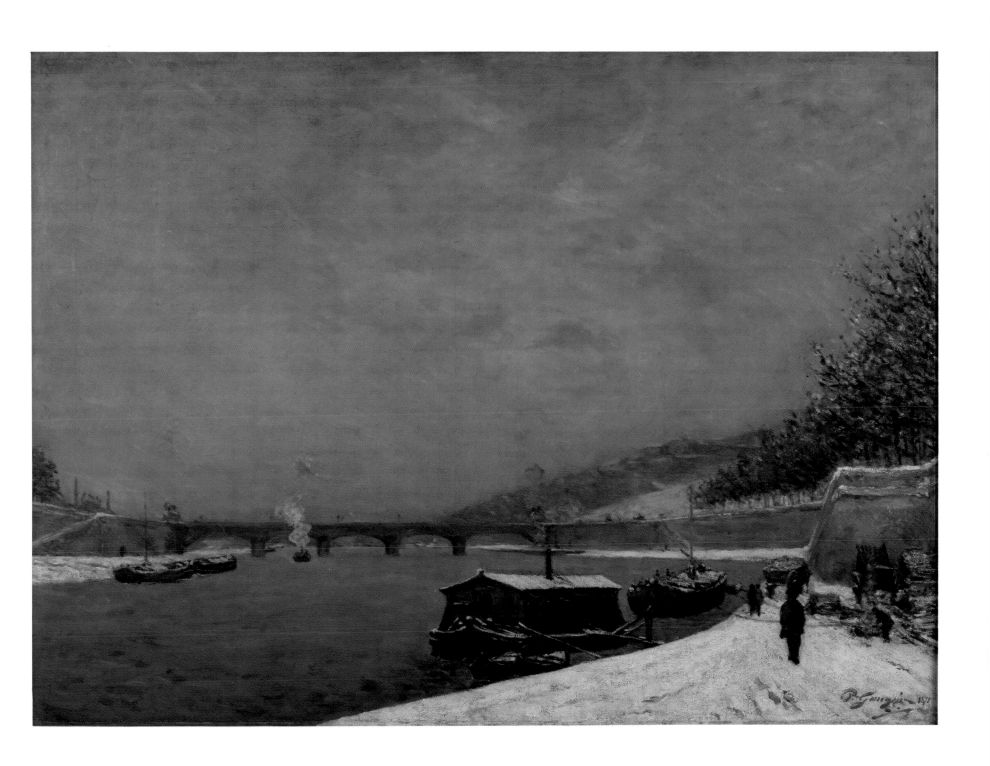

Exhibited in the sixth Impressionist exhibition of 1881, this unconventional figure painting was well received by the critic Huysmans, who saw in it a realism and vitality comparable with the great nudes of Rembrandt and excelling those of Courbet:

M. Gauguin is the first in years to have tried to represent the woman of our own time and, despite the heaviness of the shadow falling from the model's face across her chest, he has fully succeeded in creating a brave and authentic canvas.

But not all were equally enthusiastic, and many viewers even today find the image perplexing, because it seems intentionally to invoke an idealized genre at odds with the highly irregular body-shape, the grey-green flesh tones and the choppy brushwork.

The pose recalls Ingres's *Grande Baigneuse*, the mandolin and rug are stock-in-trade Orientalist props, and the idea of sewing in the nude is a distinctly impractical contrivance. These conceits suggest to the viewer that this is not in fact a spontaneous 'sketch' of an everyday scene, yet Gauguin was irritated by attempts to identify possible references and meanings. He complained to Pissarro that Huysmans was only attracted by the literary dimension of the nude, rather than the manner in which it was painted.

Study of a Nude
(or Suzanne Sewing)
Painted 1880
111.4 × 79.5cm
Ny Carlsberg Glyptotek, Copenhagen

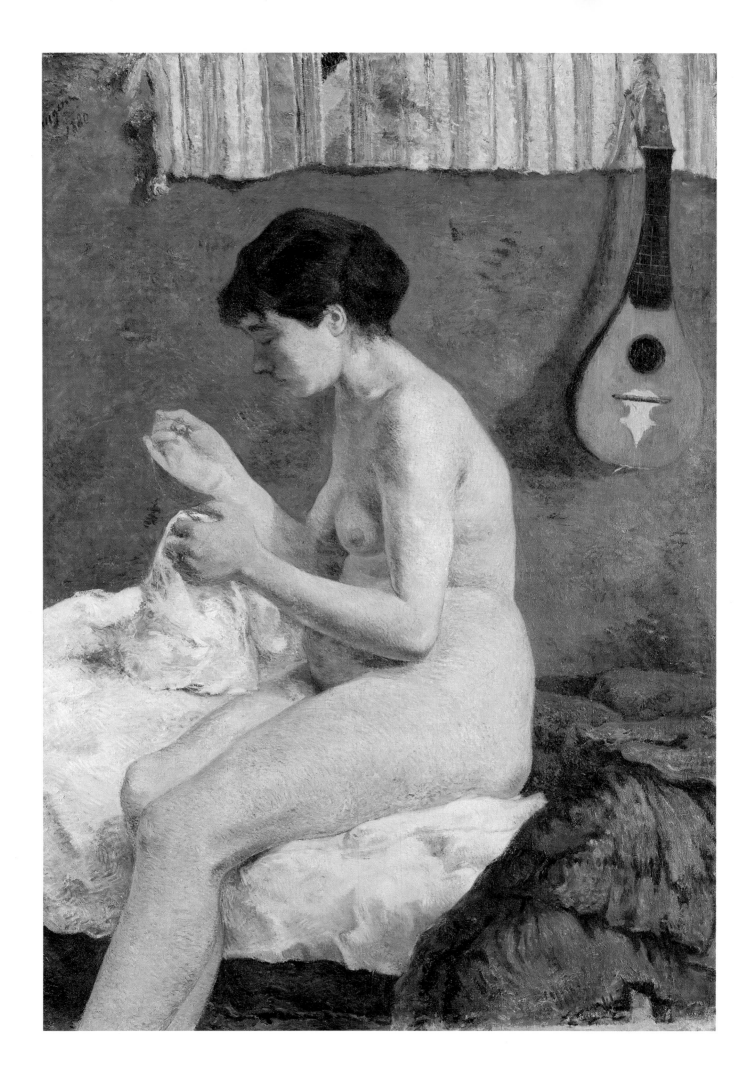

Completed in the year in which Gauguin became a full-time painter, this canvas is one of the largest and most ambitious of his works in the Impressionist style. By 1883 Pissarro, Monet and Courbet had already addressed themselves not only to the peculiar demands of capturing the reflective and textural qualities of snow, but also to the purely practical problems of *plein-air* painting in the depth of winter. It would seem that Gauguin followed their example by creating an oil sketch before the subject and subsequently working it up into a larger finished canvas in the studio. Characteristically he took the opportunity at this stage to introduce the figures of women dramatically silhouetted in the foreground.

It is thought that the garden is that of Gauguin's house in the rue Carcel, but though the exact location is in some doubt, the chimneys in the background testify to the scene's being contemporary and urban. In previous years Monet and Pissarro had frequently chosen locations where there was evidence of industry in an otherwise natural or civic scene, but in contrast to their active, smoke-billowing chimneys, those on Gauguin's horizon are stark and forbidding.

The Garden in Winter, rue Carcel
Painted 1883
117 × 90cm
Private collection

Gauguin executed a number of highly successful still-life subjects in 1885 and 1886, such as *Still-Life with Horse's Head*, 1885, and *Still-Life with Peonies and Mandolin*, 1885, but during these years it was in this canvas alone that he combined still-life with portraiture.

Although the head is 'Degasesque', the dominant stylistic debt is to Cézanne, whose *Fruit, Bowl and Apples* was one of five or six canvases by the artist that Gauguin had bought during his early years in Paris, and which appears in the background of his later *Portrait of a Woman with Still-Life by Cézanne*, *c.*1890 (page 97). Also apparent, from the angle at which Laval's head enters the painting, is the influence of Japanese prints, which frequently employed a 'cut-off' technique to achieve exciting and dramatic effects.

Still-Life with Profile of Laval
Painted 1886
46 × 38cm
The Josefowitz Collection

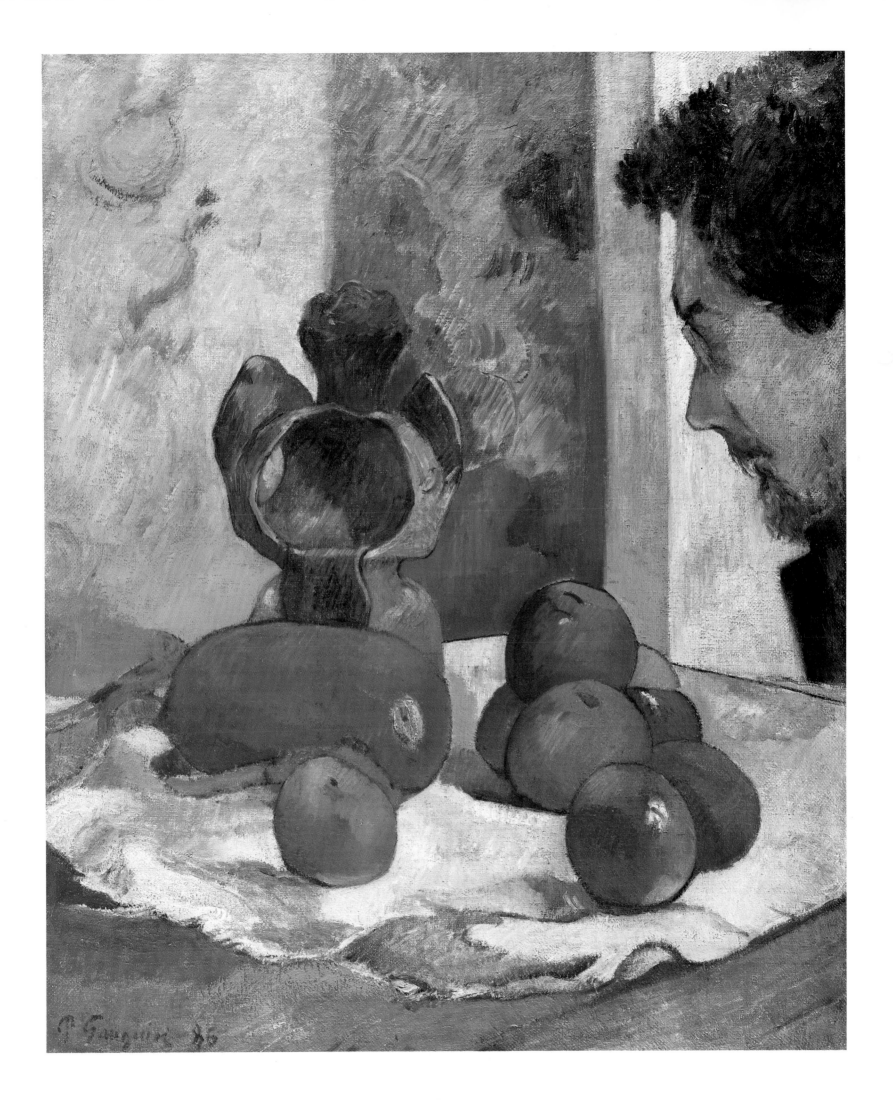

Although generally considered to be Gauguin's most important Breton work of 1886, this canvas was in fact painted in Paris, the artist referring to large coloured sketches which he had brought back with him from Pont-Aven. This process allowed him both the initial stimulus of the real model (the Breton women made a small living from posing for artists) and the distance to enable him to distil the essence of the scene from the particularities of the moment.

Stylistically this is a transitional canvas. An Impressionist touch remains in the broken brushwork of the foreground foliage, yet this combines with a variety of other treatments; short hatched strokes for the background, firm, but mottled colour areas in the women's costume and finely painted contours around the faces and headdresses. Naturalistic space is implied by the difference in size between the women and the man glimpsed farming in the background, but is contradicted by the lack of horizon and the tight interplay of shapes created by the circle of women. Although organic colours are used to represent the natural environment, the 'arbitrary' and subjective hues that invigorate later Breton canvases (the vibrant orange of *Ondine*'s hair (page 81), the saturated red of the ground of *Vision after the Sermon . . .* (page 61)) may be found 'in prototype' in the figures here. The four Breton women with their simplified features and schematized postures strongly anticipate the fully-blown Synthetism of Gauguin's work in the late 1880s.

Four Breton Women
Painted 1886
72 × 90cm
Neue Pinakothek, Munich

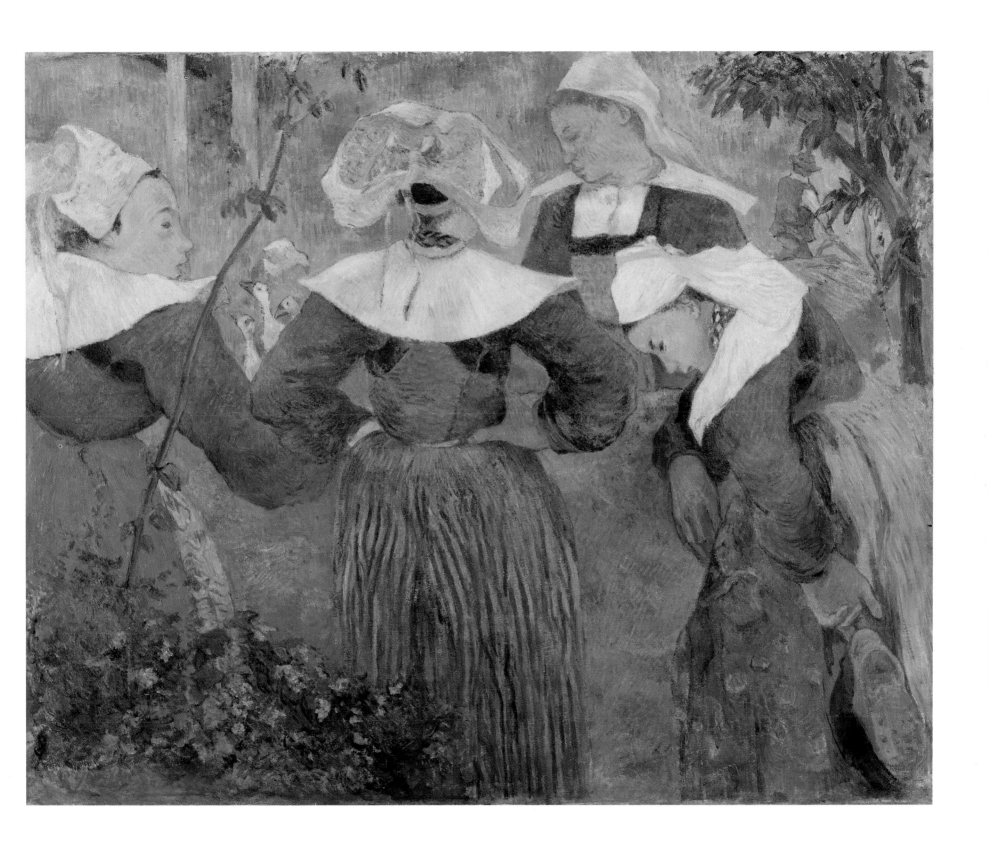

Although Gauguin's stay in Martinique was re-latively brief, the primitivism he perceived on this tropical island had an immediate and marked effect on his style, and in particular his use of colour. This vibrant work shows the vestiges of Gauguin's early Impressionist technique in, for instance, the handling of the foliage in the middle ground, loosely described with short brushstrokes. In the treatment of the trees and far distance, however, distinct areas of bright mottled colour create a more stylized, decorative effect – almost that of a woven textile.

Gauguin has carefully constructed this view of the Bay of Saint-Pierre so as to obscure any evidence of the town, which would undoubtedly have been visible from this angle; he chose rather to interpret the scene as a desert island, an idyll of natural splendour inhabited by a solitary cockerel.

Tropical Vegetation, Martinique
Painted 1887
116 × 89cm
The National Galleries of Scotland, Edinburgh

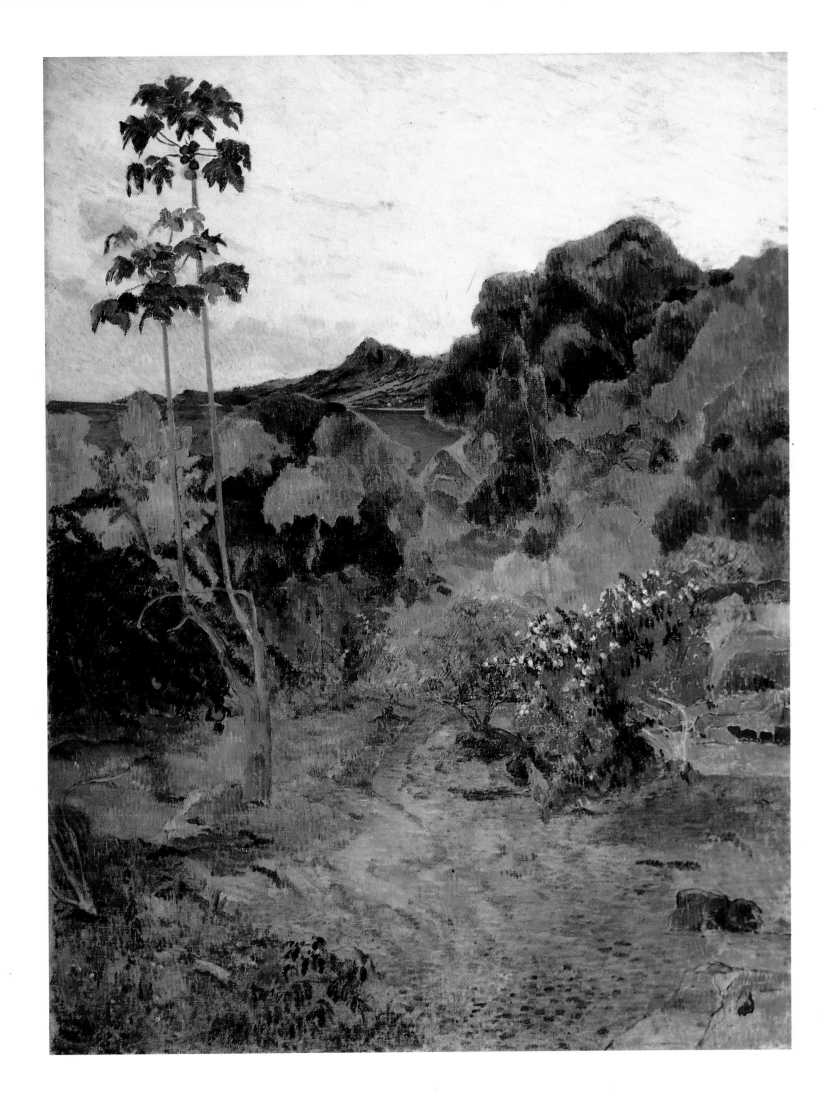

At the Café des Arts (Volpini) exhibition of 1889 this canvas was the sole representative of Gauguin's work produced outside Brittany and Pont-Aven. His decision to include it may have been due to its marked departure in style, content and treatment from his early Impressionist canvases, and its anticipation of the highly experimental figure paintings of the late 1880s.

Throughout his career Gauguin was fascinated by the subject of women grouped in work, play or repose. In Brittany the women dressed up for the artists and charged accordingly. In Martinique Gauguin was therefore overwhelmed to discover 'primitive' women who did not pose prettily but worked hard. The American writer Lafcadio Hearn, visiting the island during the same period, remarked that:

The erect carriage and steady swift walk of the women who bear burdens is especially likely to impress the artistic observer. It is the sight of such passers-by which gives, above all, the antique tone and colour of his first sensations.

From outside the town of Saint-Pierre Gauguin wrote to his wife, describing the paradise beneath his window. This spirit of utopianism permeates *Mango Pickers*, and marked the beginning of Gauguin's urgent quest for a primitive picturesqueness, which was to culminate in the monumental figurative scenes of Tahiti.

Mango Pickers, Martinique
Painted 1887
89 × 116cm
Vincent van Gogh Museum, Amsterdam

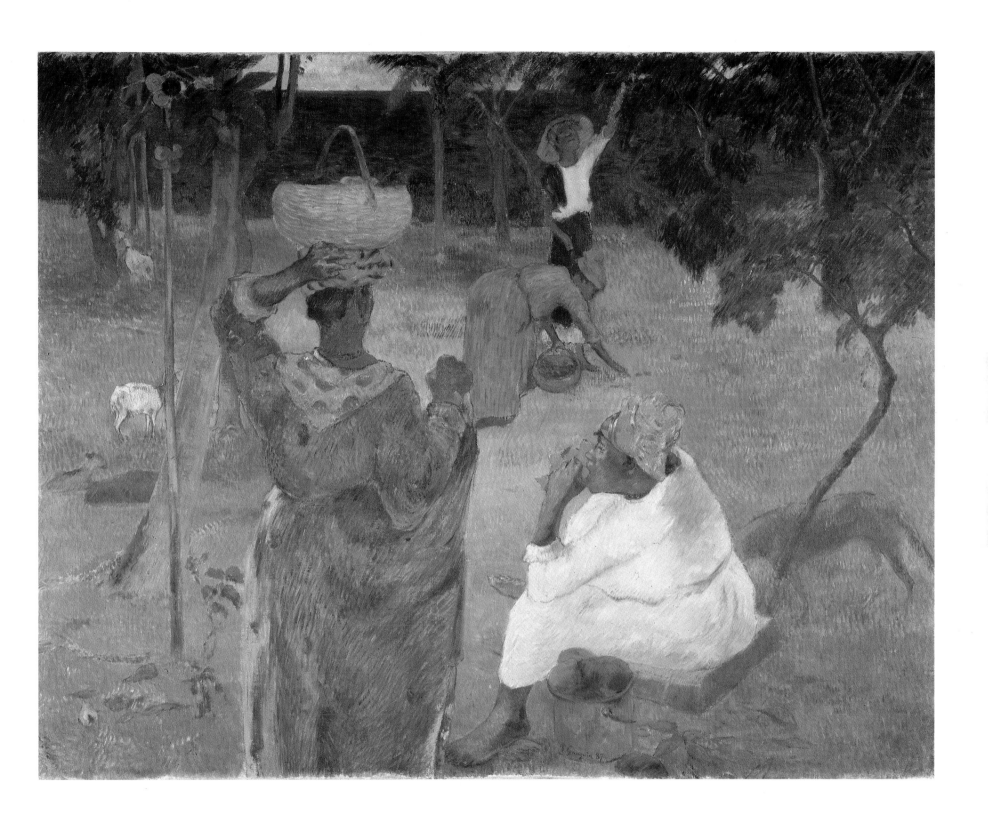

This canvas anticipates the use of wrestling figures in *Vision after the Sermon . . .* (page 61), and it is likely that, though wrestling traditionally took place in Brittany after pardons had been given, his interest in the theme of physical combat was aroused at this time primarily by the prints of the Japanese artist Hokusai. He wrote to Schuffenecker:

I have just done some nudes you will be happy with; no Degas about them whatsoever. The latest is of two boys wrestling beside the river, thoroughly Japanese, but seen through the eyes of a Peruvian savage.

But it was not only the subject matter that Gauguin considered to be very much in the Japanese style; he manipulated the perspective of the scene to eliminate a skyline, stylized the forms of the figures and painted the water in such a way as to, in his view, resemble rough Japanese *crépons*. This oriental influence was, however, tempered by that of examples closer to home and the pose of the boys bears a direct resembl- ance to that of the naked children fighting in Puvis de Chavannes's *Doux Pays (Pleasant Land)* of 1882.

Characteristically Gauguin described the paint- ing in terms of well-defined colour areas. He wrote to Vincent van Gogh:

I've just finished a Breton wrestling scene, which I'm sure you'll like. Two boys one wearing vermilion shorts, the other blue ones. Above right, a boy coming up out of the water – green grass – pure Veronese, shading off into chrome yellow . . . Also a waterfall in pinkish white, with a rainbow on the edge of the canvas just beside the frame. Below, a white patch, a black hat, and a blue smock.

The artist describes concrete objects (the vermilion shorts), atmospheric effects (the rainbow) and ab- stract areas of the canvas (the white patches) simply as juxtaposed colour pointing up the importance he placed during this period on the purely decorative surface effects of the paint, its hues and textures.

Lutte Bretonne (Children Wrestling)
Painted 1888
93 × 73cm
The Josefowitz Collection

This canvas is one of a series of nudes that includes a highly accomplished study of young Bre- tons bathing, but it was this one which Gauguin chose to show at the Café des Arts (Volpini) and at the sixth exhibition of Les XX in Brussels.

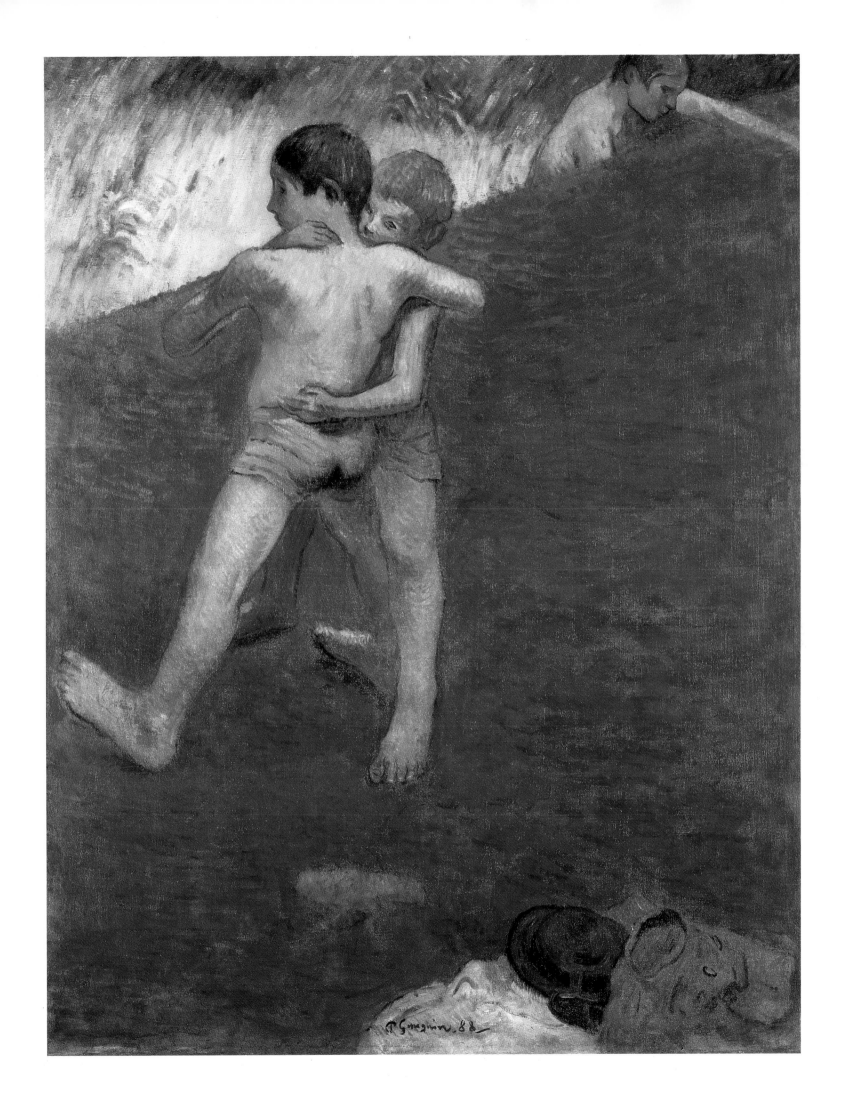

The most famous of Gauguin's Breton paintings, *Vision after the Sermon (Jacob Wrestling with the Angel)* was the first canvas in which he used a religious subject. In depicting the imaginary, he broke completely with the Impressionists and established himself as the most important artist working in a 'Synthetist' style. On completion of the work he wrote to Émile Schuffenecker:

This year I have sacrificed everything – execution, colour – for style, because I wished to force myself into doing something other than what I know how to do. I believe it is a change which has not yet borne fruit, but will one day do so.

The artist's desire to represent the symbolic was well served by his choice of theme. The story of Jacob and the Angel, taken from the Book of Genesis, was open to a number of theological interpretations, and was variously understood as man's struggle against God, Satan or himself. Gauguin described the canvas largely in terms of the purity and brilliance of the colours, but in a letter to Vincent van Gogh, also offered some explanation of the nature of the vision writing:

For me in this painting the landscape and the fight only exist in the imagination of the people praying after the sermon, which is why there is a contrast between the people, who are natural, and the struggle going on in the landscape which is non-natural and out of proportion.

In attempting 'something other than what [he] knew how to do', Gauguin looked to a variety of sources; to Japanese woodcut prints for their pure colour and clear outlines; to medieval enamels for their simplification of form; to stained glass, for its luminosity and, most controversially, to the work of his fellow Synthetist Émile Bernard, whose painting *Les Bretonnes dans la Prairie (Women in a Meadow)*, though weaker in its graphic effect, shows a marked similarity to this painting in its subject matter, treatment and

Vision after the Sermon (Jacob Wrestling with the Angel)
Painted 1888
73 × 92cm
The National Galleries of Scotland, Edinburgh

style (see page 18). The accusation of plagiarism levelled against Gauguin caused an irreconcilable split between these two artists, previously the best of friends, and led to a long dispute as to who was the true 'inventor' of the Synthetist style.

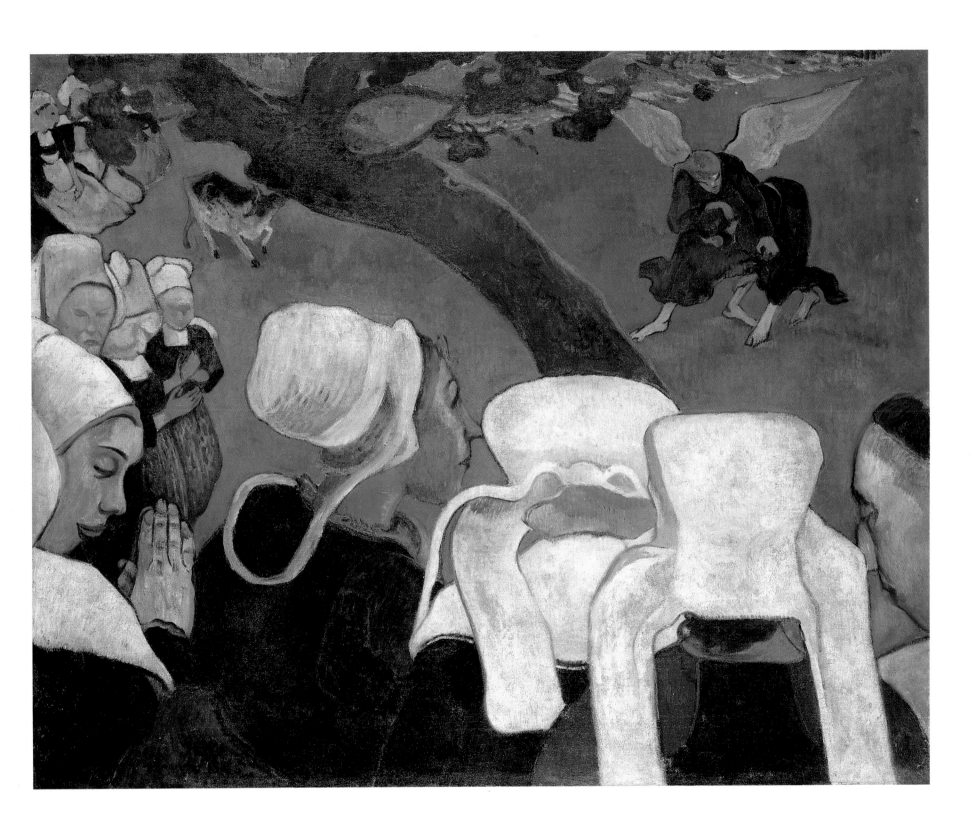

Madeleine, sister of the artist Émile Bernard, visited Pont-Aven with her mother in the summer of 1888. Then aged seventeen, she was considered to be a notable beauty and Gauguin promptly fell in love with her, though she was half his age. She, however, was keen on another of Gauguin's fellow painters, Charles Laval, to whom she later became engaged, and it is unlikely that Gauguin was ever her lover. But despite her rejection of his gifts and affection, the artist continued to be fascinated by the young girl, whose intellect he admired and whose company he much enjoyed. On arrival in Pont-Aven Madeleine had endeared herself to the artistic community as a whole by immersing herself in the life and customs of the town; preferring to wear Breton costume (though she is not depicted in it here) and being, according to her brother, 'very mystical'.

Both Émile Bernard and Gauguin favoured Madeleine as a model, but in painting her portrait it was not their intention to achieve an exact likeness. Émile wrote:

Naturally neither Gauguin nor I myself attempted anything more than a caricature of my sister, on account of the ideas we had at the time about character; but all the same Gauguin did paint a portrait (not resembling Madeleine, but very interesting from the point of view of style) with a Pont-Aven landscape behind, done in his early manner.

Portrait of Madeleine Bernard
Painted 1888
72 × 58cm
Musée de Peinture et de Sculpture, Grenoble

Though both artists chose to schematize the features of the sitter, Gauguin's painting is remarkable for the force of character implied by the exaggerated angularity of the face and the slanting, almost Egyptian eyes. Bernard's portrait by comparison shows a round, impassive visage, whose expression is difficult to read since the eyes are partially closed. Where the latter shows Madeleine in a generalized landscape setting, Gauguin chose to place her in a specific room, seated beneath an engraving by Forain of ballerinas, and described in far more detail her coiffure and the folds of her clothes. The landscape Bernard refers to in the quotation above is on the *verso* of Gauguin's painting, showing that the painter was prepared – or possibly forced through poverty – to reuse earlier canvases. It was this landscape, however, that was displayed at the *Salon d'Automne* of 1906, rather than the portrait that meant so much to the artist.

When Madeleine returned to Paris Gauguin wrote to her at length, praising her individuality and encouraging her to carve out a successful life for herself. Sadly she was not able to follow his advice as she contracted tuberculosis whilst nursing the dying Laval, and died in Cairo aged only twenty-four.

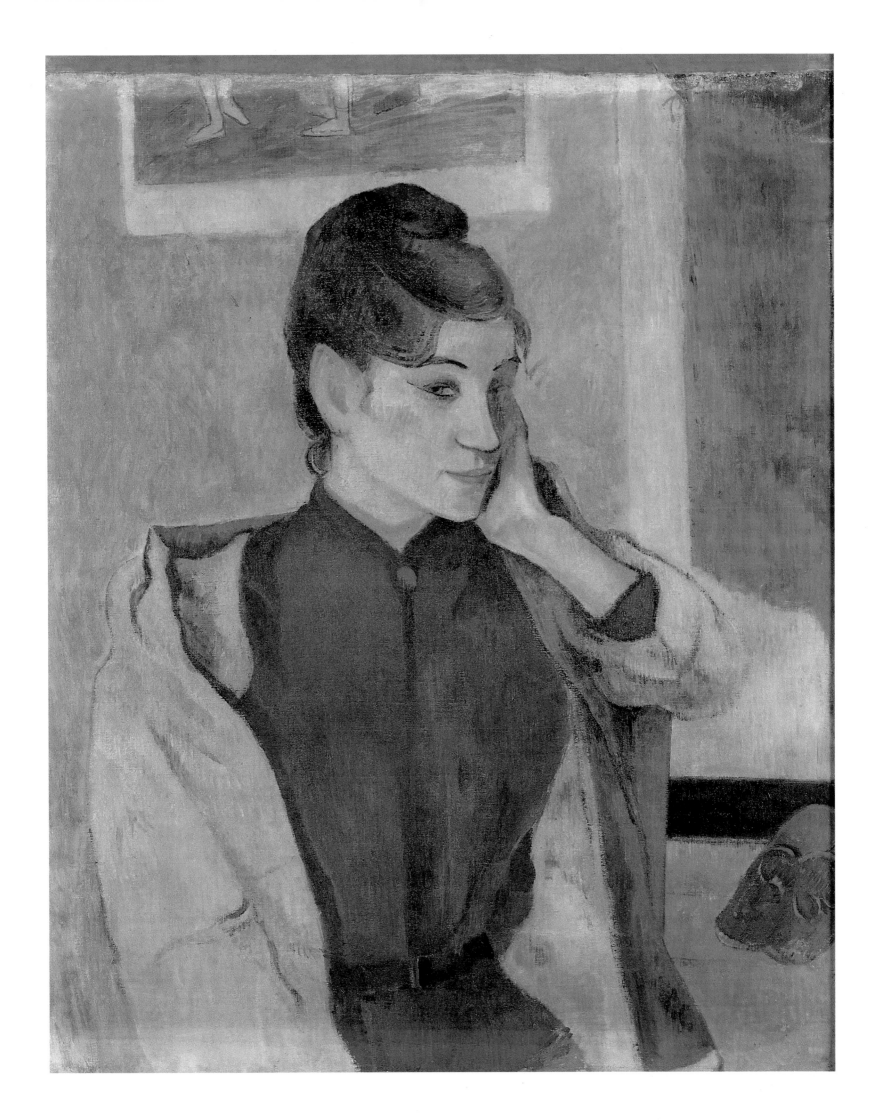

In *Avant et après* Gauguin recalled his arrival at Arles: 'I awaited daybreak in an all-night café. The owner looked at me and cried out "It's you, his friend, I recognize you." ' The artist was taken aback, but soon learned that van Gogh had shown the man the highly unconventional self-portrait he had sent in advance.

It had been van Gogh's request that Gauguin, Bernard and Laval should paint each other, but the tension between the three artists was such that ultimately each preferred to paint a self-portrait (Gauguin and Bernard including only small portrait images in the backgrounds of their respective works). Despite this setback, van Gogh wrote to Gauguin and Bernard warmly on the arrival of their pictures:

My heart was overjoyed and it glowed when I saw your faces. My house seems more lived in now. I have always been touched by the habit of Japanese artists of exchanging pictures with one another: it showed that they loved each other, that harmony reigned and that they lived in brotherly concord. So must we.

Privately, however, van Gogh was alarmed by the uncompromising expression of his friend and noted that he found the painting 'very sad, the face of a man who is ill and tormented.' Characteristically Gauguin took the opposing view, revelling in the darker implications of the work and wrote triumphantly to Émile Schuffenecker:

I believe it is one of my best things: absolutely incomprehensible, it is so abstract. Head of a bandit in the foreground, a Jean Valjean (Les Misérables) personifying also a disreputable Impressionist painter, forever chained to this world. The design is absolutely unique, a complete abstraction. The eyes, mouth and nose are like the flowers on a Persian carpet, thus personifying the symbolic aspect. The colour is far from nature; imagine a vague suggestion of pottery contorted by a great fire. All the reds, violets, streaked by flashes of fire like a furnace radiating from the

Self-Portrait. 'Les Misérables'
Painted 1888
45 × 55cm
Vincent van Gogh Museum, Amsterdam

eyes, seat of the struggles of a painter's thought. The whole on a chrome background strewn with childish bouquets. Chamber of a pure young girl. The Impressionist is pure, still unsullied by the putrid kiss of the École des Beaux-Arts.

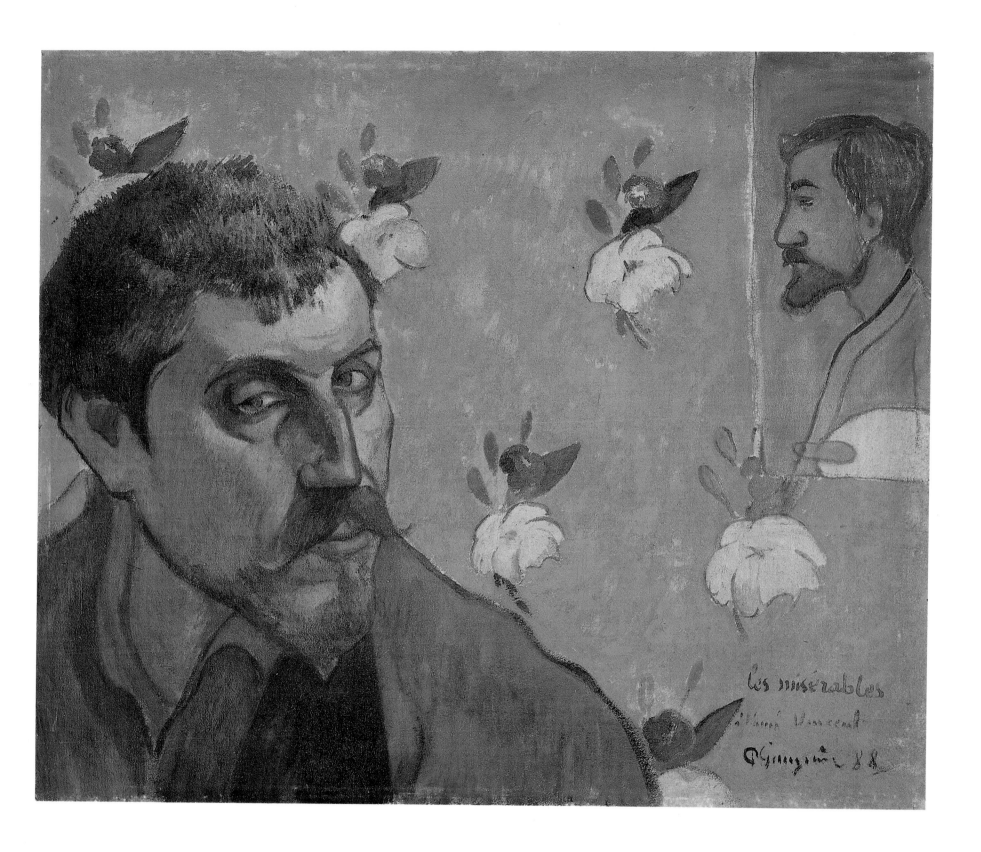

The subject matter of this composition is the Alyscamps near Arles, better known from the four views of it painted by van Gogh in the same year. Used by strollers, it was, in the 1880s, an imposing avenue of cypresses, among which were ancient sarcophagi, the remains of a Roman burial ground.

Although, in another canvas, Gauguin painted the avenue itself, this view is of a less obvious scene; a stretch of the Craponne canal with the church of Saint-Honorat visible in the distance. This perspective affords a rich autumnal landscape of strong and distinct colours, and the overall decorative and textural effect of his brushwork is not dissimilar to that of *Tropical Vegetation, Martinique* (page 55). But where the earlier work had been an exercise in pure landscape painting, this composition includes figures as a focal point of the perspective. Uniform and static, the women have the disquieting presence of stern sentries barring the way along the river bank. They face the viewer squarely, but the distance renders their features indistinct and their outlines shadowy; thus they seem otherworldly. Gauguin anticipated being asked to explain their presence when, for the benefit of Theo van Gogh, he jokingly entitled the canvas *Three Graces at the Temple of Venus.*

Les Alyscamps

Painted 1888
92 × 73cm
Musée d'Orsay, Paris

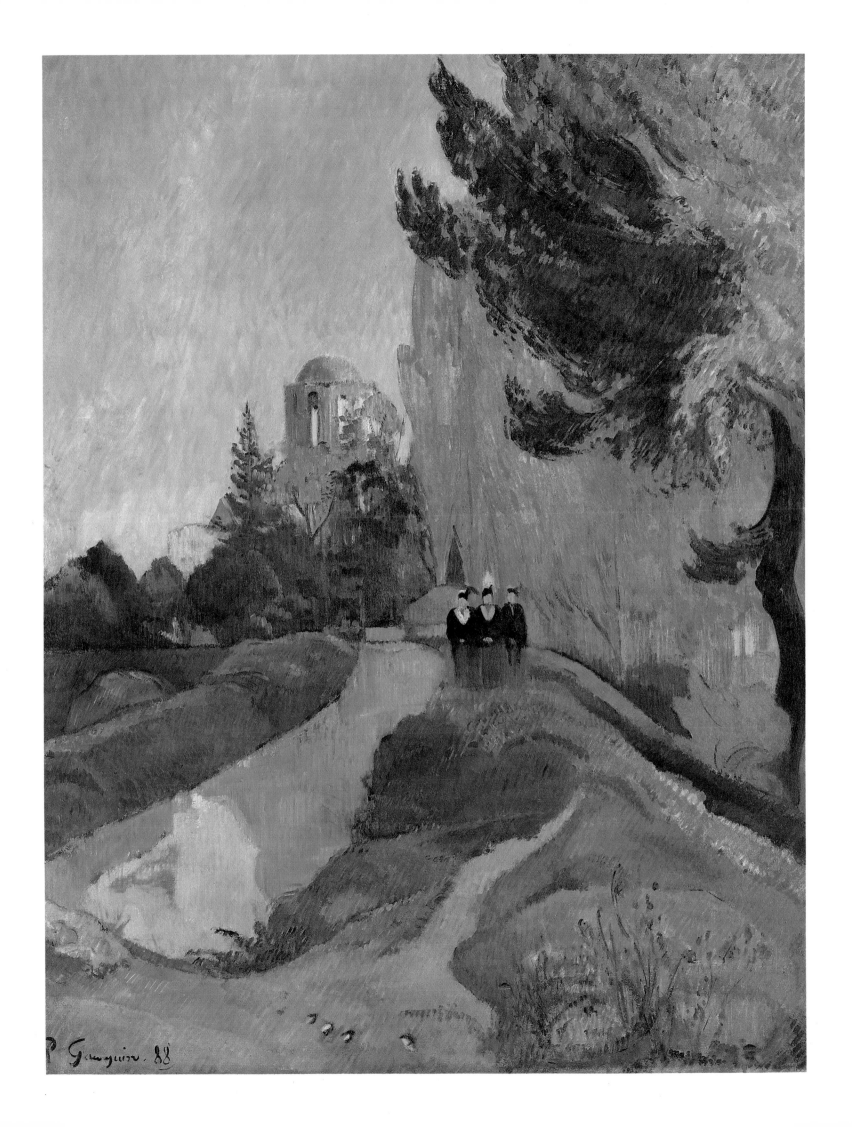

Before moving to his 'yellow house' Vincent van Gogh had stayed in the Café de la Gare at Arles, run by M. and Mme Ginoux. Its interior was depicted in his *Night Café*, and Mme Ginoux had also been his model for the *Arlesienne* canvases. Gauguin, in taking up van Gogh's subject matter (here Mme Ginoux seated in her café), also emulated his friend stylistically, adopting an aggressive palette of sharply contrasting hues. Of the *Night Café* van Gogh had written that it expressed 'the terrible passions of humanity by means of red and green', and Gauguin was consciously to adopt the same juxtapositions in this canvas. In a letter to Bernard, in which he included a rough sketch of the composition, he wrote:

I have also done a café which Vincent likes very much and I like rather less. Basically it isn't my cup of tea and the coarse local colour doesn't suit me. I like it well enough in the paintings by other people, but for myself I'm always apprehensive. It's purely a matter of education: one cannot remake oneself.

But it was not these colour contrasts only that Gauguin found unwieldy. Though relatively happy with the figures in the background (these include Roulin the postman and Milliet the Zouave), he was nevertheless extremely worried about the pose of Mme Ginoux, considering it to be too neat and stiff. In some measure this may be due to the fact that he had produced a firmly drawn preparatory charcoal sketch of her in isolation from the background.

In accordance with his agreement to send Theo van Gogh a painting a month, Gauguin duly sent this canvas – which in Vincent's view was 'very fine' – through to Paris for sale. It was initially bought by Ambroise Vollard and later became part of the great collection of modern art acquired by the Russian Alexander Morosov.

The Café at Arles
Painted 1888
73 × 92cm
Pushkin State Museum of Fine Arts, Moscow

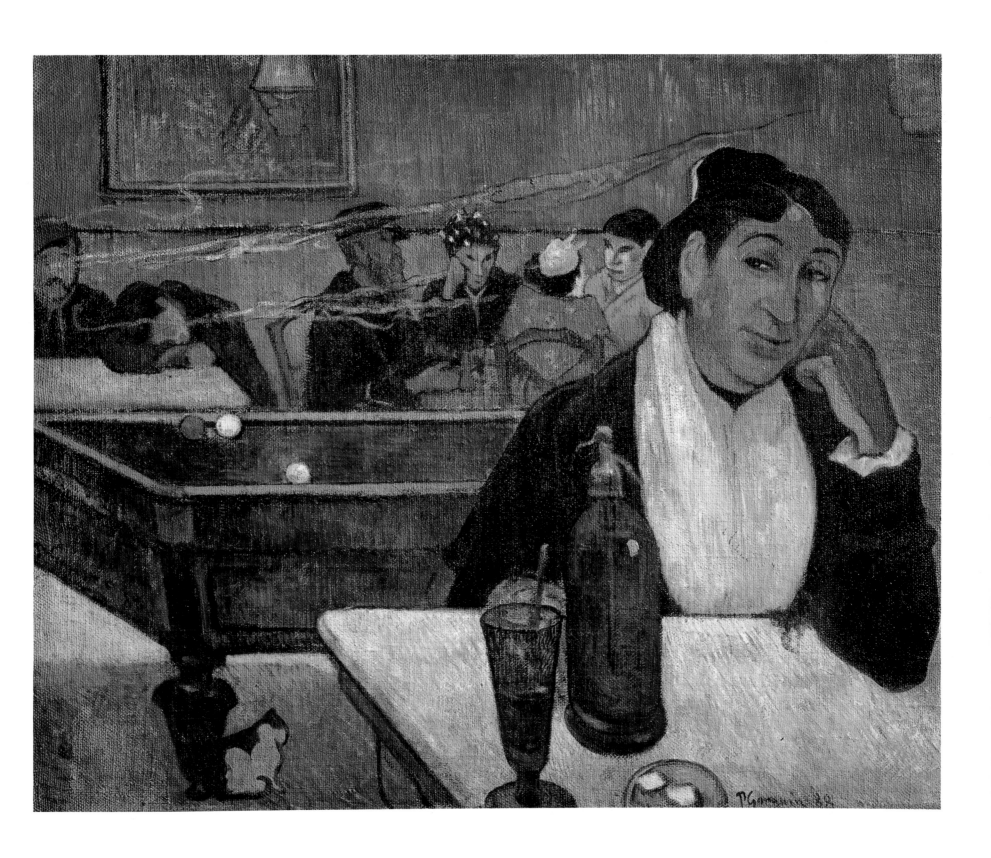

Gauguin and van Gogh had intended to produce portraits of each other in Arles, but, as with the scheme for Gauguin, Bernard and Laval to paint each other, this plan was only partially realized. That van Gogh found the task of representing his friend daunting may have been due to the fact that Gauguin cast himself in the role of master in their school of two, noting in *Avant et après*: 'When I arrived in Arles, Vincent was trying to find his way, whereas I, much older, was a mature man'. He openly criticized what he considered to be Vincent's misguided reliance on a Neo-Impressionist approach, and had set an un-matchable precedent in the form of his own *Self-Portrait*. '*Les Misérables*' (page 65), painted for van Gogh only a few months earlier. After Gauguin's departure from Arles, van Gogh attempted only a representation of his friend's armchair, 'and in the absent one's place a lighted torch and modern novels'.

But Gauguin had few qualms about attempting a portrait of his 'pupil' and fewer still about representing him highly unflatteringly; on seeing the painting van Gogh remarked, 'It is I, but gone mad'. In this work, as in others representing his fellow painters, the artist is physically marginalized within the picture space (pages 51 and 77). Uniquely, however, the effect here does not detract from the importance of the figure in the composition as a whole, for the elements of the painting are finely balanced in a broad arc that pivots on the artist's brush, the focal point both for van Gogh and for the viewer.

Practising what he so readily preached to van Gogh, that one should not paint too closely after nature nor rely on colour complementaries, Gauguin introduced a broad schematized background of flatly painted stripes, abstracted from nature to the extent that the trees appear as vertical blue bands, and the wall of the room and the ground beyond are disting-uished only by strongly contrasting fields of colour.

Van Gogh was rarely critical of Gauguin, ack-nowledging the master–pupil status quo, but the humiliation of being 'taught a lesson' by a painting

Van Gogh painting Sunflowers
Painted 1888
73 × 92cm
Vincent van Gogh Museum, Amsterdam

that depicted him as a madman may have been more than his shattered nerves could bear; for on the evening of the painting's completion he threw a glass at Gauguin's head and, during the following night, cut off a portion of his ear.

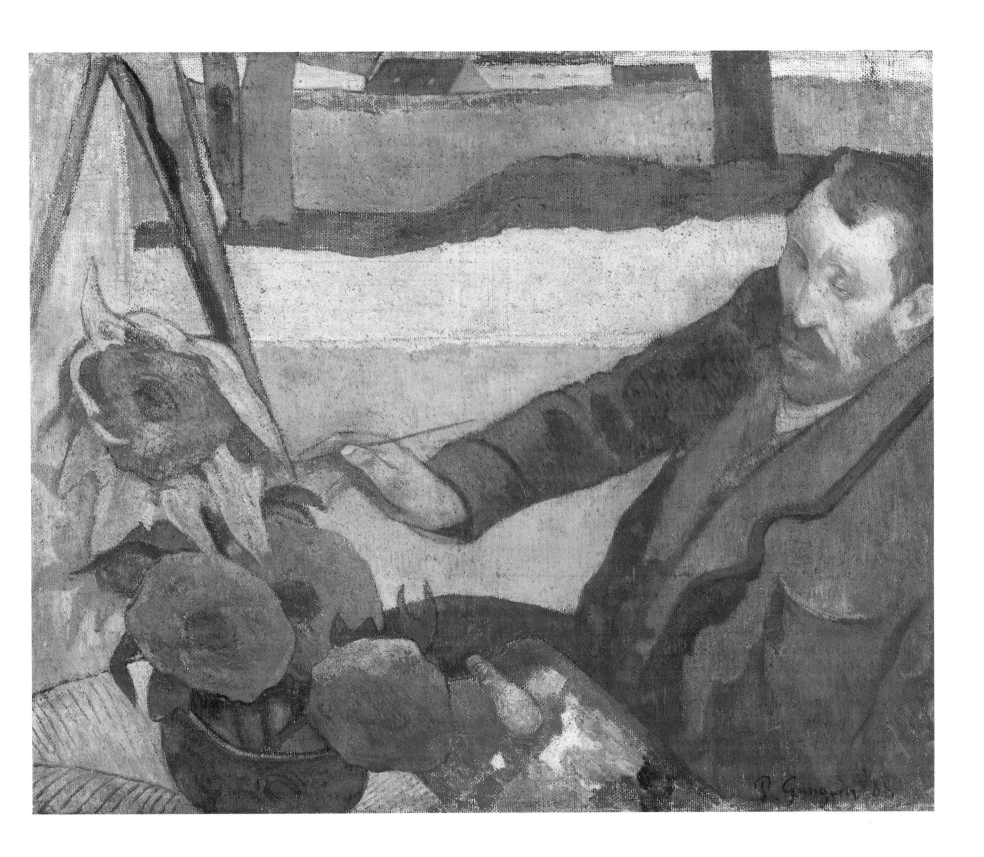

This extraordinary work is one of the most highly schematized canvases of Gauguin's Arles period. The composition is not relieved by any visible skyline, strong diagonals create a vertiginous perspective and ambiguous figures function on a decorative level in the background.

The scene is local, a public garden in which van Gogh had painted a series of views prior to Gauguin's arrival in Arles. But where van Gogh had observed the personal and the intimate in this garden, Gauguin perceived mystery and ritual. The women in the canvas are depicted as dark monumental forms and have an eerie iconic presence; the gate is too red and regular, the grass too green and well defined and a face may be read into the rough brushwork of the bush. As a supernatural setting its location in Arles or elsewhere is immaterial; Gauguin was attempting rather to depict his own response to the garden. He wrote to Schuffenecker:

Obviously this Symbolist road is full of pitfalls and I have only just taken the first step, but it is in the depths of my nature and one must always follow one's temperament. I well know that people will understand me less and less. What does it matter if I distance myself from others? For most I will be a puzzle, for a few I will be a poet, and sooner or later what's good will earn its place – no matter what, I tell you, I will end up doing things of the first order; I feel it and we will see. You well know that in art I am always right in the end.

With characteristic contempt for opinions other than his own, Gauguin challenged van Gogh to paint in the Synthetist style, working from memory, giving free rein to his imagination and interpreting the observed scene. Van Gogh's *Women at Arles* is a direct response to this canvas and shows how willing the young Dutchman was to try to please his friend. He wrote to his brother Theo, 'Gauguin gives me the courage to imagine things, and certainly things from the imagination take on a more mysterious character.'

Women from Arles in the Public Garden, the Mistral

Painted 1888
73 × 92cm
The Art Institute of Chicago, Illinois

Although Gauguin did not choose to acknowledge that he had been in any way influenced by van Gogh during his two-month stay at Arles, it is obvious from a number of the canvases which he produced during this period that he was responsive to the vigour of his friend's handling, if not his use of colour. The subject matter of this painting seems also to derive directly from a series of ten harvest scenes recently completed by van Gogh prior to his friend's arrival. Gauguin firmly recommended that van Gogh should not paint too closely from nature, but here responds to and modifies his own style in accordance with the observed scene. The most obvious influence on this work, however, it that of Paul Cézanne, whom Gauguin is likely to have met through Pissarro in the late 1870s.

Gauguin studied closely and borrowed copiously from a range of sources throughout his career, but the strength of his own powers of invention prevented him from slavishly copying any given source. Although there are obvious traces of the styles of both van Gogh and Cézanne in this canvas, neither would have chosen to use these warm colour harmonies, the banded skyscape or the unusual variety of handling displayed here.

Farm near Arles

Painted 1888
91 × 72cm
Indianapolis Museum of Art, Indiana

Emile Schuffenecker, artist, sculptor and untiring supporter of Gauguin was periodically the painter's host in Paris. At the time of painting this canvas Gauguin was again being fed and accommodated by M. and Mme Schuffenecker in the narrow studio vacated for his convenience. Despite the sacrifices made on his behalf, Gauguin was a harsh critic of his host's work, and seems to have taken the view that Schuffenecker was a useful, if somewhat tedious companion. This strained relationship was nevertheless pivotal to Gauguin's success, since besides looking after him bodily Schuffenecker organized the exhibition at the Café des Arts (Volpini), which gave the artist unprecedented exposure and introduced him to a number of influential people, such as the journalist Daniel de Monfried.

The first major group subject that Gauguin had undertaken, this canvas shows his command of the psychological, as well as the compositional organization of the scene. Schuffenecker's marriage was by all accounts a miserable one, since the wife was, in Gauguin's view, a 'harpy' and a 'limpet', later to be described by Schuffenecker himself as a 'poor lamentable creature to whom life has cruelly chained me, like a convict to his iron ball'. It may be that Gauguin had tried to seduce Mme Schuffenecker (this premise is central to Somerset Maugham's fictionalized story, *The Moon and Sixpence*), but certainly she distrusted the man who periodically made himself at home in her house. Accordingly Mme Schuffenecker is shown as a forbidding, stern figure, central to the scene, but nevertheless detached both from her children, who seem to cling to each other for comfort, and her husband, who stands marginalized in the corner of the canvas wringing his hands.

The Schuffenecker Family

Painted 1889

73 × 92cm

Musée d'Orsay, Paris

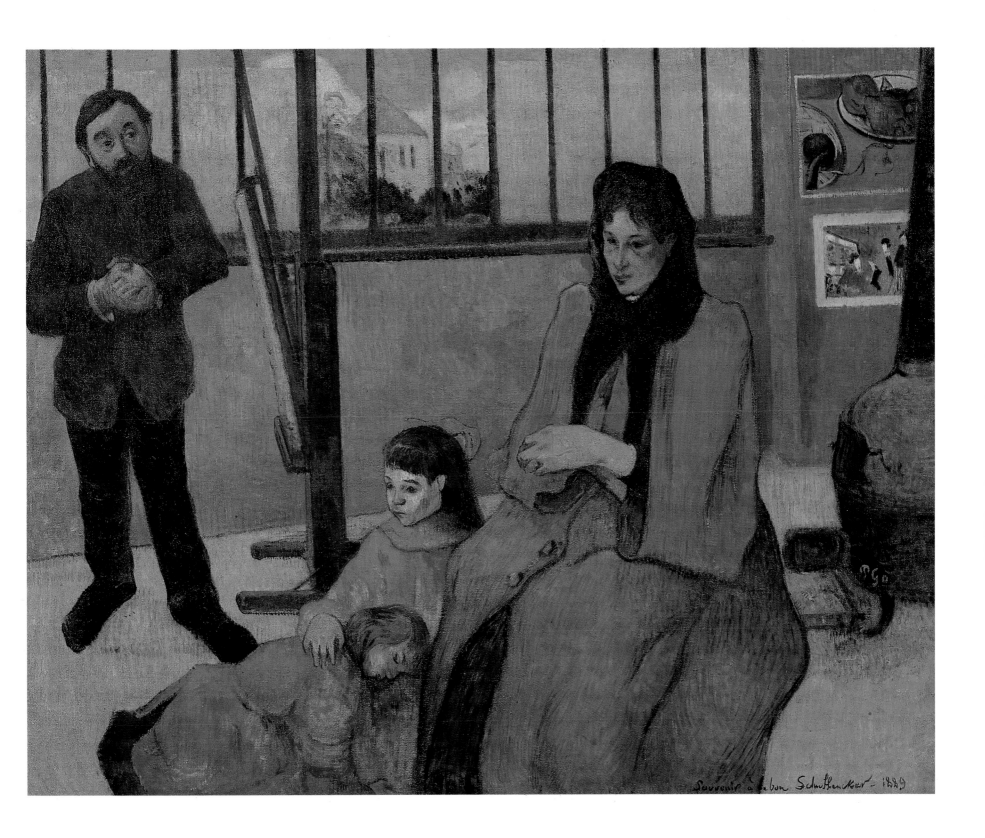

Gauguin was a highly accomplished painter of still-lives, whose repertoire of subjects ranged from vegetables and loaves, to flower and fruit studies, and exotic arrangements that also included ceramics and prints. He used the genre boldly as a touchstone for the development of different styles and techniques, so that his still lives, particularly those of the late 1880s, show a marked range of treatments. Only once did he choose to paint meat, and in this canvas the economy of colour, line and form creates a direct graphic appeal that owes little to the legacy of Impressionism, but has more in common with Japanese prints or the poster designs of the day.

For the 'untrained' artist the still life, a traditional and accepted subject, offered an important window for the display of technical virtuosity. In this painting Gauguin skilfully manages to represent the object in terms of three-dimensional space, whilst maintaining the coherence of the two-dimensional painted surface purely as a configuration of lines, colours and shapes. He makes much of the monumentality of the ham – its bulky form thickly banded in fat, and taking up the entire plate – but this heaviness is contradicted by the strongly patterned effect of the canvas as a whole, and the decorative aspect of the stripes on the meat.

In the later Tahitian canvases (in which still-life elements form a constant *leitmotif*), Gauguin suffused his subjects in a warm tropical light peculiarly his own. These rich harmonies tend to be based upon a predominantly red colour key, in which various hues sharing the same primary are used boldly together. In this work Gauguin begins to explore the power of colour 'clashes', enjoying the rawness of red, pink, orange and yellow pitted against each other.

Still-Life with Ham

Painted 1889
50 × 58cm
The Phillips Collection, Washington, DC

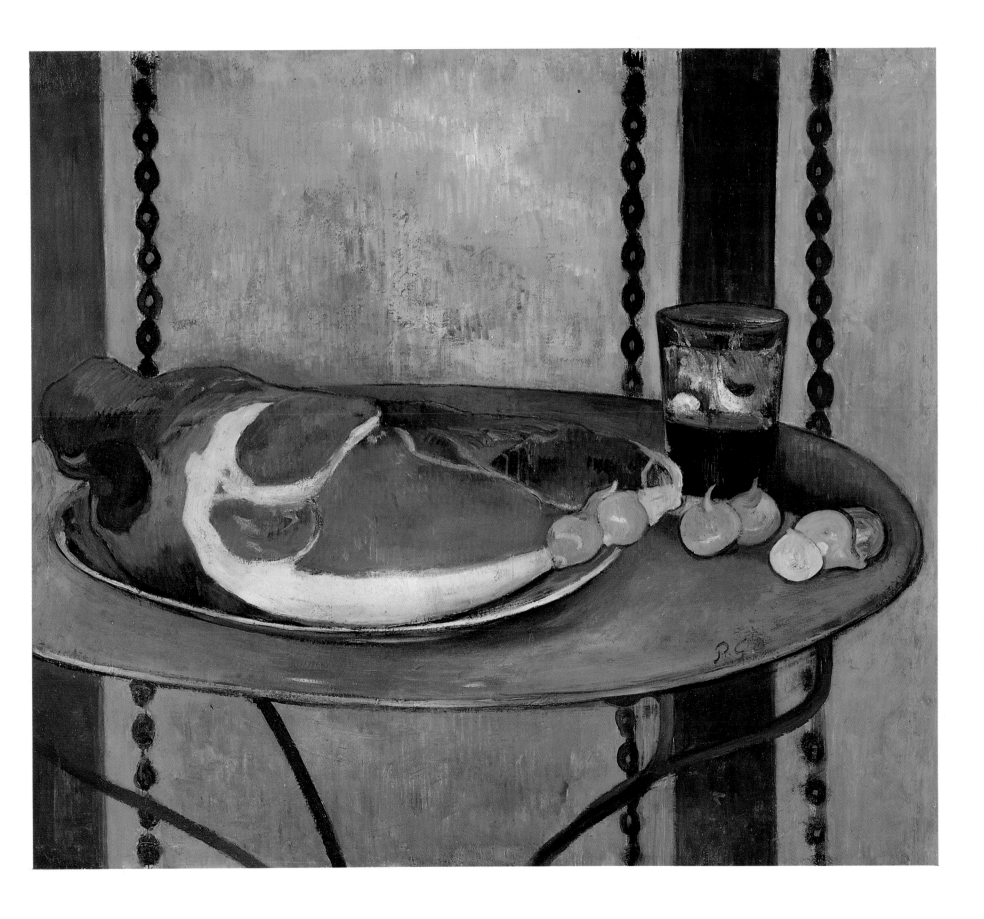

This canvas has a bold, graphic simplicity that anticipates the abstractions of the artist's later Tahitian works. Inspired by the clarity of Japanese prints, Gauguin here achieves an extraordinary economy of form and content, uncompromised by narrative elements, relying primarily on the strength of the compositional structure and the emotive force of the colour contrasts for the painting's communication.

The title *Ondine* would seem to offer some clue as to the painting's subject matter, since Gauguin is known to have been interested in the character of the *femme fatale* from La Motte-Fouqué who enticed men to their deaths, but one must be cautious of this interpretation, as the allusion may have been the invention of the auctioneer at the sale held in 1891.

The canvas was probably painted as a pendant to *Life and Death*, since both are of similar dimensions, include elemental figures of primitive naked women and have semi-abstract backgrounds. It is possible that the woman with red hair, who appears in both paintings (and takes various forms in other works), derives from a fusion between Degas's nudes and one particular photograph by O.G. Rejlander which would undoubtedly have been seen by the artists' circle at Pont-Aven.

Ondine (Woman in the Waves)
Painted 1890
92 × 72cm
Cleveland Museum of Art, Ohio

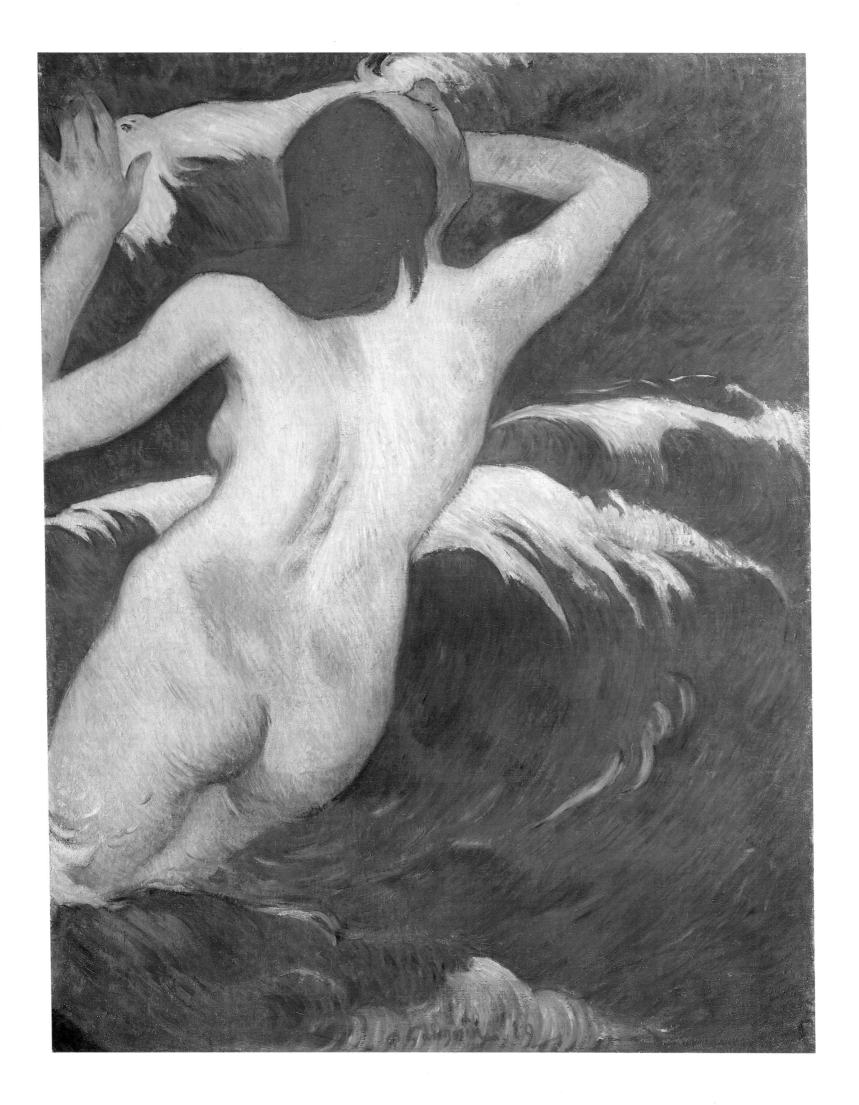

This highly decorative portrait is of one of the beauties of Pont-Aven, Marie-Angélique Satre, wife of the mayor of the town. Gauguin had repeatedly told M. Satre that he intended to paint his wife and duly set to work on what was stylistically to be his most ambitious portrait to date. Mme Satre, perplexed at not being allowed to see the painting as it progressed, became increasingly intrigued by the comments circulating about the town, so that when Gauguin arrived bearing his gift in its finished state she could hardly contain her curiosity. On seeing the painting, however, she was both disappointed and affronted:

My mother had told me, 'It seems some painters got into a fight last night, and all over your portrait. Look at the trouble you have caused!' . . . When he showed it to me, I said 'Quelle horreur!' and told him that he could take it straight back home, I didn't want that thing in my house. Imagine! At that time, and in a little place like this!

Her exclamations suggest that, in her view, such obvious flouting of artistic convention was an indecency. It is difficult now to imagine the shock value of Gauguin's simplifications, but the rejection of Gauguin's portraits throughout his career testifies to the prevailing conservatism of the majority of his European sitters. Only in the most avant-garde circles was this sort of extreme experimentation acceptable, and Theo van Gogh, to whom the painting was subsequently sent, was one of the few to appreciate its courageousness:

It's a portrait, arranged on the canvas like those big heads in Japanese crépons; the likeness, as a bust, is set directly against the background . . . The expression of the face and the attitude are very well chosen. The woman looks a bit like a heifer, but there is something so fresh and (once again) so country, that it is very delightful to look upon.

La Belle Angèle, Portrait of Madame Satre
Painted 1889
92 × 73cm, Musée d'Orsay, Paris

The unusual placing of the subject, superimposing it as a vignette on a decorative background, may have been a direct result of Gauguin's having seen Japanese *crépons* and prints, in which figures appeared boldly circumscribed by firm, curved outlines; it might also, however, have been prompted by popular book illustrations, in which similar decorative devices were common.

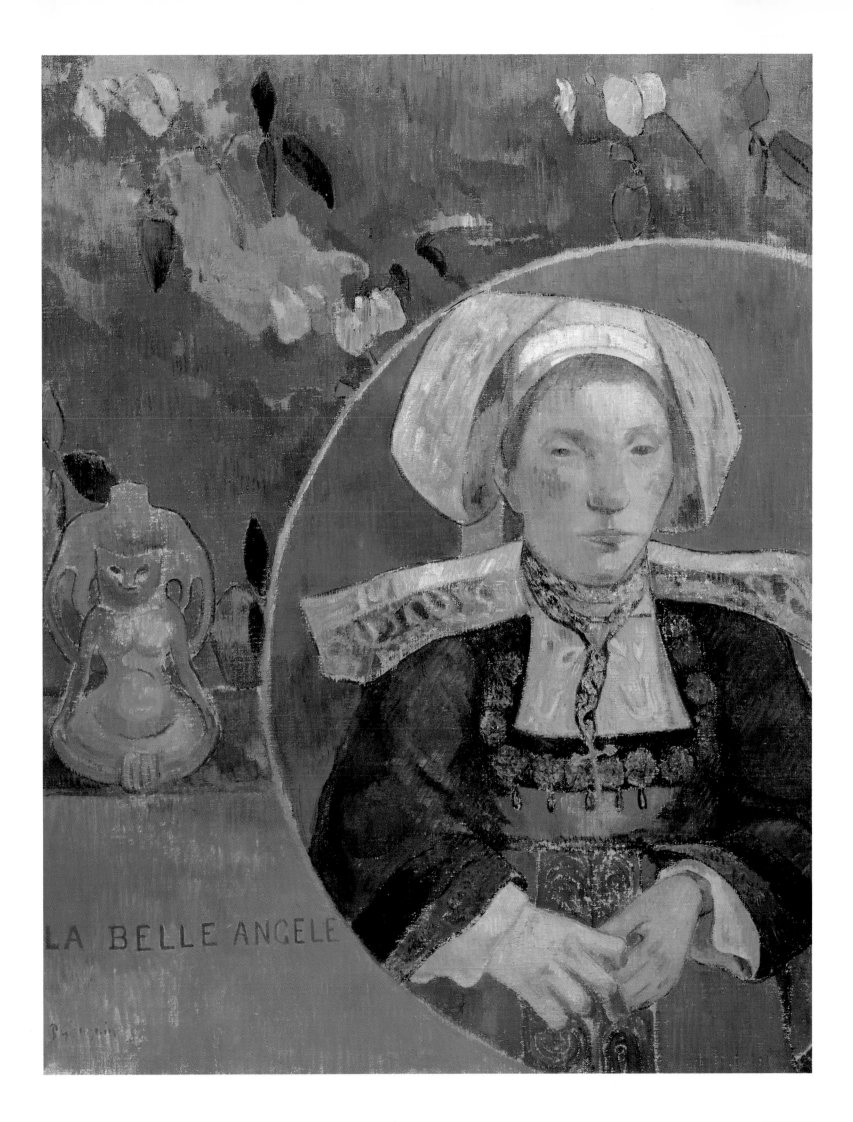

This work bears an obvious relation to *Vision after the Sermon . . .* (page 61), in that it shows Breton women in a state of focused religious contemplation. But whereas the *Vision* is provoked by their ecstatic imaginings, the Christ of this canvas seems rather to give rise to their state, towering over them as a protective canopy. The figure is copied quite closely from a small seventeenth-century carving in the chapel of Trémalo, near Pont-Aven, but is enlarged to life-size by Gauguin, introducing doubt as to whether it is intended to represent the real flesh-and-blood Christ or a wooden crucifix; a question that is in a sense irrelevant, since the painting's communication is of a more symbolic nature.

Both the conscious primitivism of the style and the pervasive yellow hues suggest that Gauguin was looking to thirteenth- and fourteenth-century Italian 'gold-ground' altarpieces by such masters as Giotto, Duccio and Cimabue. In their paintings he would have observed a symbolic disproportion, whereby Christ or the Madonna dwarf the surrounding figures of angels and apostles, as here the crucifix dwarfs the crouching Breton women. The poignancy of this painting is to a large extent achieved by the fusion of these art-historical associations with the local Breton scenery; the background landscape being recognizable as the hill of Sainte-Marguerite.

Few references exist in Gauguin's letters or other documentation relating to this image or to its 'companion' canvas, *The Green Christ* (see page 23), but it is known that by 1891 the picture was in the possession of Émile Schuffenecker and was reviewed in that year by Octave Mirbeau, who described it as, 'An unsettling and savoury mixture of barbaric splendour, Catholic liturgy, Hindu meditation, Gothic imagery, and obscure and subtle symbolism'.

The work served as a model for younger followers, particularly Maurice Denis, who recalled that 'the syntheses of the Japanese decorators were not enough to satisfy our demand for simplification', and that they had looked to a similarly eclectic range of

The Yellow Christ

Painted 1889
92 × 73cm
Albright-Knox Art Gallery, Buffalo, New York

sources: 'Primitive or oriental idols, Breton calvaries, *images d'Épinal*, figures from tapestry and stained glass'.

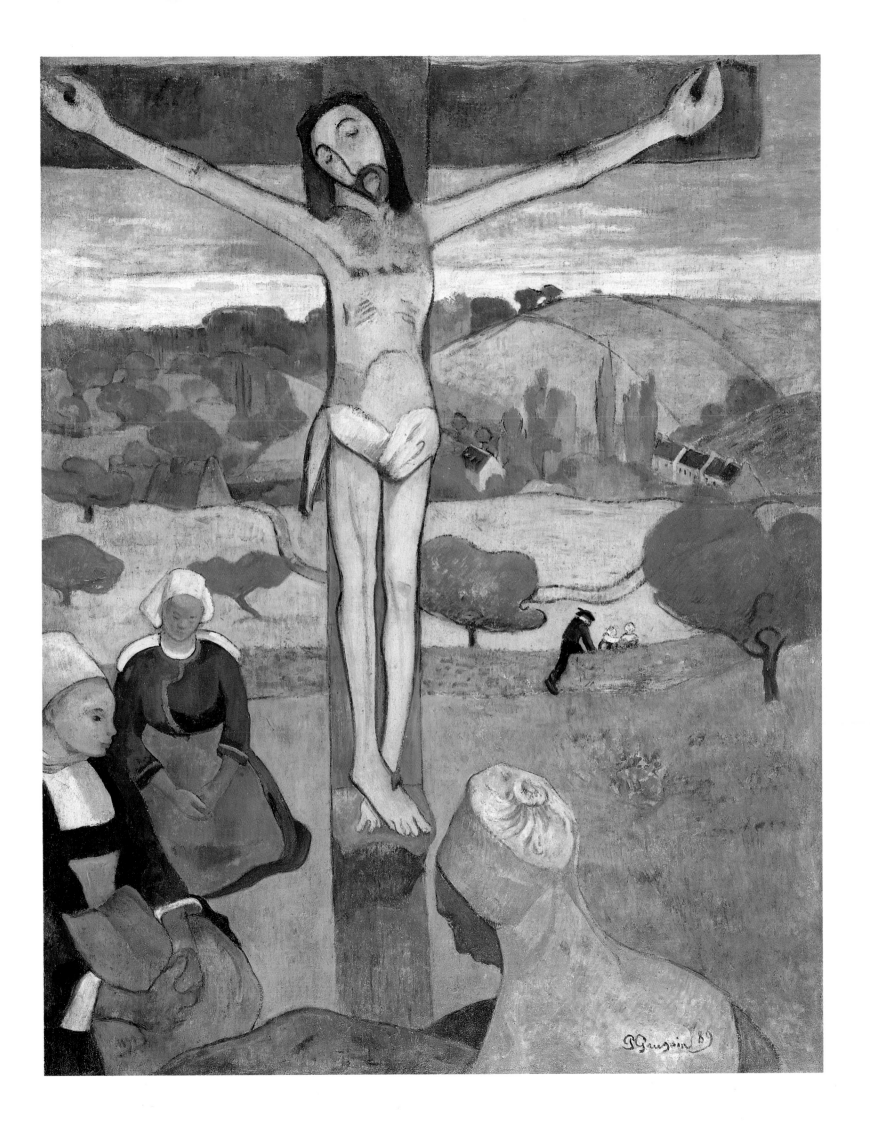

This is one of four canvases of 1889 for which Christ was the subject matter, but the only one in which Gauguin explicitly cast himself in the role. In *Self-Portrait. 'Les Misérables'* (page 65), painted the previous year, he had assumed the part of Jean Valjean, the anti-hero of Hugo's novel, thereby associating the plight of the ex-convict with his own struggles as an 'outcast' painter; but in representing himself as the betrayed Christ he took this theme of martyrdom to its logical, if blasphemous conclusion, fully realizing that by so doing he would alienate potential buyers, and even the dealers who had been most sympathetic to his work. He did hope, however, for an open-minded reaction from his fellow painters and wrote to van Gogh:

I have something I have not sent [to Theo van Gogh] and which would suit you, I believe. It is Christ in the Garden of Olives. Blue sky, green twilight, trees all bent over in a purple mass, violet earth and Christ wrapped in dark ochre vermilion hair. This canvas is fated to be misunderstood, so I shall keep it for a long time.

He here chooses to describe the painting purely in terms of its colour, probably anticipating quite correctly that van Gogh would find its pretext hard to accept. To the critic Jules Huret, however, he was far less guarded, revealing his true delight in the literary quality of the work:

There I have painted my own portrait ... But it also represents the crushing of an ideal, and a pain that is both divine and human. Jesus is totally abandoned; his disciples are leaving him, in a setting as sad as his soul.

Émile Bernard also chose this theme for a canvas in the same year, and Gauguin was perplexed to recognize his own features in those of Bernard's Judas.

Christ in the Garden of Olives or (Agony in the Garden)

Painted 1889
73 × 92cm
Norton Gallery of Art, West Palm Beach, Florida

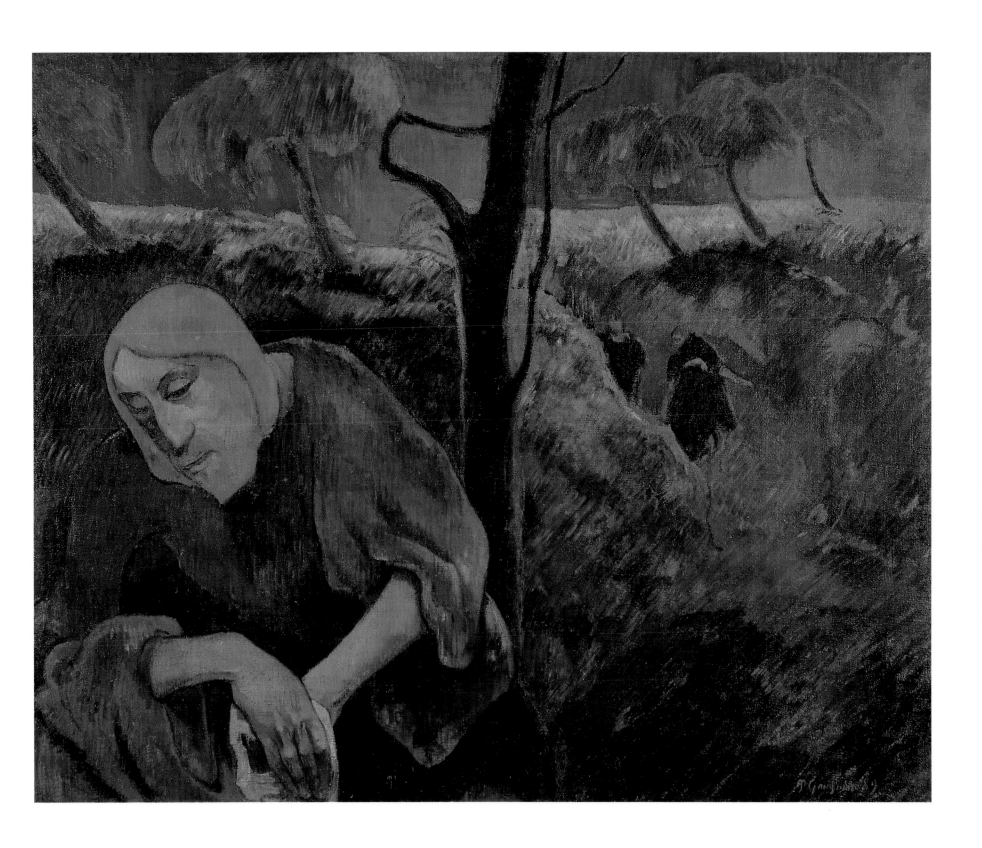

In his makeshift studio at Le Pouldu Gauguin created what he considered to be his most accomplished carving. The title echoes the sentiment of a letter the artist had recently written to his wife, demanding that his affection for her should be reciprocated, 'I am to be loved if I love', and it is probable that this work, in which a distorted self-portrait may be seen in the top right-hand corner, was prompted by his overwhelming sense of alienation from the family with whom he had not been in contact for over six months. His written explanation to Vincent van Gogh, however, indicates that the subject matter is as much literary as literal. In a letter of November 1889 he wrote: 'I am searching for and at the same time expressing a general state of mind rather than a unique thought', and in answer to his friend's worry that few understood the carvings, described what he insisted was the simple narrative:

At the top, the rotting city of Babylon. At the bottom, as though through a window, a view of fields, nature, with its flowers. Simple woman, whom a demon takes by the hand, who struggles despite the good advice of the tempting description. A fox (symbol of perversity among Indians). Several figures in this entourage who express the opposite of this advice ('you will be happy'), to suggest that it is fallacious. For those who want literature, there it is, but it is not for examination.

Avoiding discussion either of sources or symbols, the respected critic and champion of the artist, G. Albert Aurier, described this work as one 'in which all lechery, all the struggles of the mind and flesh and all the pain of sensual delight seem to writhe and gnash their teeth'. Given the heavy irony of the title, the brusque handling of the chisel, the bold caricature of the figures, and the bizarre combination of forms, it is hardly surprising that the sale of this work to the French government (of which Gauguin had boasted) was never realized. This lack of official recognition did not, however, alter Gauguin's estimation of the

Soyez amoureuses et vous serez heureuses (Be in Love and You Will be Happy)
Carved 1889
119.7 × 96.8cm
Museum of Fine Arts, Boston

value of his carvings. In 1891, when the artist did not expect payment of more than 600 fr. for the most important of his paintings, *Soyez amoureuses . . .* and its pendant *Soyez mystérieuses . . .* carried a price tag of no less than 1,500 fr. each.

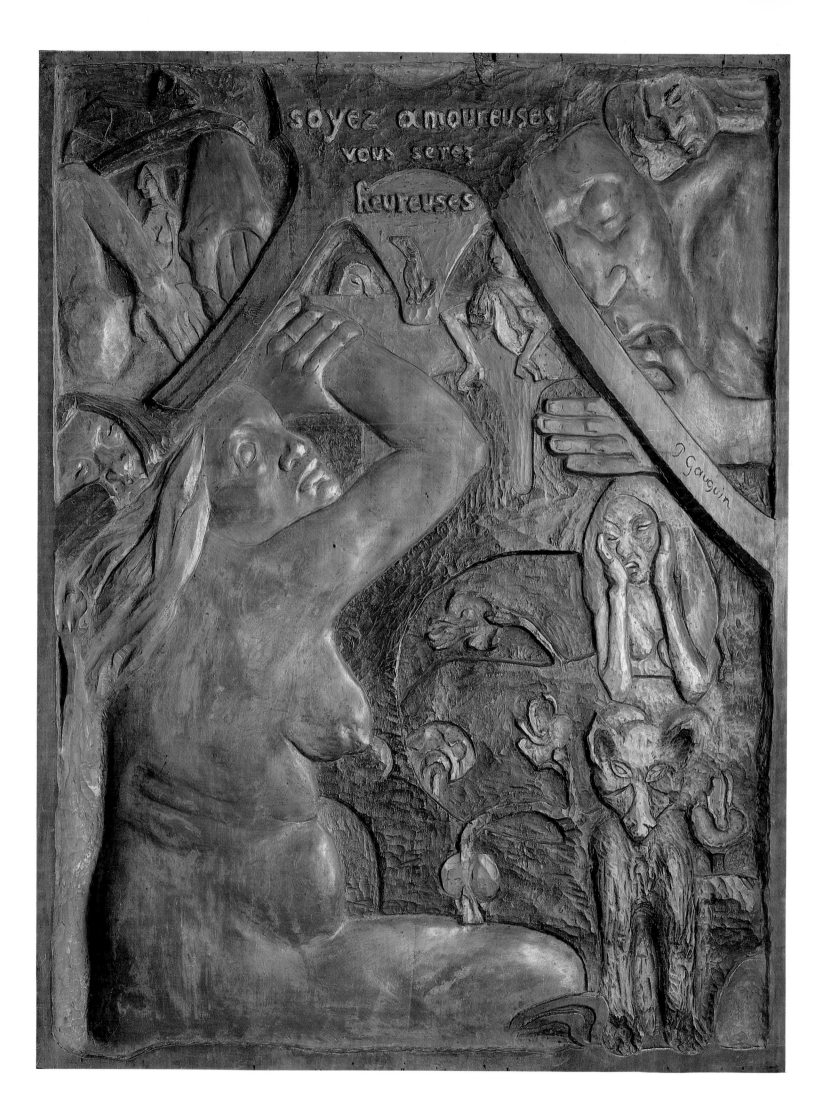

This unusual canvas was painted as a retort to Courbet's *Bonjour Monsieur Courbet* (1854), which Gauguin would undoubtedly have seen when visiting the Musée Fabre in Montpellier. But whereas Courbet had painted a lively, staged encounter between himself and recognizable contemporary figures, Gauguin chose to use the same device far more enigmatically, depicting his meeting with an unknown Breton woman in a stormy landscape.

The style of the painting is naturalistic in so far as the forms of the figures are not significantly distorted, nor is conventional perspective manipulated for dramatic effect. The composition does not ask to be read for specific symbolic meanings, but rather invites the viewer's speculation; Where are they? Who is the woman? Why have they met? Why is she awkwardly twisting round to look at him?

Though his writings provide few clues in answer to these questions, it is known that Gauguin was extremely pleased with the work, painted a further version and was keen to include the canvas among the Tahitian subjects in his Paris exhibition of 1893.

Not unaccustomed to assuming roles for the purposes of self-portraiture, Gauguin's tendency during the late 1880s was to characterize himself as an outcast and in this work, possibly even as the wandering Jew. Certainly the part of the pilgrim was one for which he was to become uniquely well qualified through the travels of the ensuing years.

Bonjour Monsieur Gauguin

Painted 1889
113 × 92cm
Národni Galeri, Prague

This canvas is the second of two extraordinary portraits that Gauguin painted of his friend and pupil within a year of the two men first meeting in Paris. Meyer de Haan's history was similar to Gauguin's own, in that he too gave up the prosperous world of business (as the owner of a firm of biscuit manufacturers) in order to become an artist. This was possibly the reason for Pissarro's suggesting that they should be introduced, and a contributory factor to the instant friendship struck up between them. Together they rented a studio in Le Pouldu, where they got on extremely well, despite Gauguin's open jealousy of the Dutchman's affair with Marie Henry, owner of an inn in the town.

The first portrait of de Haan formed a pair with Gauguin's *Self-Portrait with Halo* (1889), both conceived as part of the decorative scheme executed by the two artists for the dining-room of the inn. The canvases were caricatural, but nevertheless introduced potent imagery, Gauguin depicting himself with halo, apple and serpent, and de Haan in contemplation of *Sartor Resartus* and *Paradise Lost*, (an allusion to the artist's erudition and preference for works of a metaphysical nature). The self-conscious symbolism of these paintings was extended to this second portrait, in which the artist's meaning becomes even more abstruse and the physiognomy of the sitter further distorted. Here Meyer de Haan's face becomes a primitive mask, a threatening, satanic image, which was to reappear in a number of Gauguin's later works.

Gauguin's tendency to resurrect elements from earlier canvases in later ones (page 95) is well illustrated here by the composite imagery of de Haan before two female figures; one derived from *Life and Death*, 1889, and the second from its pendant *Ondine (Woman in the Waves)* (page 81). The quotation from these paintings establishes a complex and obscure symbolism, hinted at by the provocative title of the work.

Nirvana. Portrait of Meyer de Haan

Painted 1889

20 × 29cm

Wadsworth Athenaeum, Hartford, Connecticut

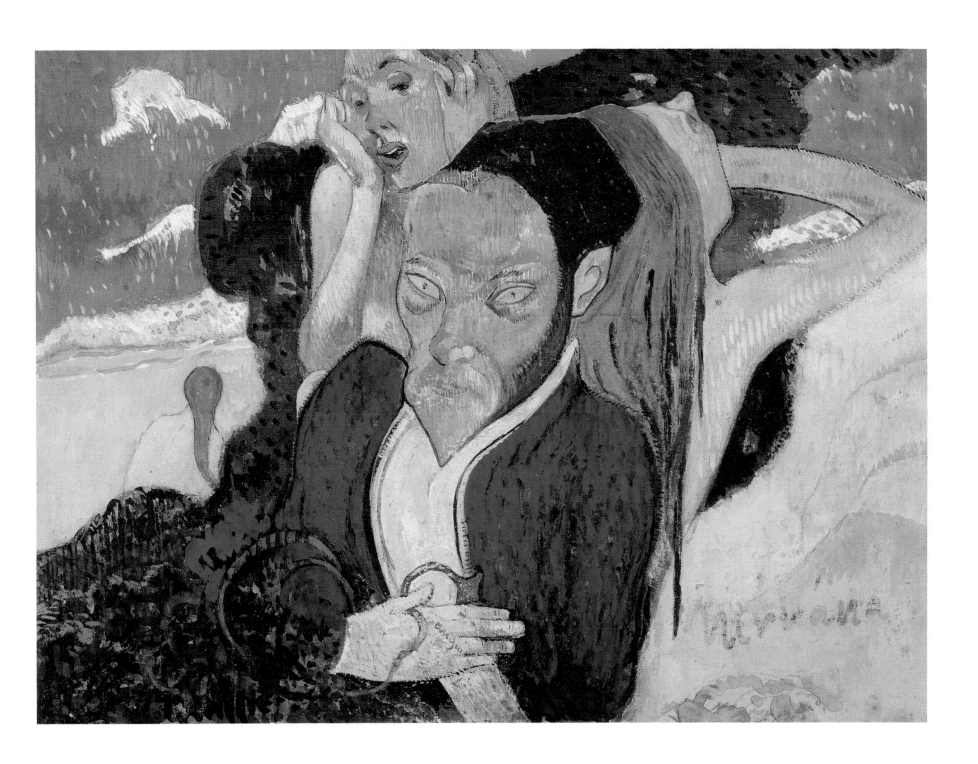

Gauguin frequently depicted paintings, prints and sculptures in his canvases, both by other artists and by himself, and it is unsurprising therefore to find his own recent work used as the backdrop to this self-portrait. In the seventeenth century it became common for the sitter to be seen surrounded by the attributes of his trade; the explorer by his globe, the soldier by his arms, the artist by his brushes and paints. Here Gauguin extends and adapts this conceit, integrating himself with his own paintings.

The two quite different works behind the artist, *The Yellow Christ* (page 83) and the ceramic tobacco jar, may be seen to offer an 'objective correlative' or analogue for Gauguin's state of mind. That there are two works, however, complicates the viewer's reading of the picture, offering two sets of conflicting connotations. The artist had already demonstrated a readiness to identify himself with the figure of Christ, an interpretation that is certainly prompted by this canvas, but at the same time contradicted by the echoing of his features and even of his pose in the contorted tobacco jar.

The contrast between the two works – one religious, the other secular; one serene, the other grotesque; one flat and schematic, the other fully modelled and irregular – confounds any attempt to deduce a simple meaning from the canvas, and the triangular structure of the composition draws the eye in an appropriately restless cycle from the yellow of the Christ, to the blue of the artist, to the rich red of the jar.

Gauguin was never shy of self-promotion, and on one level this canvas may be seen as a clever ploy. It is known that he was particularly pleased with both of the works illustrated, and the painting affords the viewer a sort of mini exhibition.

Self-Portrait with Yellow Christ
Painted 1889–90
38 × 46cm
Private collection

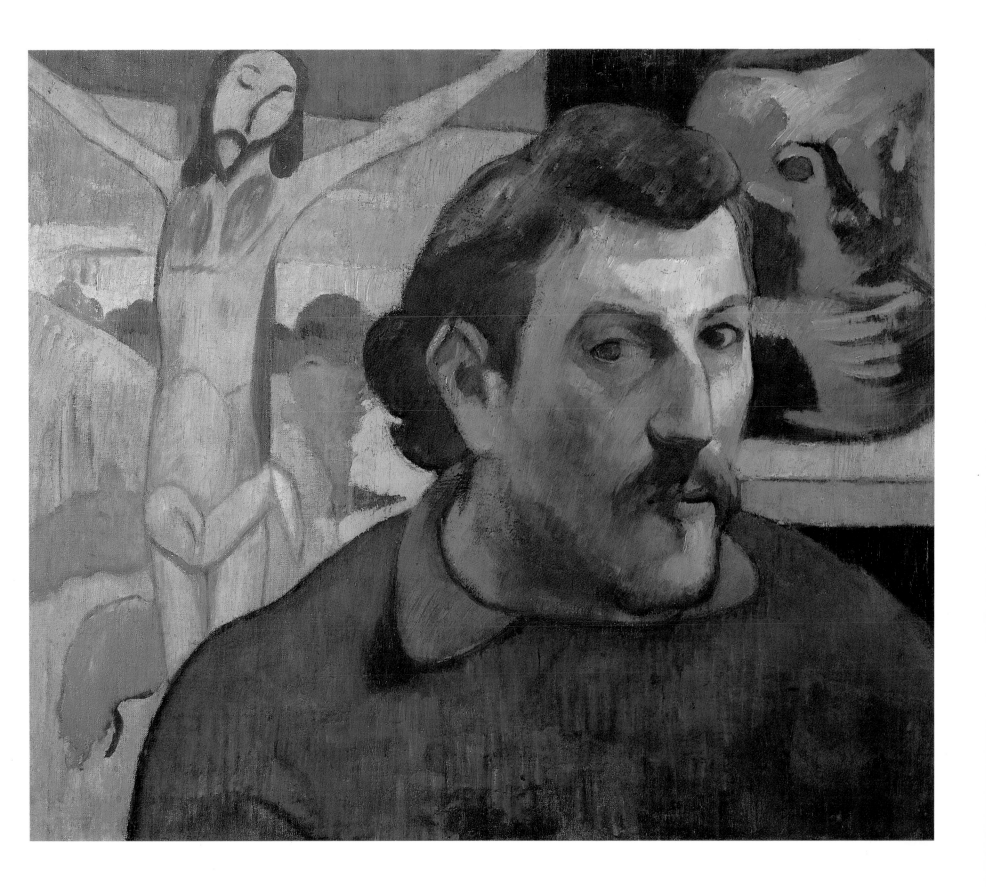

Whilst still a stockbroker in Paris Gauguin was an avid collector of Impressionist art, buying work from painters who were to become the great masters of the period: Manet, Renoir, Monet, Sisley, Cézanne, Guillaumin, Jongkind and Pissarro. At one point the artist was in possession of half a dozen canvases by Cézanne, of which his favourite was the still life that may be seen in the background here, *Fruit Bowl, Glass and Apples*, dating from between 1885 and 1887. By the late '80s Cézanne was already a venerated artist among avant-garde circles in Paris, and Gauguin was filled with a proselytizing zeal to further the appreciation of his work among younger painters.

No records exist to indicate when the two artists first met, but it is certain that Cézanne was acquainted with his 'disciple', but held him in little regard. Despite the fact that Cézanne made openly disparaging remarks about Gauguin's work following the 1882 Impressionist exhibition, Gauguin continued to be influenced by his example (pages 75 and 79), and held on to the little still-life long after the rest of his collection had been sold off.

The artist Sérusier recorded that when undertaking a still-life Gauguin would frequently cry 'Let's do a Cézanne', an intention carried out quite literally in both the matter and the manner of this canvas, for both the woman and the painting behind her derive directly from known works. The placing of the still-life in the composition introduces equivocation as to whether it is intended to be perceived as painted or real. A similar 'double take' is induced by the figure, who, though differing in detail from *Mme Cézanne* (painted 1881–82), nevertheless recalls her pose, expression and monumental presence.

Since Gauguin makes no effort to disguise the extent of his borrowings, but rather chooses to contrive a highly 'literary' pastiche of Cézanne's work, he removes all grounds for the accusation of plagiarism. In this canvas imitation is the sincerest form of homage.

Portrait of a Woman with Still-Life by Cézanne
Painted c.1890
65.3 × 54.9cm
The Art Institute of Chicago, Illinois

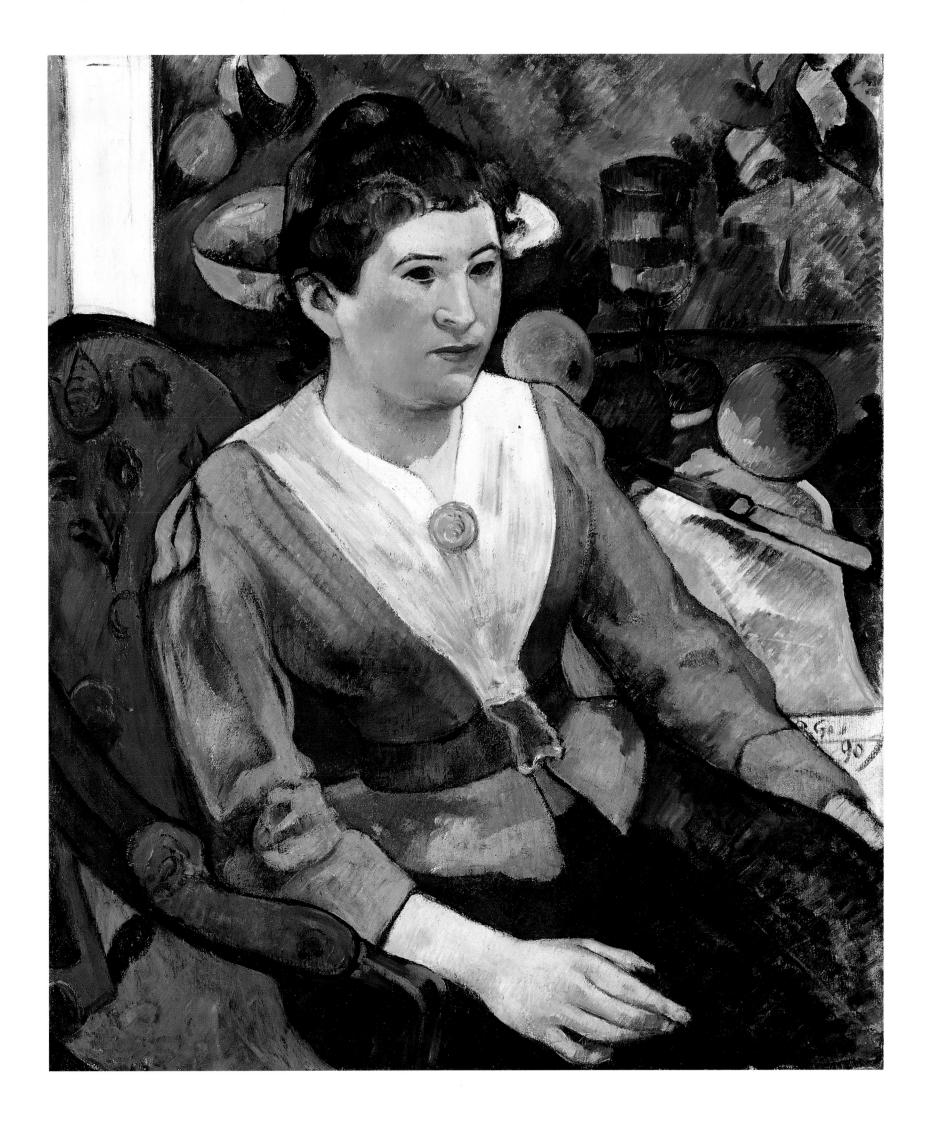

In 1888 Émile Bernard painted his sister Madeleine lying fully clothed, but flatly horizontal against the local Brittany scenery. In reproducing the pose almost exactly in this canvas Gauguin made no attempt to disguise the debt to Bernard's work, but seems rather to have invited a comparison between the two paintings. In the light of this connection, and given that Gauguin is known to have been in love with Madeleine Bernard, a more personal interpretation of the title than the Synthetist style would necessarily invite might be appropriate. As Madeleine Bernard was engaged to Charles Laval, it is highly improbable that Gauguin was ever able to sleep with her, but by a painterly sleight-of-hand he here depicts his mistress, the 22-year-old seamstress Juliette Huet naked in the same pose. This subtext may account in part for the presence of the fox, identified in *Soyez amoureuses . . .* (page 89) as a symbol of perversity among Indians.

The Loss of Virginity
Painted late 1890–early 1891
90 × 130cm
The Chrysler Museum, Norfolk, Virginia

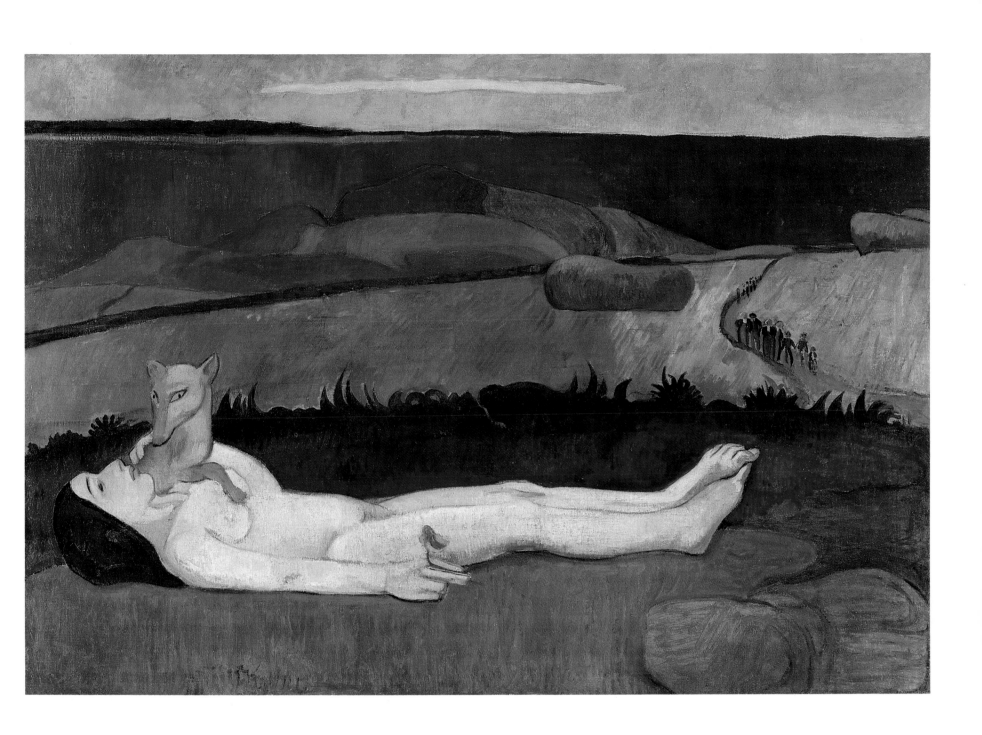

In this canvas, Gauguin's first Tahitian portrait, may be seen enduring characteristics of the artist's Breton work. The sitter is placed against broad patches of contrasting saturated hues that create an evocative but ambiguous environment, and Gauguin uses a tempered version of *cloisonniste* outlining of form.

It is possible, however, that the formality of the pose was partly due to the response of the sitter who, realizing that she was to be the subject of Gauguin's painting, changed out of her native *pareu* into her missionary dress, a demure smock usually worn only on Sundays. But the rigidity of her posture may also owe something to Cézanne's portraits of his wife, the style of which Gauguin had emulated closely in his *Portrait of a Woman with Still Life by Cézanne* (page 97).

A feature remarked upon by critics of the day was the plastic quality of the face, 'sculpted' into broad planes of light and dark and therefore prominent against the less modelled passages of the dress and background. There is a similarity here with *Self-Portrait. 'Les Misérables'* (page 65), where although the face reflects the colours that surround it, it is painted so as to stand out strikingly in high relief.

Vahine no te tiare (Woman with a Flower)
Painted 1891
70.5 × 46.5cm
Ny Carlsberg Glyptotek, Copenhagen

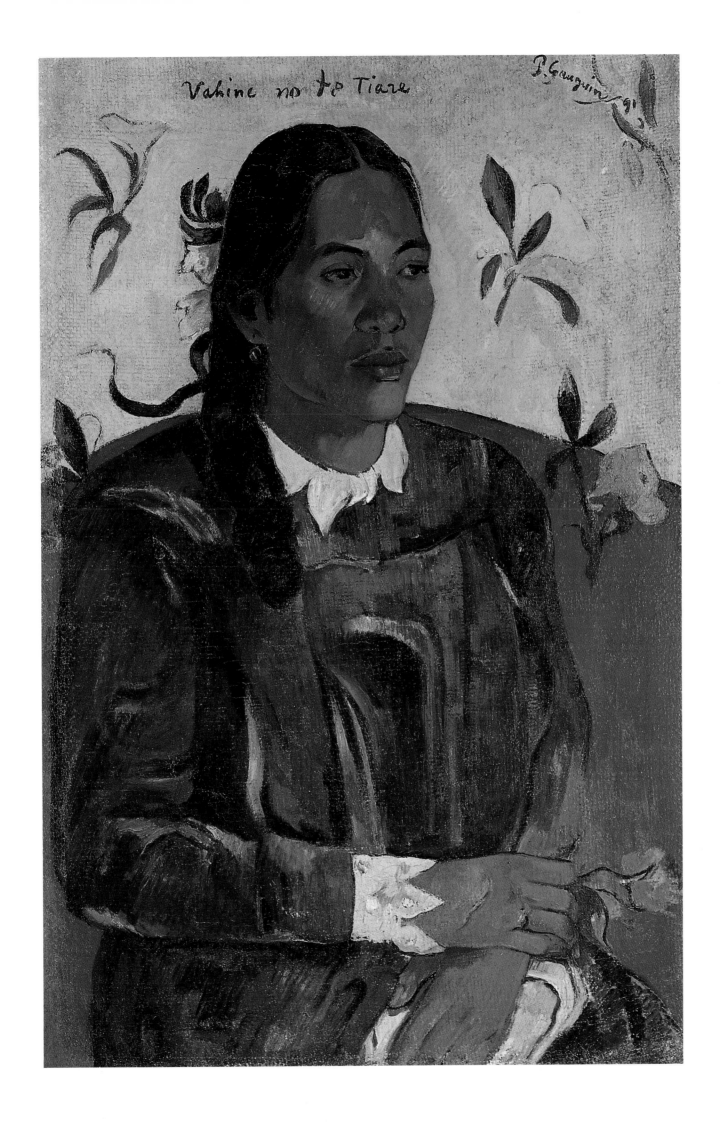

This intimate painting is a further example of Gauguin's interest in combining figure and still-life subjects in a single composition (pages 51 and 107). Despite his professed desire to become as 'savage' as the native Tahitians, the image here is a highly organized one, constructed in accordance with western European schemata, both in terms of its content, treatment and style.

The supper table, with all its biblical associations, forces the children to sit formally, conveniently aligned so as to face the spectator; the food is arranged for display rather than practicality, out of reach of the children and (like the uncooked red bananas) not yet prepared for consumption. The tablecloth too is a painterly conceit, probably constructed by the artist literally out of sheets of canvas, setting off the warm hues of the food and dishes and casting a dramatic reflected light up on to the children's faces. Although the canvas appears at first to be the result of direct observation, containing nothing fabulous or inexplicable, these conventionalizing tendencies, and the fact that Gauguin made preparatory studies of Tahitian children, point up the degree to which the artist was influenced by the work of Western masters, most notably Holbein, Rembrandt, Manet, Degas and Cézanne.

The Meal (or The Bananas)
Painted 1891
73 × 92cm
Musée d'Orsay, Paris

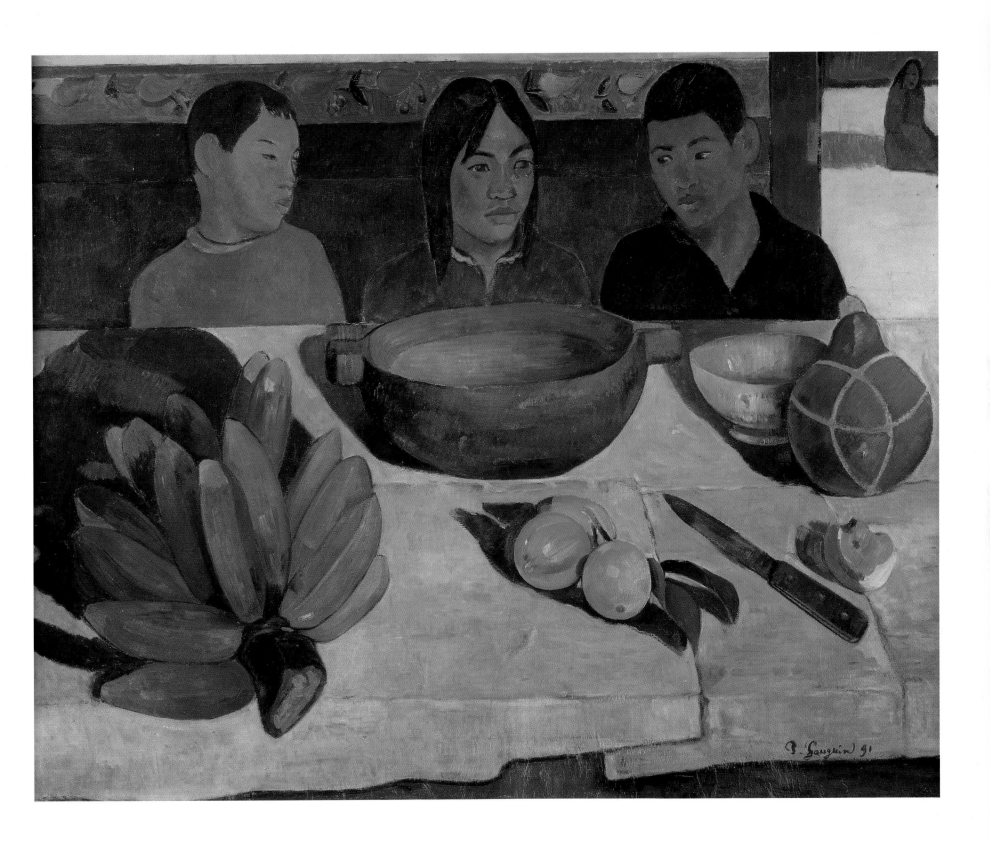

This canvas is the first of two versions of the pose – the second being entitled *Parau api (What News?)*, 1892. Gauguin's close reworking of the theme suggests that he was particularly pleased with the subject matter and composition of this painting and, moreover, with its remarkably quick sale in Tahiti.

Tahitian Women is an early example of what was to become a preoccupation throughout the 1890s; the tendency to focus upon the sculptural interrelation of (most frequently two) female figures, viewed in close up as an isolated group. In this painting the distinct curvilinear masses of the women's bodies contrast strongly with the flat horizontal banding of the near-abstract background, a counterpoint enhanced by the contrasting position of the figures themselves.

It is likely that the pose of the woman on the right derives from the central seated figure in Delacroix's *Women of Algiers*, 1834, and that Gauguin therefore invented a complementary posture for the figure on the left. The later version, however, shows adjustments to the right-hand figure, indicating the artist's subsequent desire to 'improve' upon his source, in order to create an even more successful interrelation between the two forms. In the interest of primitivism (and an increased area of exposed flesh), he also removed the pink missionary dress, replacing it with a startlingly striped *pareu*.

It is likely that Teha'amana, Gauguin's thirteen-year-old *vahine*, was the model for both figures in the composition; with her striking Tongan features and long curly hair, she was to become the subject of a number of Gauguin's most beautiful figure studies.

Two Women on a Beach (or Tahitian Women)

Painted 1891

69 × 91cm

Musée d'Orsay, Paris

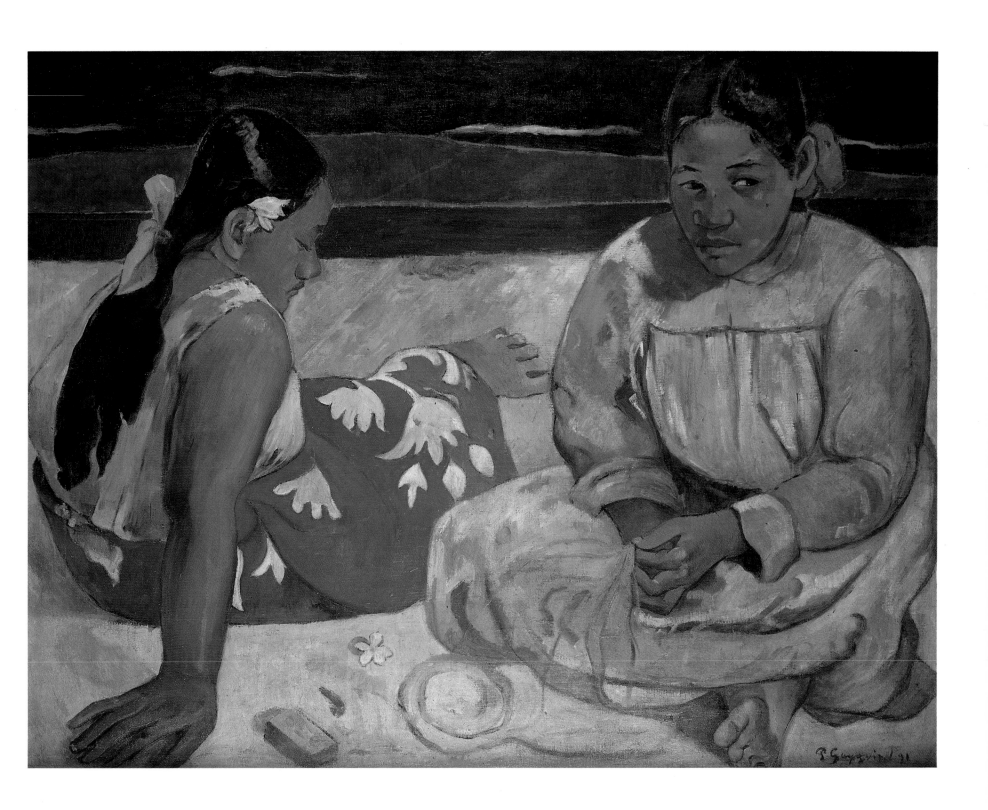

This ambitious canvas pivots upon the extraordinary fusion of Christian iconography with a Tahitian setting to create an exotic and highly unconventional paradise. In March 1892 Gauguin described the work in a letter to Monfried:

I have . . . done a painting. Size 50 canvas. An angel with yellow wings reveals Mary and Jesus, Tahitians just the same, to two Tahitian women – nudes dressed in pareus, *a sort of cotton cloth printed with flowers that can be draped as one likes from the waist. Very sombre mountainous background and flowering trees. Dark violet path and emerald green foreground, with bananas at the left. – I'm rather happy with it.*

It is notable that the artist avoids any discussion of the controversial nature of the imagery – non-Western depictions of religious figures were not sanctioned by the Pope until 1951 – and confines himself, in effect, to listing the components of the canvas. Having experienced the rejection by the church of *Vision after the Sermon . . .* (page 61), however, he cannot have been unaware of the possibility that the painting would provoke mixed responses from a Catholic audience.

The subject matter is further complicated by ambiguity as to whether the vision experienced by the Tahitian women is of the Annunciation or the Adoration of the Shepherds; neither story aligns exactly with what is painted. Gauguin was never dogmatic in his religious interpretations, and it is probable therefore, that he intentionally avoided restricting the picture's reference in order to widen its symbolic scope. He was also unafraid of drawing inspiration from the imagery of other religions, the figures of the two Tahitian women being based upon bas-relief friezes from a Javanese temple of Borobudur (also based on a photograph), indicating the extent of his syncretism.

Gauguin was exceptionally proud of this painting.

Ia Orana Maria (Hail Mary)
Painted 1891–92
113.7 × 87.7cm
The Metropolitan Museum of Art, New York

After it had been refused by the Luxembourg Museum, it soon found an important purchaser at a good price, and was hailed by most critics as a modern masterpiece. The artist subsequently coloured up a photograph of the work, as published in the *Figaro Illustré*, and inserted it into the manuscript of *Noa Noa*.

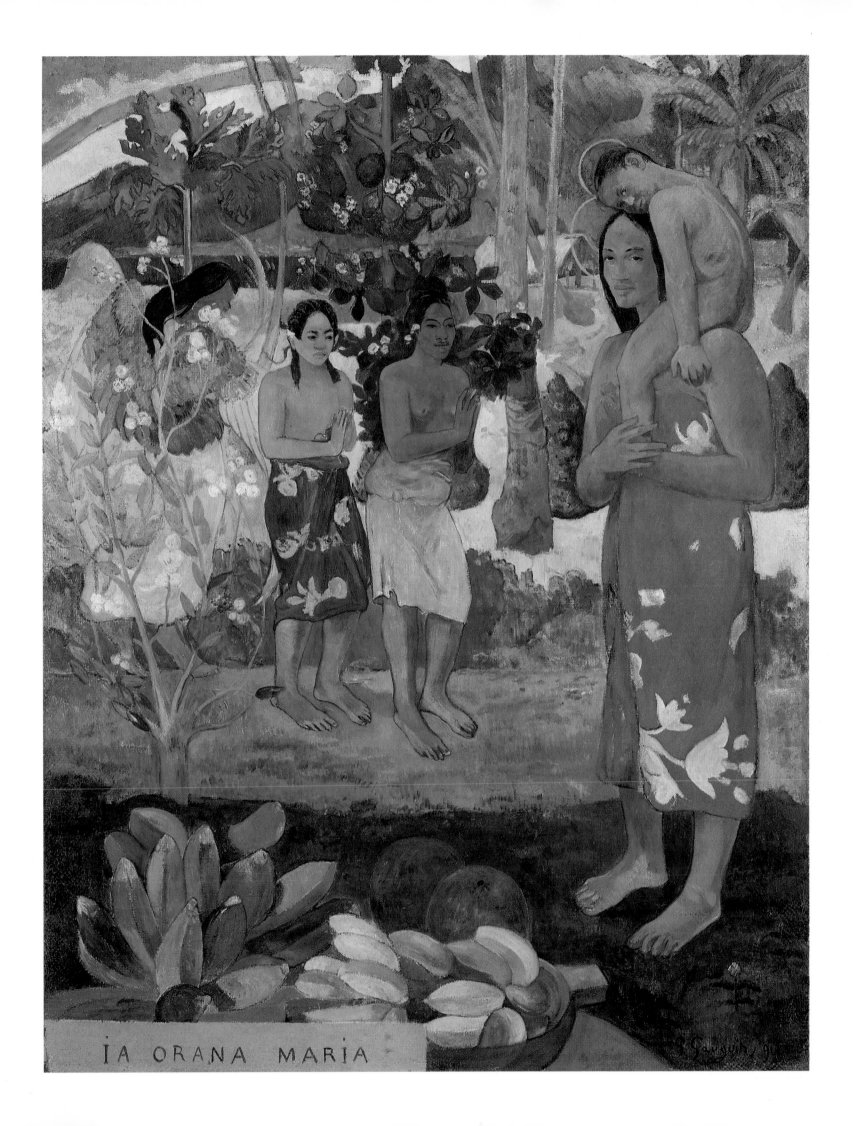

The importance that Gauguin placed upon this canvas is indicated by a lengthy evocation of the work in the draft manuscripts of *Noa Noa*, written in the winter of 1893–1894:

Near my hut there was another hut. Nearby a native canoe – while the diseased coconut palm looked like a huge parrot, with its golden tail drooping and a huge bunch of coconuts grasped in its claws. The nearby naked man was wielding in both hands a heavy axe that left, at the top of the stroke, its blue imprint on the silvery sky and, as it came down, its incision on the dead tree, which would instantly live once more in a moment of flames – age-old heat, treasured up each day. On the ground, purple with long, serpentine, copper-coloured leaves, a whole oriental vocabulary – letters (it seemed to me) of an unknown, mysterious language. I seemed to see the word of Oceanic origin: Atua, God. As Taata or Takata, it reached India and is found everywhere and in everything (Religion of Buddha): In the eyes of Tathagata, all the fullest magnificence of the kings and their ministers are merely like spittle and dust./In his eyes purity and impurity dance like the dance of the six nagas. In his eyes, the search for the way of the Buddha is like flowers set before a man's eyes./A woman was stowing nets in the native canoe, and the horizon of the blue sea was broken by the waves' crests against the coral breakers.

This perplexing narrative contrasts strongly with the perfunctory descriptions of his paintings – essentially lists of colour areas – that Gauguin would often include in his letters, and gives a far better idea of the extraordinary range of thoughts and impressions contributing to a single composition. In going beyond that which is visually apparent, his words suggest but do not circumscribe the painting's meanings; he does not need to say who the man is, when he has so eloquently described the spiritual context of his actions.

The possible sources for the imagery are as diverse as the elements of his description; the highly

Man with an Axe
Painted 1891
92 × 70cm
Private collection

androgynous figure of the woodcutter derives loosely from Buddhist Javanese reliefs, the slight *contrapposto* of his torso recalling classical sculpture; the woman's posture owes a debt to Degas's studies of women working and bathing; the boat in the background seems to inhabit an Impressionist scene and the composition as a whole is a variation on the compositional plan of Puvis de Chavannes's great Symbolist painting *The Poor Fisherman*, 1881.

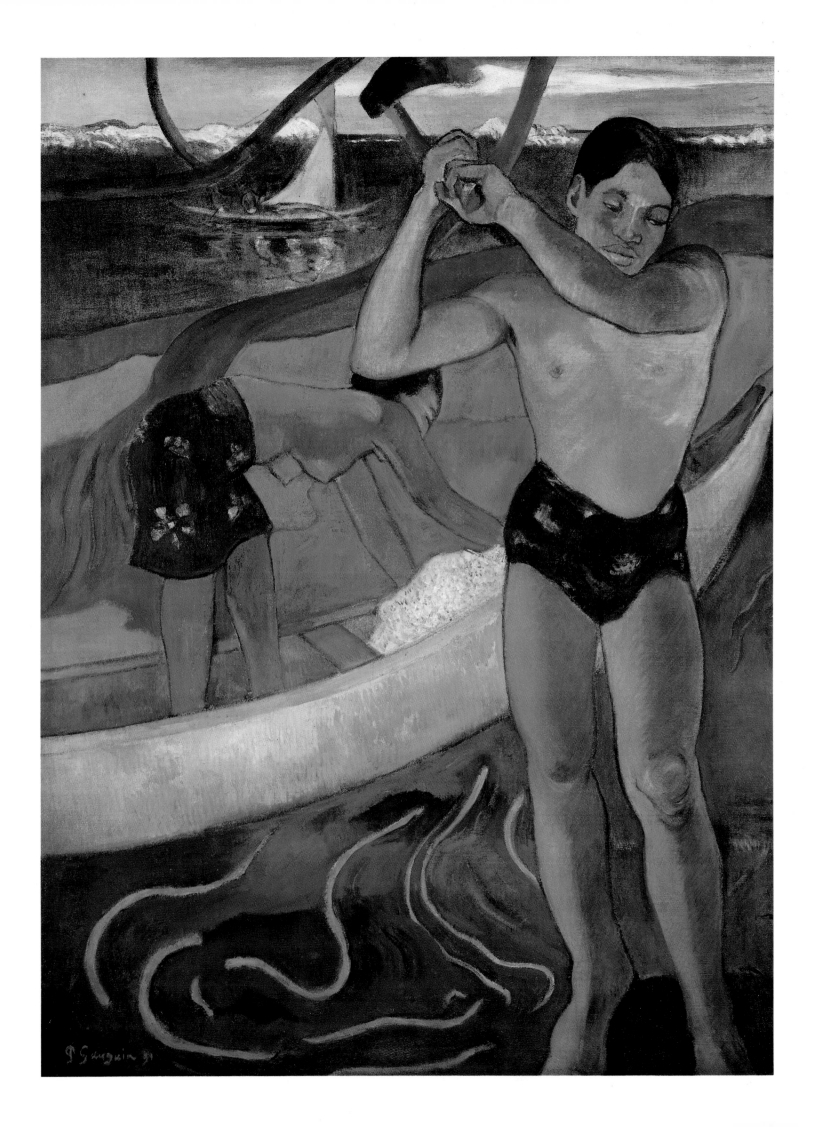

In developing his 'primitive' aesthetic, Gauguin looked beyond the established canon of fine art to the example of ancient eastern civilizations, advising: 'Have always before you the Persians, the Cambodians, and a little of the Egyptians.' In this canvas direct use is made of a specific Egyptian fresco from an Eighteenth-Dynasty Theban tomb, a postcard of which Gauguin had brought with him from France. Both the original image and Gauguin's painting exploit the inately decorative effect of figures ranged on a bench to produce a highly organized frieze. But instead of alleviating the formality of this arrangement by softening the outlines of the figures and introducing naturalistic expression, Gauguin chooses rather to emulate the hieratic style in the rigidity of the posture, the simplification of form and the schematization of gesture. Residual Western elements remain, such as the recession of the bench in three-dimensional space, but overall it is a clear attempt to invest his subject matter with the 'patina' of an ancient culture.

The canvas is generally thought to depict prostitutes awaiting their customers in the marketplace at Papeete. This reading is contradicted, however, by the fact that the women wear missionary smocks rather than *pareus*. Their poses bear some resemblance to a contemporary photograph of native women performing a mime, and a fan design, clearly based on this subject was given as a gift to Madeleine, daughter of August Goupil, an important potential buyer. These considerations give credence to the alternative translation of the title, *We Shall not go to Market Today*, with its suggestion that the women are being entreated to go (probably by the figure standing on the right who wears traditional dress). This interpretation also allows a significance to be read into the strikingly different hues of the dresses; those who have resisted in sober green, the central (vacillating) figure in a neutral colour and those tempted in bright, saturated

Ta Matete (The Market)
Painted 1892
73 × 91.5cm
Kunstmuseum, Basel

hues. Gauguin was never interested in painting moral exempla, but his fascination with the antithesis of good and evil, restraint and temptation, is apparent in works throughout his career.

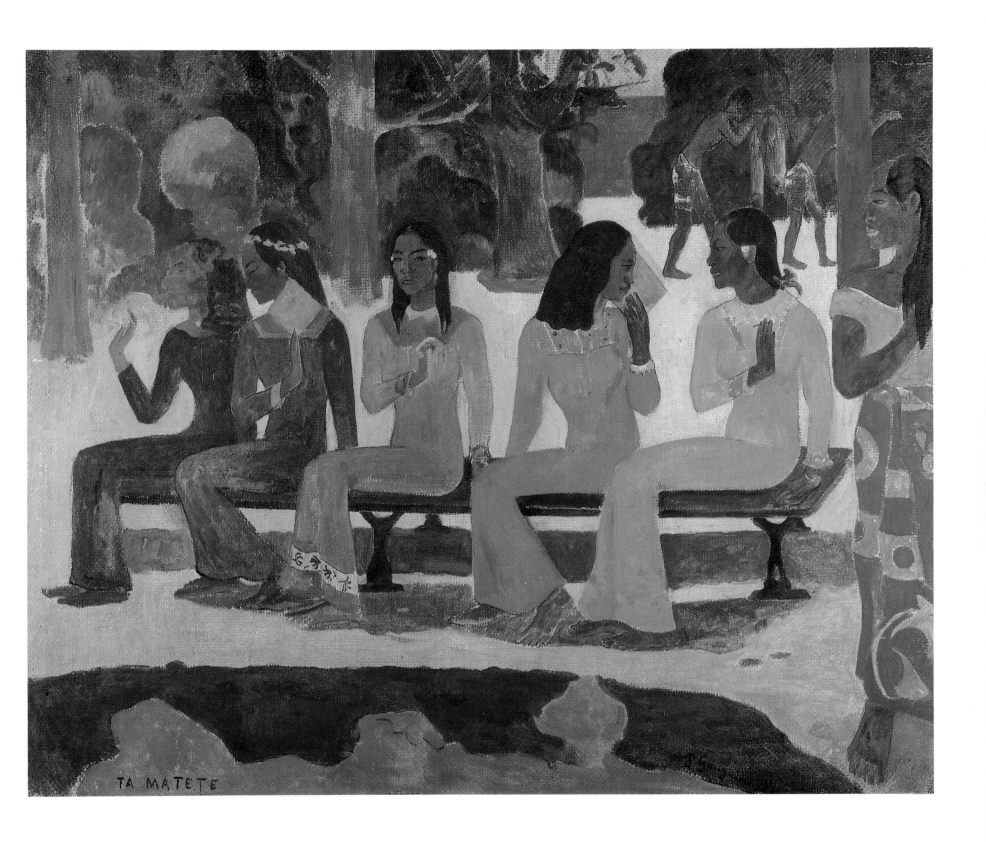

This canvas bears an obvious relation to *Aha oe feii?* (page 117), painted in the same year. Both focus on a figural group comprised of two young Tahitian women, share an emphasis on the decorative interrelation of colours and shapes and were given enigmatic but provocative titles by Gauguin. It would seem too that neither work was painted from life, but made up as a composite of initial sketches. A pastel and charcoal study of the crouching woman (a favourite pose) is considered to be among Gauguin's finest drawings, but of the two figures together there only remains a small sketch on the verso of preparatory work for *Aha oe feii?*

This canvas is distinguished, however, by the searing colour combinations centring around the red, pink and orange tones of the women's clothing. Gauguin was tantalized by the unorthodox colour juxtapositions in the patterns of the traditional *pareo*, and here uses the costume of the crouching figure to set the colour key of the painting, balancing these hot hues against cooler, but nevertheless rich bands of colour in the landscape.

A further distinguishing feature of this work, as opposed to *Aha oe feii*, is the contrast between the broad, flat areas of colour in the foreground and the looser, more modulated passages of the background scenery. This sense of distance has the effect of making the vibrant figures seem more prominent, centrally positioned in the canvas space and offered up for the viewer's appraisal. The women, huddled together and glancing obliquely across the canvas, seem threatened and nervous, a response perhaps provoked in some way by the question *When will you marry?*, although it is in no way clear who is asking whom, or what specific relevance the question has to the painting's meaning as a whole.

Nafea faa ipoipo?
(When will you marry?)

Painted 1892
105 × 77.5cm
Rudolf Staechelin Collection, Basel

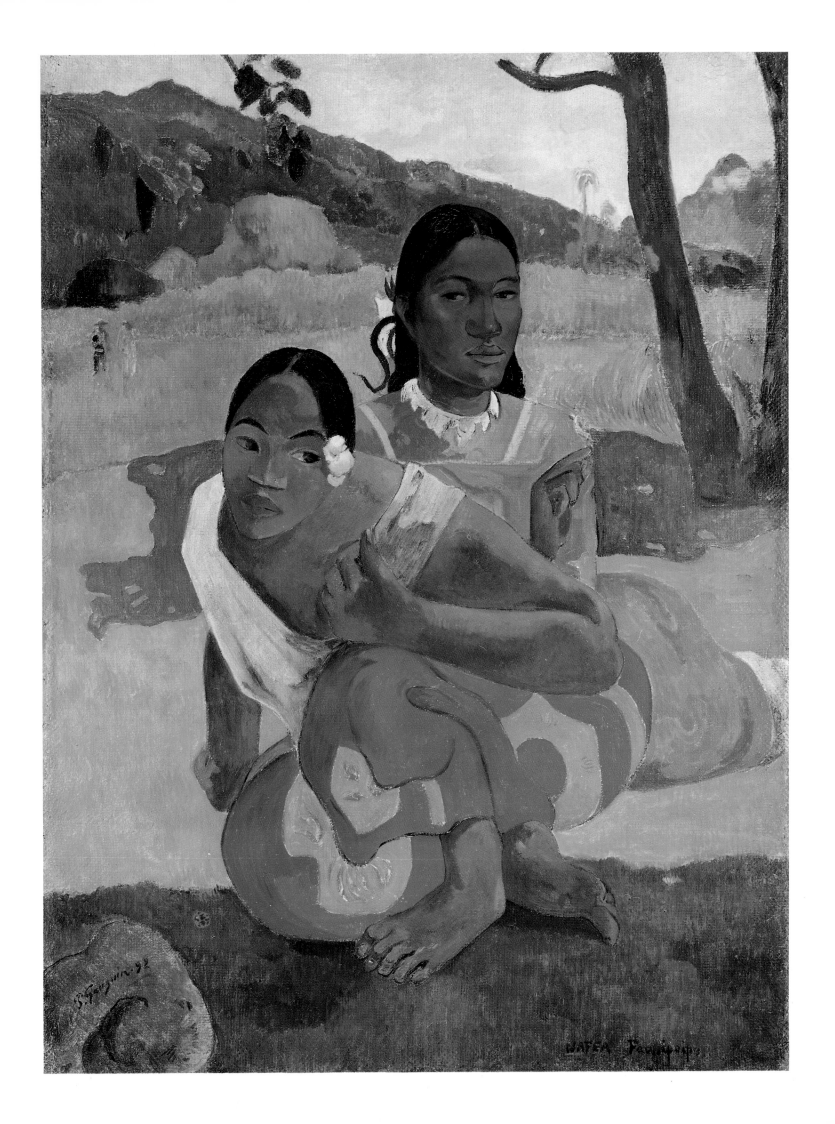

The theme of bathing nymphs is recurrent in the history of post-Renaissance Western art and within Gauguin's own oeuvre. The utopian vision that inspired painters as diverse as Titian, Boucher, Gainsborough, Courbet and Degas to explore the subject in classical or contemporary guise, is sustained in this canvas, which combines elements of both. The presence of the male figure in the water and the gestures of the women (which could be interpreted as indicating shock or surprise) recall the scene of *Diana and Actaeon*, which Gauguin would have known in a number of versions, including those of Titian and Gainsborough. This reference is not explicit but Gauguin probably anticipated that it would be read as a subtext by those who knew the older paintings, and does not include any element to contradict this.

Although no preparatory drawings are extant, the composition reuses a number of elements from earlier works. Borrowings from Gauguin's own visual repertoire include the figure with arms raised, who is the direct descendant of *Ondine* (page 81), and the obliquely angled tree, which was also pivotal to the composition of *Vision after the Sermon . . .* (page 61). Having completed *Fatata te miti*, Gauguin then mutated the main elements of the scene in a pendant painting *Arearea no varua ino (Amusement of the Evil Spirit)*, in which the women, the tree, highly stylized water and foliage combine in a different configuration.

Overall the canvas is remarkable for its sinuousness of line, uniting the smooth contours of the women's bodies with the delicate organic shapes of wave, foliage and tree. Representational and abstract forms equally contribute to the startling decorative effect, and the composition as a whole is orchestrated by a rich symphony of colour. Undoubtedly this is one of Gauguin's most erotic paintings, in which he has created a sumptuous blend of sensory delights.

Fatata te miti (Near the Sea)
Painted 1892
68 × 92cm
National Gallery of Art, Washington, DC

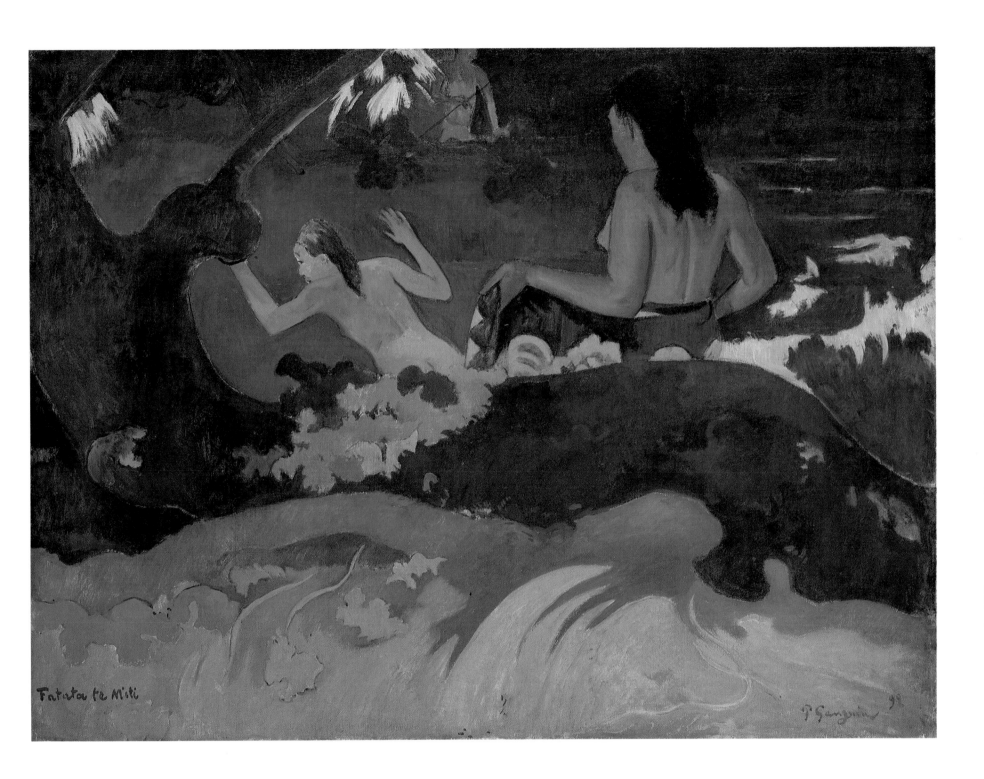

Fascinated by the theme of bathing women, Gauguin undertook a number of important nudes in the early nineties, among which he thought this canvas the finest.

Not drawn directly from a Tahitian model, the pose of the seated figure may be traced to the frieze from the Theatre of Dionysus, which Gauguin knew from a photograph; he sketched it a number of times, subsequently sticking the studies into the manuscript of *Noa Noa*. The same pose is recalled in later paintings, but that of the reclining woman, for which there is no obvious source, seems not to have been used again (other than in a watercolour transfer of 1894).

The unusual title has led to numerous interpretations of the painting's meaning. It has alternatively been thought of as: an ironic allusion to the imposition of Western moral values upon the native people; as Gauguin challenging the spectator to be jealous of his exotic (and erotic) lifestyle; as a sentiment analogous solely to the colour harmonies of the painting; or as a suggestion of a complex relationship between the two women, implicating a third unseen figure. This ambiguity seems, however, to have been the artist's intention, since he offered no explanation of the subject matter and made clear his preference that the painting should be known by its Tahitian name.

The lack of obvious narrative concentrates the spectator's attention on the purely sensuous aspects of the scene; the rich patchwork of colour reflecting off the calm water, the luxuriant bodies of the women, and the way in which both background and figures are suffused with a warm light unifying the whole.

Aha oe feii? (What! Are You Jealous?)

Painted 1892
68 × 92cm
Pushkin State Museum of Fine Arts, Moscow

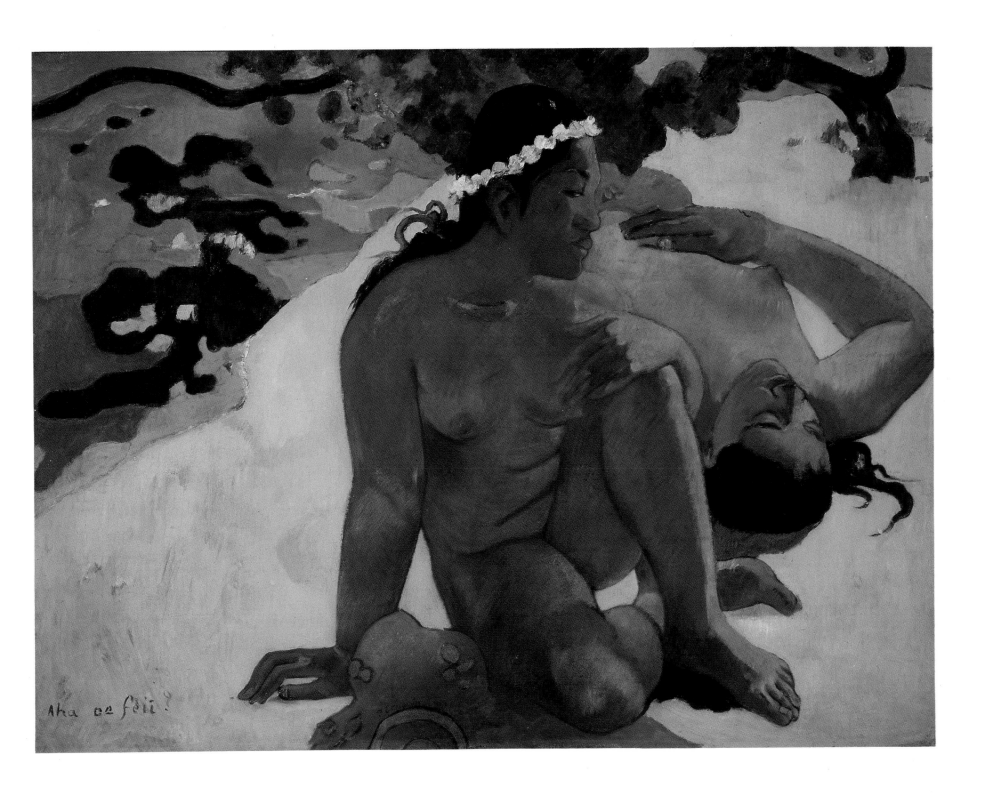

The subject of this canvas arose directly out of an episode with Gauguin's child-wife Teha'amana (whom he called Tehura), later described by the artist in the manuscript of *Noa Noa*. On his late return from Papeete in the middle of the night, he entered the hut to find the young girl frozen with terror:

Tehura lay motionless, face downwards on the bed, and stared up at me, her eyes wide with fear. She looked at me, but seemed not to know who I was. For a moment I too felt a strange uncertainty. Her terror was contagious. It seemed that a phosphorescent light streamed from her staring eyes. Never had I seen her look so tremendously beautiful. In the half-light I feared to make any movement that might increase the child's paroxysm of terror. Would she realize, at that moment, who I was? Might she take me for one of those legendary demons or spectres, the Tupapaus, *who give the people of her race sleepless nights? Did I really know her myself? The extreme of fright she was in due to her superstitions transformed her into a strange being, entirely different from anything I had known before.*

Immediately translating the scene into visual terms, Gauguin painted the room as the girl imagines it to be, placing great importance on the inclusion of the *tupapau* positioned behind her — an 'ordinary little woman', but a spectre of Death — and the depiction of 'phosphorescences' (in the form of flowers) scattered across the background. The artist acknowledged that the naked pose could be construed as indecent, but believed that the 'native feeling, character and tradition' inherent in the subject matter legitimized his representation. The provocative conclusion reached in his assessment of the canvas in the *Cahier pour Aline* ran as follows:

To sum up. The musical part: horizontal, wavy lines; harmonies of orange and blue, linked by yellows and violets — their derivatives — lit up with greenish sparks. The

Manao tupapau (The Spirit of the Dead Keeps Watch)
Painted 1892
73 × 92cm
Albright-Knox Art Gallery, Buffalo, New York

literary part: the spirit of a living girl linked with the Spirit of the Dead. Night and Day.

This genesis is written for those who have always wanted to know the whys and wherefores.

Otherwise, it is simply a study of a Polynesian nude.

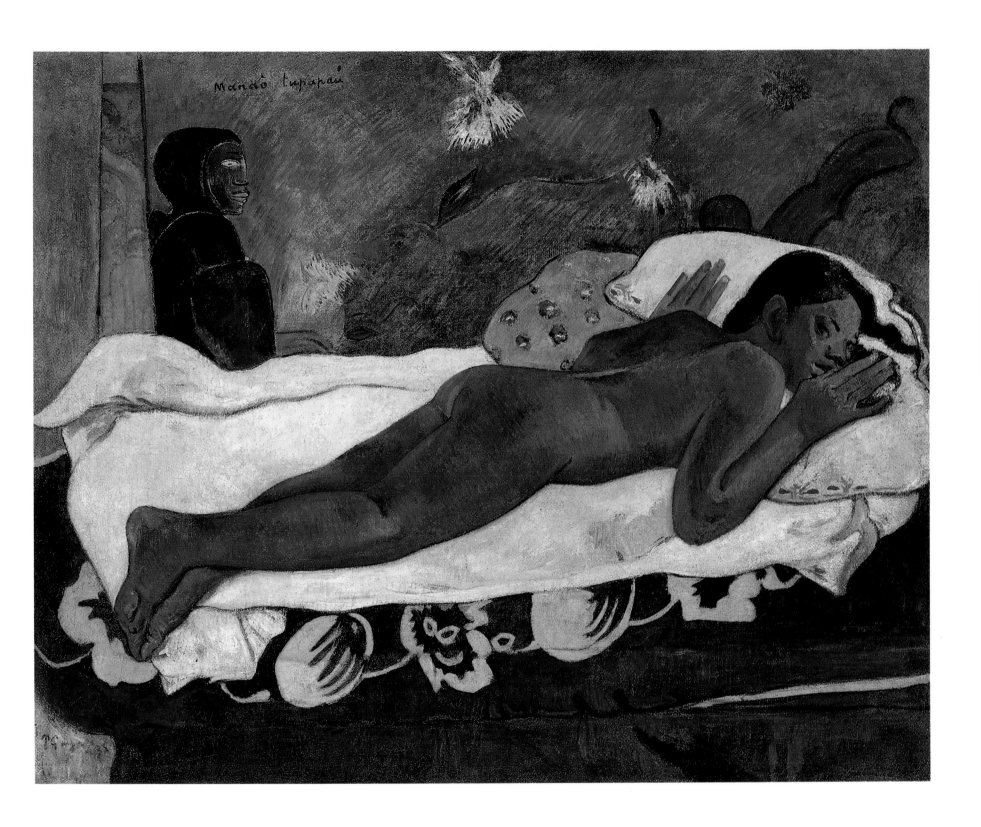

In his manuscript *Noa Noa* Gauguin documented in detail his relationship with Teha'amana his thirteen-year-old Tahitian wife. He recalled:

Tehura was sometimes very wise and affectionate, and then again quite filled with folly and frivolity. Two opposite beings, leaving out of account many others, infinitely varied, were mingled in one. They gave the lie, the one to the other; they succeeded one another suddenly with astonishing rapidity. She was not changeable; she was double, triple, multiple – the child of an ancient race.

This monumental portrait was painted soon before Gauguin's return to France, and seems to be a memorial, both to Teha'amana and to the Maori culture that bore her. Further to his reading about the beliefs of the Tahitians, Gauguin had become fascinated by ancient Polynesian culture and, wherever possible, introduced deities, glyphs and spirit forces into his canvases. In *Manao tupapau* (page 119) Teha'amana has succumbed to the superstitions of her people and lies in a state of terror; here, on the other hand, her heritage literally 'backs her up' and her statuesque figure pronounces her belief in being descended from the deities Hina and Taaroa (the former represented on the wall behind her).

Though referring to a common Tahitian heritage and probably not drawn directly from life, this canvas is truly a work of portraiture, concentrating on the specific facial characteristics of the sitter, rather than presenting an 'ideal' Tahitian physiognomy. Gauguin also carefully describes the particularities of the costume and adornment, closely observing detail in, for instance, the lace of the collar. It may be that he painted this canvas as a 'keepsake' of Teha'amana, for which reason he ultimately chose to withdraw it from the Paris auction of his work in 1895.

Merahi metua no Teha'amana (The Ancestors of Teha'amana)
Painted 1893
76.3 × 54.3cm
The Art Institute of Chicago, Illinois

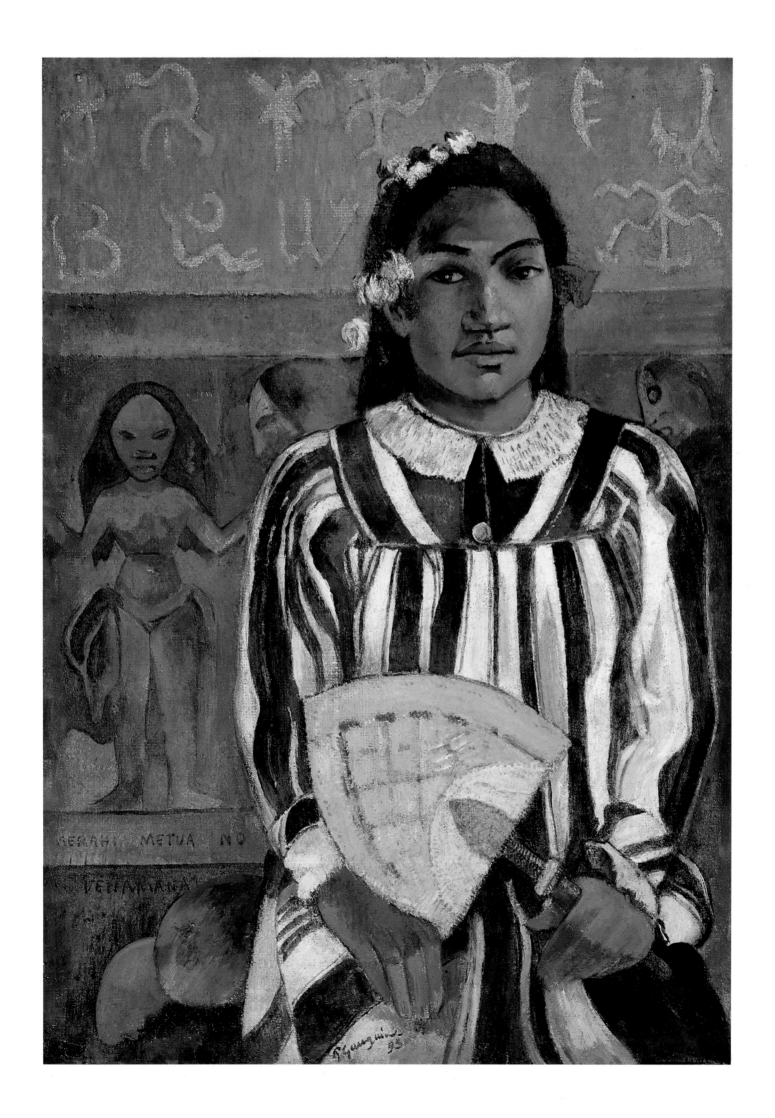

The Tahitians believed that the coupling of Hina (the goddess of the moon) with Taaroa (the god of the universe) brought about creation in the form of Fatou (the animating spirit of the earth). Gauguin was fascinated by this mythology, and these gods reappear in a number of his works in different media. They also feature in his manuscript, *Ancien culte mahorie*, which includes a dialogue between mother and son; Hina trying to coax Fatou out of his destructive impulses:

Hina said to Fatou: 'Bring man back to life after his death.'
The god of the earth answered the goddess of the moon: 'No, I will not return him to life. The earth will die; plants will die and the men whom they nourish; the soil that makes them will die. The earth will end; the soil will die; will die never to be reborn.'
Hina replies: 'Do as you want: as for me, I shall bring the moon back to life. And all that belongs to Hina shall continue to exist, and all that belongs to Fatou shall perish, and man must die.'

It might be supposed, though it is not made explicit, that Hina is depicted in this painting whispering these words in the ear of her son. The resemblance of the scene to Ingres's *Jupiter and Thetis* – with the pliant body of the goddess reaching up to the stern, square-set face of the god – also points to this being a scene of entreaty. But *Hina Tefatou* has not the melodrama of *Jupiter and Thetis*, and the figure of Hina is closer to that of Ingres's *La Source*. It is perhaps unsurprising that the painting was ultimately bought by Degas, the greatest disciple of Ingres.

Hina Tefatou (The Moon and the Earth)
Painted 1893
114.3 × 62.2cm
The Museum of Modern Art, New York

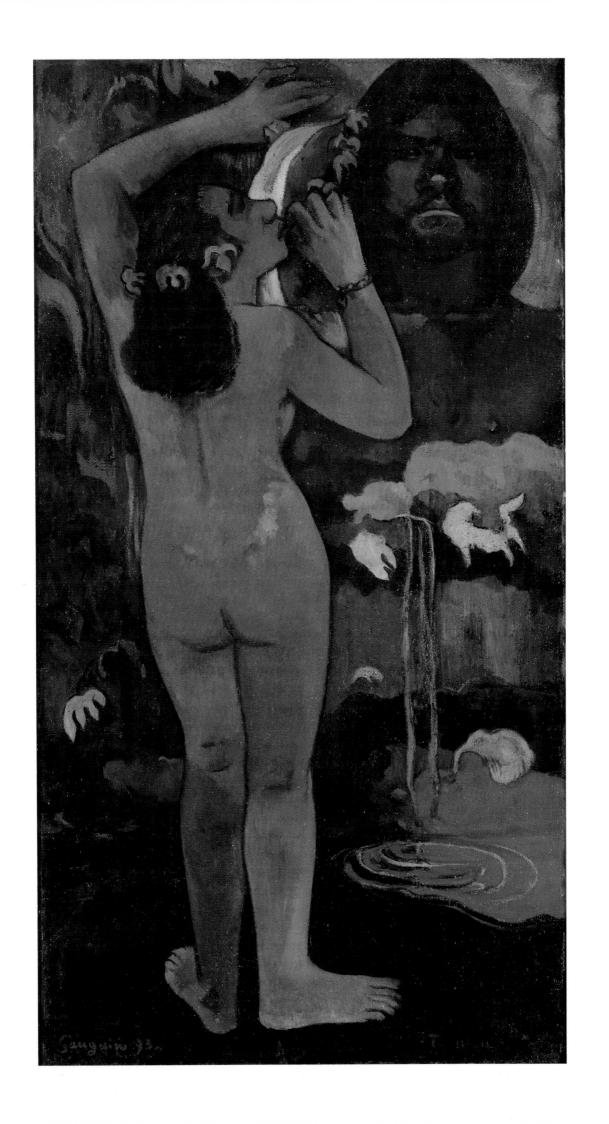

This small painting is one of the few canvases that the artist completed between trips to Tahiti, and one of two quite dissimilar self-portraits of this period (the other being the Rembrandtesque *Self-Portrait with Palette*).

Here the artist returns to the device of surrounding himself with his work (page 95); to his left *Manao tupapau* (page 119) is clearly discernible and to his right, no less prominent, is evidence of his efforts as a decorator – the vibrant yellow and green colour scheme of his Parisian 'Studio of the South Seas'.

Unlike *Self-Portrait with Palette*, this canvas is not based on a photograph, but posed before a mirror; this is suggested by the intensity of the artist's gaze and confirmed by the reversal of *Manao tupapau*. Although neither painting taps a Symbolist vein (as had, for instance, *Self-Portrait. Les Misérables*, page 65) the images are both modulated by the artist's own vanity, for he appears younger, darker, more angular and 'primitive' than contemporary cameras have revealed.

The broad handling of the paint and the artist's slightly confrontational demeanour combine to give this work an air of vigorous informality. The portrait of William Molard which appears on the verso appears stark, sombre and formal in contrast. But this discrepancy did not prevent the artist from giving this double-sided canvas to Molard as a token of their friendship.

Self-Portrait with Hat
Painted 1893–94
46 × 38cm
Musée d'Orsay, Paris

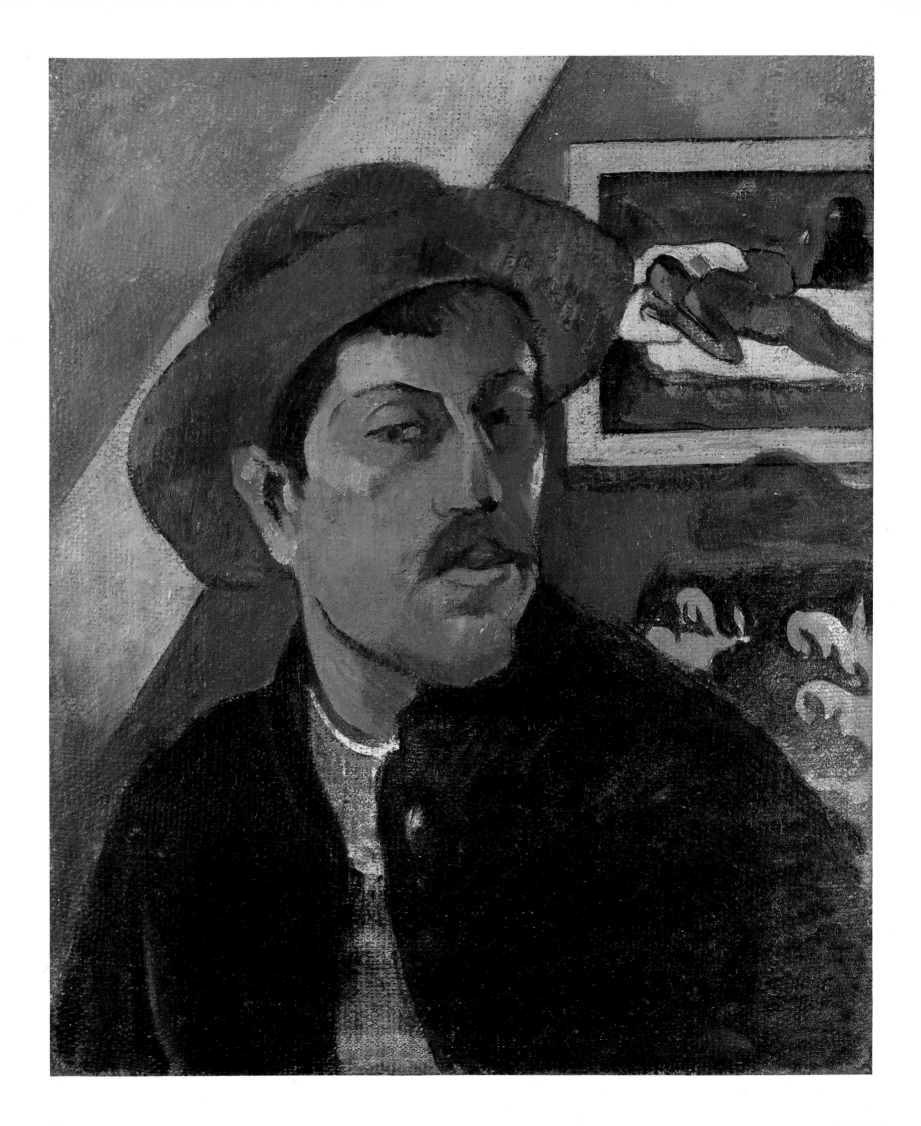

In this small canvas Gauguin draws together a number of the different forms and themes that he had developed in his earlier Tahitian work, to create an extraordinary vision of a fantastical primitive paradise. On first glance, one is struck by the firmly symmetrical composition and broad sinuous bands of pure colour which, on a purely sensuous level, make it one of the artist's most popular works. Despite its small size the painting conveys a monumentality in both composition and subject matter that render the overall effect comparable to the grandest decorative schemes of Ingres or Puvis de Chavannes.

In many ways, however, it is also a perplexing work, drawing on so many sources that its symbolism is difficult to decipher. The extraordinary god, pivotally positioned at the top of the canvas, is a composite creation probably intended to represent Taaroa, but not based on any known Tahitian prototype; it derives rather from figures in the temple complex of Borobudur in Java and from Gauguin's reading about the iconography of Easter Island. The other participants in this ritual scene include naked bathers, presented symmetrically to create a similar triad to the Three Graces of classical mythology. The pose of the right-hand figure, however, recalls the tortured form of a Peruvian mummy, which the artist had first used in *Life and Death* in 1889. The women bearing baskets on their heads seem to derive from Egyptian tomb paintings, whilst the form of the isolated boy playing a pipe in the background closely resembles the central figure in Seurat's *Bathers, Asnières*. Not only did Gauguin borrow extensively and reuse elements from his own oeuvre, but he subsequently 'recycled' this image too, in a number of woodcut illustrations made for *Noa Noa*.

For many, the primary importance of this work lies in its exploration of abstract form, anticipated in areas of earlier canvases (see page 117), but here

Mahana no atua (Day of the Gods)
Painted 1894
68.3 × 91.5cm
The Art Institute of Chicago, Illinois

taken to an unprecedented extreme. The brightly coloured, organic shapes of the water in the foreground invest the scene with a magical hallucinatory quality, the boldness of which was to stun twentieth-century artists.

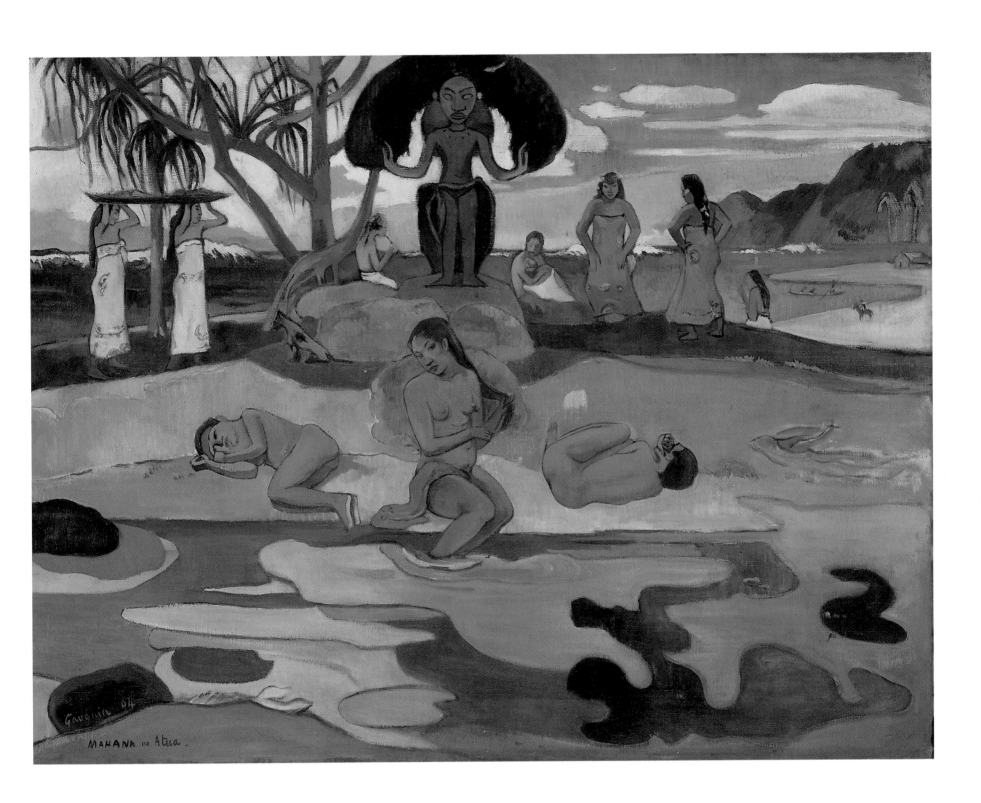

This was the most ambitious canvas to be undertaken by the artist, painted with the specific intention that it should be received as his artistic and philosophical testament. In a letter to Monfried of February 1898 he described at great length the details of its composition and some of the meanings implied by its imagery:

It is a canvas about five foot by twelve. The two upper corners are chrome yellow, with the inscription on the left and my signature on the right, like a fresco on a golden wall damaged at the corners. On the lower right a sleeping baby and three seated women. Two figures dressed in purple confide their thoughts to each other; an enormous crouching figure, deliberately out of perspective, raises an arm in the air and looks in surprise at these two people who dare to think of their destiny. A figure in the centre picks a fruit. Two cats beside a child. A white goat. The idol, both arms raised mysteriously and rhythmically, seems to point to the beyond. A crouching figure appears to listen to the idol; then, lastly, an old woman near death seems to accept, to resign herself to what she is thinking. She completes the story; at her feet a strange white bird holding a lizard in its foot represents the futility of words.

The setting is the bank of a stream in the woods. In the background the sea, then the mountains of a neighbouring island. Despite the changes in tone the landscape is blue and Veronese green from one end to the other. The nude figures stand out against it in bold orange.

The painting's tripartite structure, read from right to left, maps an allegorical progress through three ages of man – birth, life and death – and the baby, the figure picking fruit and the old woman may be seen to personify the questions that comprise the title of the work. But beyond outlining the general theme of this great frieze, the artist does not offer any explanation for many of the enigmatic elements of its magic world, preferring that it should be experienced meditatively and not put into 'futile words'.

Where Are We From? What Are We? Where Are We Going?
Painted 1897, probably completed 1898
139.1 × 374.6cm
Museum of Fine Arts, Boston

In the same letter to Monfried, Gauguin related that the entire canvas was completed prior to his suicide attempt in December 1897, painted 'day and night' without either the use of a model or preparatory drawings. This assertion is, however, contradicted both by the fact that sketches and a squared-up drawing, dated 1898, are extant, and by a photograph taken of the painting in June of the same year which shows it to be still incomplete.

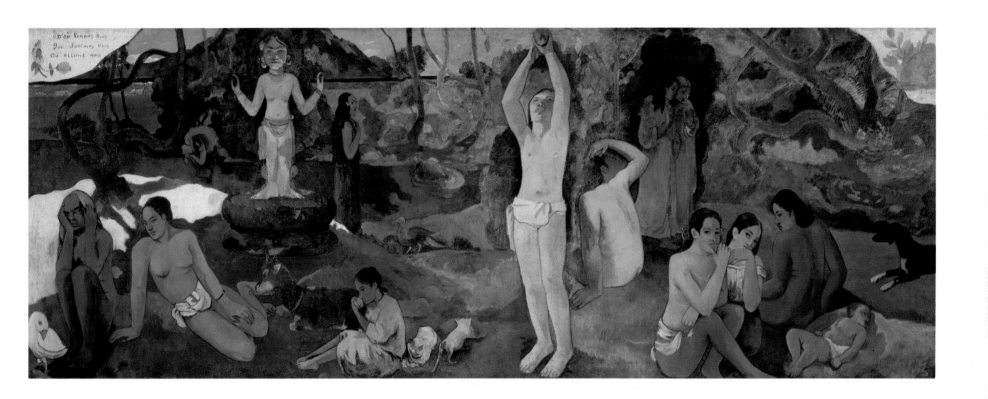

This famous canvas should be viewed in the context of Gauguin's other major 'odalisques' of the 1890s: *Manao tupapau* (page 119) and *Te tamari no atua*. Each of these three works bears a debt to Manet's *Olympia*, which Gauguin had copied in 1891, focuses upon the form of a reclining Tahitian girl and has a strong symbolic content. In a letter to Daniel de Monfried, Gauguin was keen to stress his particular objective in this painting. He wrote:

I am trying to finish a canvas to send with the others . . . I may be mistaken, but I believe that it's a good thing. I wanted to suggest, by means of a simple nude, a certain long-lost barbaric luxury. The whole thing is suffused with colours that are deliberately sombre and sad; it's not silk, nor velvet, nor muslin, nor gold that creates this luxury, but simply the material enriched by the artist. No nonsense . . . man's imagination alone has enriched the dwelling with his fantasy.

As a title, Nevermore; *not exactly the raven of Edgar Poe, but the bird of the devil who keeps watch. It is painted badly (I am so nervous that I can only work in bouts), but no matter, I think it is a good canvas . . .*

As with many of Gauguin's influences, the poem is merely a starting point for the picture that emerges, the literal correspondence extending only to the unexplained presence of a raven within an interior. Perhaps Gauguin felt that the ambiguous nature of the poem itself allowed such a loose interpretation; that as the bird arrives unexpectedly in Poe's narrative, so it is equally appropriate that it should alight in a Tahitian setting – in neither work is its meaning explained. The poem must, however, have been of great personal significance to Gauguin, since it had been translated by Mallarmé, illustrated by Manet and recited at the farewell banquet given in his honour prior to his departure for Tahiti.

The model was the artist's young *vahine* Pahura, previously depicted as the ecstatic mother of Christ in *Te tamari no atua*. In *Nevermore . . .* she lies naked,

Nevermore, O Tahiti
Painted 1897
60.5 × 116cm
Courtauld Institute Galleries, London

her face partially hidden by her hand, turned away from the alien presence of the bird in a similar manner to the way in which Teha'amana in *Manao tupapau* turns guardedly from the spirit whom she imagines to be behind her. In discussing the earlier of the two paintings Gauguin had pointed out that Tahitians 'by tradition are very much afraid of spirits of the dead', and it is likely that the raven with its melancholy refrain 'Nevermore' is here borrowed from Poe, and the earlier painting recalled, as references to the recent death of Gauguin and Pahura's first child.

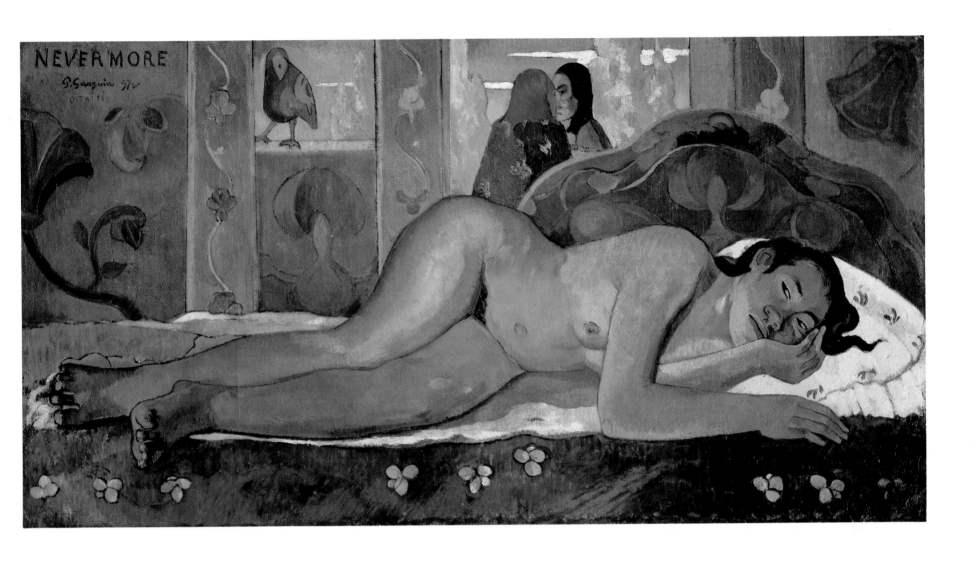

In this ambiguous work Gauguin again invites an interpretation of the background scene as an analogue for the sitters' state of mind, and one may choose to read the friezes either as a straightforward record of an interior setting, or as an abstruse account of the women's reverie.

On the left-hand wall is a double frieze separated by a dado; below, a series of stylized animals linked by plant forms comprise a running pattern; above, an entwined couple are watched by a woman covering her nakedness with leaves (the possible implication being that the child depicted at the foot of the picture is the result of this courtship), and to the right-hand side of the facing wall is a solitary idol of uncertain sex, at whose feet two rabbits mate. These monochrome episodes are interrupted by a vibrant Tahitian landscape, though whether this is intended to represent a real or painted scene it is difficult to establish.

In its composition the interior resembles those of Japanese *ukiyo-e* prints; sparsely furnished and sharply angular, but with a flattened perspective making the floor seem raked. Although the overall effect of the painting is decorative, this firm structural context and the restricted palette of warm but muted hues evoke a calm and contemplative atmosphere. The baby sleeps, but the 'dream' of the title may equally well relate to the meditative waking dreams of the women who sit close to each other, though distanced by their preoccupied state. Gauguin, however, had no wish to identify a specific dreamer, and wrote to Monfried:

Everything is dream-like in this painting. Is it the child, the mother, the rider on the path or, perhaps, the painter's own dream?

Te Rerioa (The Dream)
Painted 1897
95 × 130cm
Courtauld Institute Galleries, London

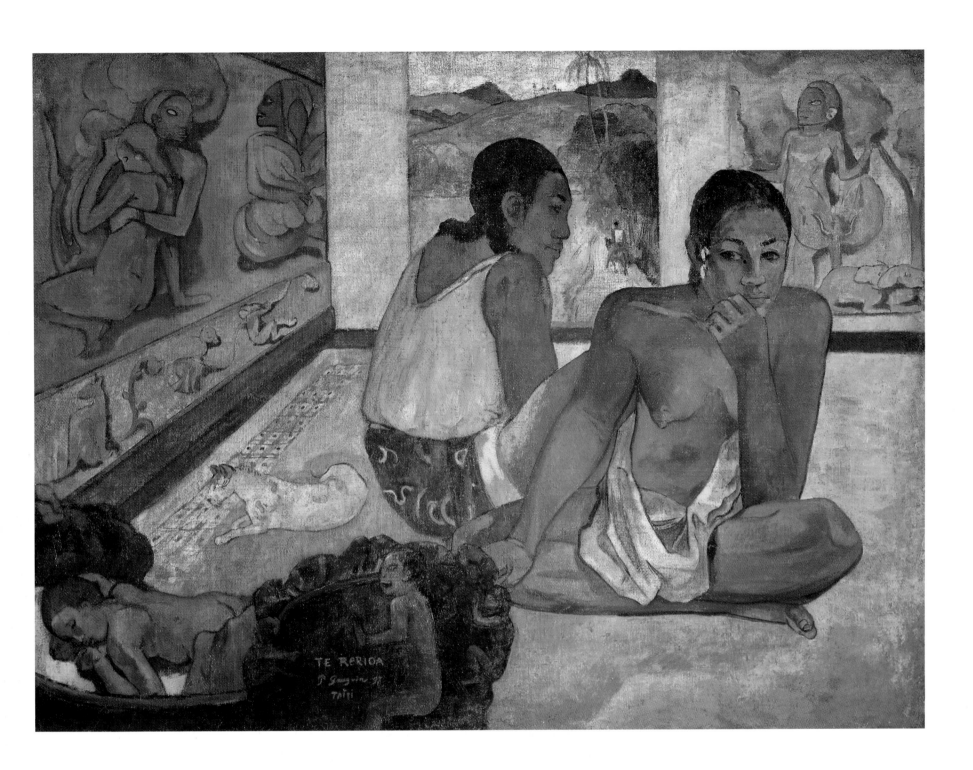

From 1897 onwards horses began increasingly to appear in Gauguin's large oils, though the animals were not native to Tahiti, having been introduced to the islands only in the late sixteenth century. It is appropriate, therefore, that for *The White Horse* the artist should have looked for inspiration to ancient Greece, in particular the Parthenon horses of Phidias, which were among the Elgin marbles in the British Museum (known to Gauguin from photographs).

The resulting painting, his largest and most ambitious of 1898, owes much to classical sculpture and bas-relief, both in the firm modelling of the animal's form and in the frieze-like composition of the canvas as a whole; but its classical aspect is tempered both by the influence of Degas, who was fascinated with the delicate elegance of horses, and by Japanese prints, with their strong linear emphasis and disregard for orthogonal perspective.

This mysterious work is, however, far more than the sum of its influences, communicating as it does an enigmatic spirituality in its unexplained subject matter, tight compositional structure and dark, rich hues. Though based on observable reality, it is essentially a literary, illustrative picture, inspired by fantasy and legend. Gauguin was later to recall in *Avant et après*:

Sometimes I withdrew very far beyond the horses of the Parthenon ... back to the gee-gee of my childhood, the faithful hobbyhorse.

It was perhaps this naivety that dissuaded Ambroise Millaud from claiming the work he had commissioned. According to his daughter, this prosperous pharmacist felt justified in refusing to pay for the painting on the grounds that the artist had depicted a green horse rather than a white one. Arguments that the green was reflected colour from the surrounding foliage held no sway, and the canvas remained unsold, being sent finally to Monfried in 1902.

The White Horse

Painted 1898
140 × 91cm
Musée d'Orsay, Paris

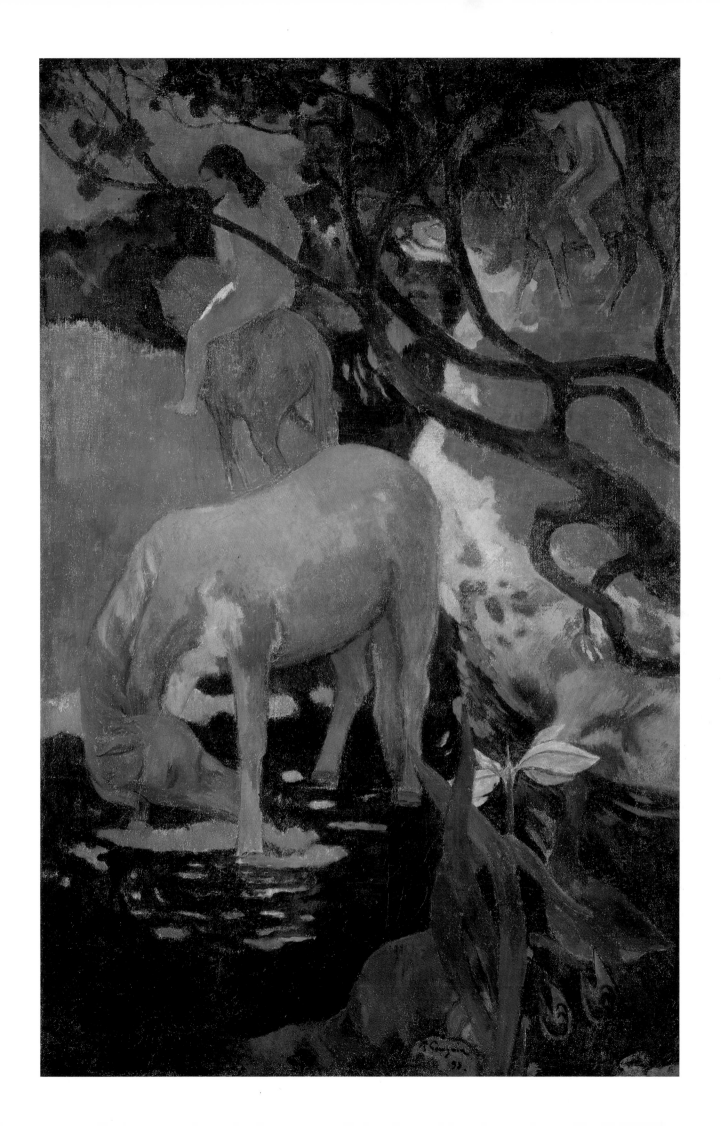

This sensuous work is considered by many to epitomize the artist's fantasy of Tahiti as a place of warmth, endless natural bounty and welcoming, unashamed native women. When not plagued by illness, money worries and petty bureaucracy Gauguin was able for short periods to believe that the island was the paradise he had searched for. In 1897 he had written to Armand Séguin:

But just to sit here in my doorway, without a single worry, smoking a cigarette and drinking a glass of absinthe, is a pleasure I enjoy every day. And my 15-year-old wife [Pahura] prepares my simple meals daily and gets down on her back for me any time I want, all for a 10-franc dress every few months ... You can't imagine how far 125 francs will go here.

A beautiful and atmospheric painting, *Two Tahitian Women* is an accomplished essay in eroticism, offering no symbols, inscriptions or literary allusions to conceal the blatantly sexual nature of the subject matter. The smooth and monumental forms of the women owe a debt to classical sculpture, which rendered them acceptable within the genre of 'nudes' to a bourgeois French audience; this undeniable elegance does not, however, mask the fact that the focal point of the composition is not the faces of the women, for these are cast in shadow, but the full breasts of the figure on the left.

If the canvas may be said to have a theme, it is ripeness, the offering of mashed fruit or mango blossom being held so close to the nipples as to imply that these are also 'fruits' on offer to the viewer. If what is held is indeed mashed fruit the painting becomes more overtly sexual in implication, for Tahitian men and women were forbidden from eating together.

Two Tahitian Women
Painted 1899
94 × 72.2cm
The Metropolitan Museum of Art, New York

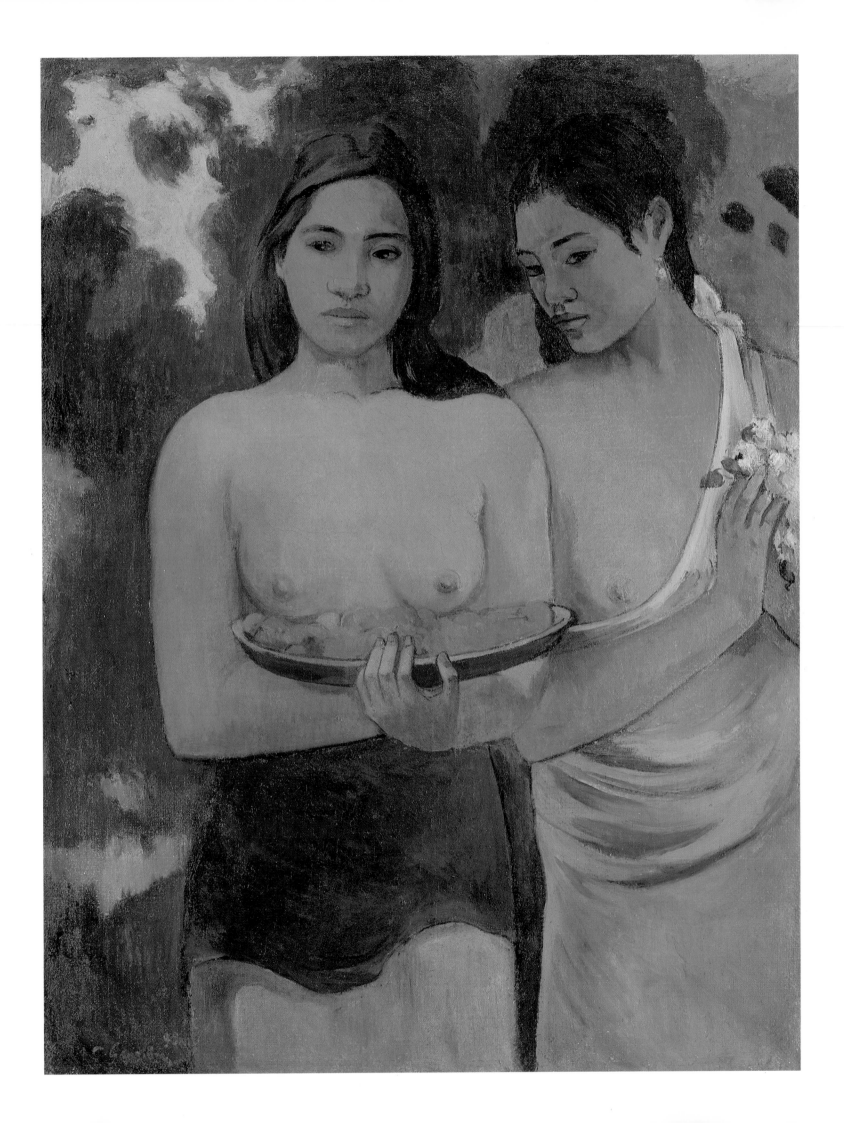

This is one of two canvases of 1902 painted in direct response to Degas's equestrian scenes, most particularly *Racehorses at Longchamp* (1873–75). Gauguin had always held Degas in high esteem, but prior to the late '90s it was largely in figurative compositions that the influence of the older master was most apparent. From 1898 onwards, however, the presence of horses in a number of Gauguin's important works suggests that he had begun to look closely at Degas's racecourse subjects.

Of the central group, the pose of the left-hand horse and rider is a direct (albeit inverted) quotation from the Degas, and in their style the other two animals with native riders would seem to derive from the same source. It was rare, however, for the artist ever to rely exclusively on one influence and, in keeping with his more eclectic borrowings, the grey horses to the left resemble those of the Parthenon frieze (known to Gauguin only from photographs). These are not ridden by natives, as are the others, but by what seem to be *tupapau*, strangely liveried spirit figures that contribute an unexplained fantastic dimension to the scene.

Horsemen on the Beach
Painted 1902
66 × 76cm
Folkwang Museum, Essen

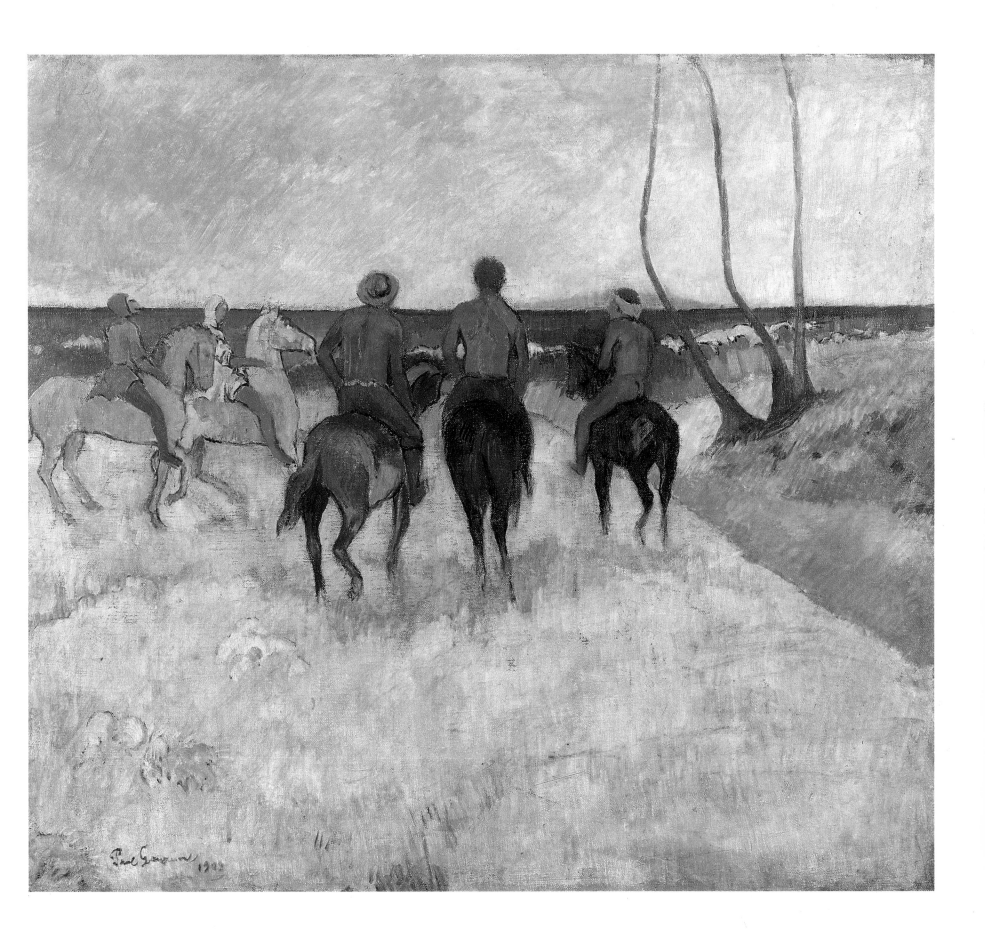

CHRONOLOGY

1848
7 June. Birth of Eugène Henri Paul Gauguin at 52 (today 56) rue Notre-Dame de-Lorette, Paris, to Pierre Guillaume Clovis Gauguin and Aline Marie Chazal.
1849
Family sail to Peru and Clovis dies on the journey.
1855
Return to France to live with Gauguin's paternal uncle in Orléans.
1859–62
Attends Junior Seminary of the Saint-Mesmin Chapel in Orléans.
1861
Mother takes work in Paris as a seamstress.
1862
Joins mother in Paris and prepares for the entrance exam at the Naval Academy.
1864
Final year of school; boards at the *lycée* in Orléans.
1865
Mother leaves Paris, appointing the banker and collector Gustave Arosa the children's legal guardian.
Enlists as an officer's candidate in the merchant marine.
Sails for Rio de Janeiro.
1866
Travels around the world as a second lieutenant.
1867
Mother dies while Gauguin in India.
Returns to France.
1868
Officially enlists in the military and is based in Le Havre.
1869
Admitted to hospital.
1871
Given renewable leave from military service.
1872
Gustave Arosa helps him to find a job with Paul Bertin, the stockbroker, in Paris.
Probably begins painting under the guidance of Arosa's daughter.
Meets Émile Schuffenecker at Bertin's.
Meets Mette Sophie Gad, a 22-year-old Danish governess.
1873
Marries Mette Gad.
1874
Birth of first son, Émile.
Meets Pissarro who introduces him to the Impressionist circle.

1876
Exhibits a landscape at the Salon.
1877
Birth of a daughter, Aline.
Starts to sculpt.
1879
Employed by the banker André Bourdon.
Exhibits a sculpture at the fourth Impressionist exhibition.
Frequents the Café de la Nouvelle-Athènes, mixing with Manet, Degas, Renoir and Pissarro; begins to collect their work.
Birth of second son, Clovis.
Begins to paint with Pissarro at Pontoise.
1880
Exhibits eight works at the fifth Impressionist exhibition.
Employed by the Thomereau insurance agency.
1881
Exhibits ten works at the sixth Impressionist exhibition.
Birth of third son, Jean Réné.
1882
Exhibits thirteen works at the seventh Impressionist exhibition.
Stock market collapse; career crisis.
1883
Death of Gustave Arosa.
Attempts to find work with an art dealer.
Birth of fourth son, Paul Rollon (Pola).
1884
Moves with family to Rouen and visits Paris occasionally.
Mette leaves for Copenhagen with the children.
Works for A. Dillies and Co., canvas and tarpaulin manufacturers.
Joins his family in Copenhagen.
1885
Writes *Notes synthétiques*.
Exhibits at The Society of the Friends of Art in Copenhagen.
Returns to Paris with Clovis. Stays with Émile Schuffenecker.
Visits England.
Returns to Paris and takes various jobs.
1886
Exhibits twenty works in the final Impressionist exhibition.
Makes first ceramics with Ernest Chaplet.
Leaves Paris to stay in the Gloanec inn at Pont-Aven, where he meets Émile Bernard and Charles Laval.
Refuses to exhibit at the Independents' exhibition.
Breaks off friendship with Pissarro and the other Neo-Impressionists.
Returns to Paris and meets Vincent van Gogh.
Hospitalized for tonsillitis.

1887
Sails for Panama with Charles Laval. Works in Colón for the Society of Public Works and on the construction of the Panama Canal.
Leaves for Saint-Pierre, Martinique, with Laval.
Returns to Paris ill, and stays with Schuffenecker.
Exhibits paintings and ceramics in a group show at Boussod, Valadon and Co., the gallery managed by Theo van Gogh.
1888
Visits Pont-Aven, where he works with Laval, Sérusier and Bernard.
Theo van Gogh offers to pay 150 fr. per month in exchange for one painting, if Gauguin will live with Vincent van Gogh in Arles.
Accepts and leaves for Arles.
Small exhibition at Boussod, Valadon and Co.
Threatened by van Gogh who cuts off part of his own ear.
Returns to Paris three days later to stay with Schuffenecker.
1889
Exhibits twelve works with Les XX in Brussels.
Visits Pont-Aven.
Returns to Paris to help organize the exhibition of the *Groupe Impressionniste et Synthétiste* at the Café des Arts of M. Volpini, situated outside the *Exposition Universelle*. Exhibits seventeen works.
Travels frequently between Pont-Aven and Le Pouldu, often in the company of Meyer de Haan.
Exhibits early works with The Friends of Art Association in Copenhagen.
1890
Exhibits sculpture and ceramics at Boussod, Valadon and Co.
Visits Le Pouldu and Pont-Aven.
Death of Vincent van Gogh at Arles.
Theo van Gogh enters a clinic for mental illness.
Meets Charles Morice.
Juliette Huet becomes his model and mistress.
1891
Friendly with Bonnard, Denis and Vuillard, and frequently visits their studio.
Theo van Gogh dies in Holland.
Exhibits wood reliefs with Les XX in Brussels.
Sale of thirty works at the Hôtel Drouot.
Visits family in Copenhagen; the last time he will see them.
Banquet at the Café Voltaire in Gauguin's honour.
Ministry of Public Education and Fine Arts agrees to sponsor his trip to the South Seas.
Leaves for Papeete, Tahiti.

Exhibits four works at the Salon of the Société Nationale des Beaux-Arts.
Rents native house in Mataiea, south of Papeete.
Takes 13-year-old Teha'amana as his *vahine* and model.
1892
Admitted to hospital haemorrhaging but discharges himself.
Penniless; requests repatriation.
First Tahitian painting *Vahine no te tiare* is exhibited in Paris.
Request for repatriation granted by the French government.
Begins to write *Cahier pour Aline*.
1893
Exhibits fifty works in the *Free Exhibition of Modern Art* in Copenhagen.
Moves back to Papeete with Teha'amana.
Leaves for France with sixty-six paintings.
Inherits half of his uncle's estate.
Exhibits Tahitian work in a one-man show at the Durand-Ruel Gallery.
Shows Morice the first draft of *Noa Noa*.
1894
Lives with Annah 'the Javanese', a 13-year-old model.
Visits *La Libre Esthétique* exhibition in Brussels, which shows five of his paintings.
Death of Charles Laval.
Visits Brittany with Annah; Pont-Aven and Le Pouldu.
Breaks his leg in a brawl with sailors at Concarneau.
Annah leaves him, taking many of his possessions.
Decides to return to Tahiti.
1895
Auction of work at the Hôtel Drouot.
Gives Morice the manuscript for *Ancien culte mahorie*.
Leaves for Tahiti; travels via Australia.
Stays first in Papeete, then Panaauia on the west coast.
1896
Takes 14-year-old native mistress, Pahura.
Extreme leg pain and depression. Admitted to hospital in Papeete.
Temporarily employed to give drawing lessons to the daughters of the lawyer Goupil.
One-man exhibition at Galerie Vollard.
Pahura has a daughter, who dies within a few weeks of birth.
1897
In need of medical treatment, but refuses to be admitted to hospital.
Death of his daughter Aline.
Exhibits six paintings with *La Libre Esthétique* in Brussels.
Suffering from leg pain, syphilis, eczema and an eye infection;

unable to paint.

Begins writing *L'Église Catholique et les temps modernes*.

Breaks off correspondence with his wife.

Suffers a series of heart attacks. Begins *Where Do We Come From? What Are We? Where Are We Going?*

La Revue Blanche publishes *Noa Noa*.

Attempts suicide with arsenic.

1898

Employed as a draughtsman in the Public Works Department.

Moves with Pahura to Paofai, a suburb of Tahiti.

Pahura leaves him, stealing some of his belongings.

Difficulty walking; short stay in hospital.

Exhibits ten works at Ambroise Vollard's gallery including *Where Do We Come From? . . .*

1899

Leaves job at the Public Works Department and returns to Panaauia.

Pahura bears him a son, Émile.

First contributes to *Les Guêpes* ('The Wasps'), a satirical journal published in Papeete, and publishes his own broadsheet, *La Sourire*.

1900

Becomes editor-in-chief of *Les Guêpes*.

Ignorant of death of his son Clovis.

Ill health and repeated stays in hospital prevent him from painting.

1901

Leaves for Atuona on the island of Hivaoa in the Marquesas Islands.

Begins to build his 'House of Pleasure'.

Takes Vaeoho Marie Rose as his native mistress.

1902

Angers the Marquesan authorities by refusing to pay taxes and encouraging unrest among the natives.

Vaeoho bears him a daughter, Tahaitikaomata, and leaves him.

Severely ill, finds it difficult to paint.

1903

Convicted of libelling the Governor and sentenced to imprisonment.

Appeals for a new trial in Papeete where the sentence is reduced.

8 May: Dies following a large dose of morphine, of a possible heart attack.

9 May: Buried in the Catholic cemetery above Atuona.

SELECT BIBLIOGRAPHY

BODELSEN, Merete, *Gauguin's Ceramics*, London, 1964.

DANIELSSON, Bengt, *Gauguin in the South Seas*, London, 1965.

FEZZI, Elda, *Gauguin – The Complete Paintings* (vols. I & II), London, 1979.

GOLDWATER, Robert, *Gauguin*, London, 1985.

HOOG, Michael, *Paul Gauguin*, London, 1987.

LEYMARIE, Jean, *Gauguin – Watercolours, Pastels, Drawings*, Geneva, 1989.

MALINGUE, M. (ed.), *Paul Gauguin: Letters to his Wife and Friends*, London, 1948.

PRATHER, M., and STUCKEY, C. (eds.), *Gauguin – A Retrospective*, New York, 1987.

REWALD, John, *Studies in Post-Impressionism*, London, 1986 (revised edition), 1978.

ROSKILL, Mark, *Van Gogh, Gauguin and the Impressionist Circle*, London, 1970.

THOMPSON, Belinda, *Gauguin*, London, 1987.

Exhibition Catalogues:

Gauguin and the School of Pont-Aven, Royal Academy of Arts, London, 1986.

The Art of Paul Gauguin, National Gallery of Art, Washington and The Art Institute of Chicago, 1988.

LIST OF PLATES

All paintings are by Gauguin unless otherwise identified.

2 *Two Marquesans, c.* 1902. Monotype heightened with colour, 37.2 × 32.5 cm. The Philadelphia Museum of Art, purchased with funds from the Frank and Alice Osborn Fund.

7 *Madame Mette Gauguin in Evening Dress,* 1884. Oil on canvas, 65 × 54 cm. National Gallery, Oslo.

9 *Garden in the rue Carcel,* 1881. Oil on canvas, 87 × 114 cm. Ny Carlsberg Glyptotek, Copenhagen.

10 *Poplars,* 1883. Oil on canvas, 73 × 54. Ny Carlsberg Glyptotek, Copenhagen.

11 Photograph of Paul and Mette Gauguin, Copenhagen, *c.* 1874. Photo courtesy of Musée Gauguin, Papeari, Tahiti.

13 *Seated Breton Woman, c.* 1886. Charcoal and pastel on ivory laid paper, 32.8 × 48 cm. The Art Institute of Chicago, Gift of Mr and Mrs Carter H. Harrison 1933.910 (© 1992 The Art Institute of Chicago. All Rights Reserved).

14 Vase with Breton Girls, executed by Chaplet and decorated by Gauguin, 1886–7. Glazed stoneware, height 29.5 cm. Musées Royaux d'Art et d'Histoire, Brussels. © A.C.L. Bruxelles.

15 *Self-Portrait Jug,* 1887. Glazed stoneware, height 19.5 cm. Museum of Decorative Art, Copenhagen. Ole Woldbye.

16 *The Artist's Mother,* 1889. Oil on canvas, 41 × 33 cm. Staatsgalerie, Stuttgart.

17 Photograph of the Pension Gloanec, Pont-Aven. Photo Roger-Viollet.

18 Emile Bernard, *Les Bretonnes dans la prairie (Breton Women in a Meadow),* 1888. Oil on canvas, 74 × 92 cm. Private collection. Photo Giraudon.

21 *The Locusts and the Ants,* 1889. Zincograph, 22.2 × 29 cm. State Museum of Art, Copenhagen.

23 *The Green Christ, Breton Calvary,* 1889. Oil on canvas, 92 × 73 cm. Musées Royaux des Beaux-Arts de Belgique, Brussels. Photo G. Cussac.

24 Letter to Vincent van Gogh, November 1889, showing sketches of *Soyez amoureuses . . .* and *Christ in the Garden of Olives.* Vincent van Gogh Foundation/Vincent van Gogh Museum, Amsterdam.

26 *Soyez symboliste (Be a Symbolist. Caricature of Jean Moréas),* 1891. Pen and ink, 35 × 42 cm. Private collection. Courtesy of Editions Ides et Calendes, Neuchâtel.

27 Photo of Paul Gauguin with his children, Emile and Aline, Copenhagen, *c.* 1874. Photo courtesy Musée Gauguin, Papeari, Tahiti.

28 *Head of a Tahitian Man, c.* 1891–3. Graphite, black and red chalk on paper, 35 × 37 cm. The Art Institute of Chicago, Gift of Mrs Emily Crane Chadbourne 1922.4794 recto (© 1992 The Art Institute of Chicago. All Rights Reserved).

29 *Tahitian Landscape, c.*1892. Oil on canvas, 68 × 92 cm. The Minneapolis Institute of Arts.

30 *Mask of Tehura, c.* 1892. Pua wood, height 25 cm. Musée

d'Orsay, Paris. Photo Reunion des musées nationaux.

34 Folio 57 from the Louvre manuscript of *Noa Noa,* with woodcut of Hina and Tefatou from *Te atua,* watercolour sketch and a photograph of an unidentified Tahitian girl. Cabinet des Dessins. Musée du Louvre, Paris. Photo Réunion des musées nationaux.

37 *Te arii vahine (The Noble Woman),* 1896. Oil on canvas, 97 × 128 cm. Hermitage Museum, Leningrad.

39 *Père Paillard (Father Lechery), c.* 1901. Wood, height 67.9 cm. National Gallery of Art, Washington DC; Chester Dale Collection.

41 *Oviri,* 1894–5. Stoneware, glazed in parts, painted, height 74 cm. Musée d'Orsay, Paris. Photo Réunion des musées nationaux.

42 Photographic portrait of Paul Gauguin, *c.*1893. Photo Roger-Viollet.

45 *The Seine at Pont d'Iéna,* 1875. Oil on canvas, 65 × 92 cm. Musée d'Orsay, Paris. Photo Réunion des musées nationaux.

47 *Study of a Nude* or *Suzanne Sewing,* 1880. Oil on canvas, 115 × 80 cm. Ny Carlsberg Glyptotek, Copenhagen.

49 *The Garden in Winter, rue Carcel,* 1883. Oil on canvas, 117 × 90 cm. Private collection. Courtesy Acquavella Galleries, New York.

51 *Still-Life with Profile of Laval,* 1886. Oil on canvas, 46 × 38 cm. The Josefowitz Collection.

53 *Four Breton Women,* 1886. Oil on canvas, 72 × 90 cm. Neue Pinakothek, Munich. Photo Artothek, Munich.

55 *Tropical Vegetation, Martinique,* 1887. Oil on canvas, 116 × 89 cm. National Galleries of Scotland, Edinburgh.

57 *Mango Pickers, Martinique,* 1887. Oil on canvas, 89 × 116 cm. Vincent van Gogh Foundation/Vincent van Gogh Museum, Amsterdam.

59 *Lutte Bretonne (Children Wrestling),* 1888. Oil on canvas, 93 × 73 cm. The Josefowitz Collection.

61 *Vision after the Sermon (Jacob Wrestling with the Angel),* 1888. Oil on canvas, 73 × 92 cm. National Galleries of Scotland, Edinburgh.

63 *Portrait of Madeleine Bernard,* 1888. Oil on canvas, 72 × 58 cm. Musée de Peinture et de Sculpture, Grenoble.

65 *Self-Portrait. Les Misérables,* 1888. Oil on canvas, 45 × 55 cm. Vincent van Gogh Foundation/Vincent van Gogh Museum, Amsterdam.

67 *Les Alyscamps,* 1888. Oil on canvas, 92 × 73 cm. Musée d'Orsay, Paris. Photo Réunion des musées nationaux.

69 *The Café at Arles,* 1888. Oil on canvas, 73 × 92 cm. Pushkin State Museum of Fine Arts, Moscow. Photo Art Resource, New York.

71 *Van Gogh painting Sunflowers,* 1888. Oil on canvas, 73 × 92 cm. Vincent van Gogh Foundation/Vincent van Gogh Museum, Amsterdam.

73 *Women from Arles in the Public Garden, the Mistral,* 1888. Oil on canvas, 73 × 92 cm. The Art Institute of Chicago, Mr and Mrs Lewis Larned Coburn Memorial

Collection 1934.391 (© 1991 The Art Institute of Chicago. All Rights Reserved).

75 *Farm near Arles*, 1888. Oil on canvas, 91 × 72 cm. Indianapolis Museum of Art, Gift in memory of William Ray Adams (© 1991 Indianapolis Museum of Art).

77 *The Schuffenecker Family*, 1889. Oil on canvas, 73 × 92 cm. Musée d'Orsay, Paris. Photo Réunion des musées nationaux.

79 *Still-Life with Ham*, 1889. Oil on canvas, 50 × 58 cm. The Phillips Collection, Washington DC (© 1991 The Phillips Collection).

81 *Ondine (Woman in the Waves)*, 1889. Oil on canvas, 92 × 72 cm. The Cleveland Museum of Art, Gift of Mr and Mrs William Powell Jones.

83 *La Belle Angèle, Portrait of Madame Satre*, 1889. Oil on canvas, 92 × 73 cm. Musée d'Orsay, Paris. Photo Réunion des musées nationaux.

85 *The Yellow Christ*, 1889. Oil on canvas, 92 × 73 cm. Albright-Knox Art Gallery, Buffalo, New York, General Purchase Funds 1946.

87 *Christ in the Garden of Olives* or *Agony in the Garden*, 1889. Oil on canvas, 73 × 92 cm. Norton Gallery of Art, West Palm Beach, Florida.

89 *Soyez amoureuses et vous serez heureuses (Be in Love and You Will Be Happy)*, 1889. Carved, polished and polychromed lime wood, 119.7 × 96.8 cm. Museum of Fine Arts, Boston, Arthur Tracy Cabot Fund.

91 *Bonjour Monsieur Gauguin*, 1889. Oil on canvas, 113 × 92 cm. Národni Galeri, Prague.

93 *Nirvana, Portrait of Meyer de Haan*, c. 1889–90. Oil and turpentine on silk, 20 × 29 cm. Wadsworth Athenaeum, Hartford. The Ella Gallup Sumner and Mary Catlin Sumner Collection.

95 *Self-Portrait with Yellow Christ*, 1889. Oil on canvas, 38 × 46 cm. Private Collection. Photo Lauros-Giraudon.

97 *Portrait of a Woman with Still-Life by Cézanne*, 1890. Oil on canvas, 65.3 × 54.9 cm. The Art Institute of Chicago, The Joseph Winterbotham Collection 1925.753 (© 1991 The Art Institute of Chicago. All Rights Reserved).

99 *The Loss of Virginity*, 1891. Oil on canvas, 90 × 130 cm. The Chrysler Museum, Norfolk, Virginia, Gift of Walter P. Chrysler, Jr.

101 *Vahine ne te tiare (Woman with a Flower)*, 1891. Oil on canvas, 70.5 × 46.5 cm. Ny Carlsberg Glyptotek, Copenhagen.

103 *The Meal* or *The Bananas*, 1891. Oil on canvas, 73 × 92 cm. Musée d'Orsay, Paris. Photo Réunion des musées nationaux.

105 *Two Women on a Beach* or *Tahitian Women*, 1891. Oil on canvas, 69 × 91 cm. Musée d'Orsay, Paris. Photo Réunion des musées nationaux.

107 *Ia Orana Maria (Hail Mary)*, 1891. Oil on canvas, 113.7 × 87.7 cm. The Metropolitan Museum of Art, New York, Bequest of Sam A. Lewisohn, 1951 (© 1991 By the Metropolitan Museum of Art).

109 *Man with an Axe*, 1891. Oil on canvas, 92 × 70 cm. Private collection, Switzerland. Photo courtesy Galerie Beyeler, Basel.

111 *Ta Matete (The Market)*, 1892. Oil on canvas, 73 × 91.5 cm. Oeffentliche Kunstsammlung, Kunstmuseum, Basel. Colorfoto Hans Hinz, Munich.

113 *Nafea faa ipoipo? (When will you marry?)*, 1892. Oil on canvas, 105 × 77.5 cm. Collection Rudolf Staechelin, Basel. Colorfoto Hans Hinz, Munich.

115 *Fatata te miti (Near the Sea)*, 1892. Oil on canvas, 68 × 92 cm. National Gallery of Art, Washington DC; Chester Dale Collection.

117 *Aha oe feii? (What! Are You Jealous?!)*, 1892. Oil on canvas, 68 × 92 cm. Pushkin State Museum of Fine Arts, Moscow. Photo Art Resource, New York.

119 *Manao tupapau (The Spirit of the Dead Keeps Watch)*, 1892. Oil on burlap mounted on canvas, 73 × 92 cm. Albright-Knox Gallery, Buffalo, New York, A. Conger Goodyear Collection 1965.

121 *Merahi metua no Teha'amana (The Ancestors of Teha'amana)*, 1893. Oil on canvas, 76.3 × 54.3 cm. The Art Institute of Chicago, Gift of Mr and Mrs Charles Deering McCormick 1980.613 (© 1991 The Art Institute of Chicago. All Rights Reserved).

123 *Hina Tefatou (The Moon and the Earth)*, 1893. Oil on burlap, 114.3 × 62.2 cm. The Museum of Modern Art, New York, Lillie P. Bliss Collection (Collection, The Museum of Modern Art, New York).

125 *Self-Portrait with Hat*, 1893. Oil on canvas, 46 × 38 cm. Musée d'Orsay, Paris. Réunion des musées nationaux.

127 *Mahana no atua (Day of the Gods)*, 1894. Oil on canvas, 68.3 × 91.5 cm. The Art Institute of Chicago, Helen Birch Bartlett Memorial Collection 1926.198 (© 1991 The Art Institute of Chicago. All Rights Reserved).

129 *D'où venons-nous? Que sommes-nous? Où allons-nous? (Where do we come from? What are we? Where are we going?)*, 1897–98. Oil on canvas, 139.1 × 374.6 cm. Courtesy of Museum of Fine Arts, Boston, Tompkins Collection.

131 *Nevermore, O Tahiti*, 1897. Oil on canvas, 60.5 × 116 cm. Courtauld Institute Galleries, London (Courtauld Collection).

133 *Te Rerioa (The Dream)*, 1897. Oil on canvas, 95 × 130 cm. Courtauld Institute Galleries, London (Courtauld Collection).

135 *The White Horse*, 1898. Oil on canvas, 140 × 91 cm. Musée d'Orsay, Paris. Photo Réunion des musées nationaux.

137 *Two Tahitian Women*, 1899. Oil on canvas, 94 × 72.2 cm. The Metropolitan Museum of Art, New York, Gift of William Church Osborn, 1949 (© 1991 By the Metropolitan Museum of Art).

139 *Horsemen on the Beach*, 1902. Oil on canvas, 66 × 76 cm. Folkwang Museum, Essen.